www.viennapaint.com

Copyright © 2000 Vienna Paint
and Prestel Verlag

Publishers
Andreas Fitzner, Albert Winkler

Project Director
Albert Winkler

Art Director
Martin Keller, Christine Angerer

Image Researcher
Edo Zierotin

3-D Rendering
Markus Degen

Editorial Director
Andreas Fitzner

Text
Gerhard Loibelsberger

Paintbox is a registered trademark
of Quantel Ltd., Newbury, UK

Designed and produced by Vienna Paint
Sandwirtgasse 11, 1060 Vienna/Austria
phone +43 - 1 - 597 43 13
fax +43 - 1 - 597 43 13 13
email vip@viennapaint.com
www.viennapaint.com

Prestel books are available worldwide. Please contact your
nearest bookseller or write to one of the following addresses
for information concerning your local distributor.

Prestel Verlag
Mandlstrasse 26
80802 Munich, Germany
phone (49 89) 381 7090, fax (49 89) 381 70935

4 Bloomsbury Place
London WC1A 2QA
phone (0171) 323 5004, fax (0171) 636 8004

175 Fifth Avenue, Suite 402
New York, NY 10010, USA
phone (917) 627 0460, prestel-newyork@gmx.net

Library of Congress catalogue card no. 99-069776
Clothbound ISBN 3-7913-2363-6

Also available:
Paintbox No. 1
ISBN 3-7913-2360-1

PAINTBOX® No.2

by Andreas Fitzner and Albert Winkler

People — 8

Animals — 84

Technology — 120

Landscape — 186

Food — 250

Painting — 274

Index — 297

V ienna, April 1996. Still reeling from a transatlantic flight, I am collapsed in the reception area of Vienna Paint. As I wait for my initiation into the inner sanctum, I watch a mud-spattered bicycle messenger deliver a parcel. Instead of heading back out into the drizzle, he ambles over to a shiny square machine perched on a nearby counter top.

With complete familiarity and precision, he slides open the drawer below and withdraws a porcelain cup which he places under the machine's spigot. Then he pushes a bright red button. Moments later, the machine lets out a hiss and dispenses a perfect shot of Viennese espresso. Opening a second drawer, he pulls out a matching saucer and sets the cup on it. To complete the ritual, he plucks a small wrapped chocolate from an overflowing box and balances it on the rim of the saucer. Oblivious to his soaked clothes and the elements that await him, he takes a sip and escapes into a moment of pure caffeine ecstasy.

The sight snaps me from my daze – back home messengers consider themselves lucky if they get a smile from the receptionist. I feel as though I have been downloaded into a new dimension. And I have. This simple episode perfectly defines the communal spirit and attention to detail that I have come to experience as the hallmarks of Vienna Paint.

Eight months earlier in Chicago, I had met Vienna Paint's co-founder Andreas Fitzner at a booksellers convention at which we were gamely plugging our respective first books. Fate drew my attention to his tiny one man booth, crammed between the sprawling displays of the big league publishers. The instant I saw the bananafish on the cover of the lonely book on display, I knew I had discovered a kindred spirit. Despite the fact that we were separated by continents, culture and technology (I'm old world analog, he's cutting edge digital), we spoke the same visual language, and quickly discovered that we shared a passion for pushing the envelope of surrealism.

I have a personal (and completely unsubstantiated) theory about the style of art that was popularized by René Magritte and Salvador Dali. Whereas abstract art can be intimidating and make people feel inadequate, everybody gets the joke in a surreal image.

The works of Vienna Paint and their contemporaries collected in this book are quintessential examples of this eye-popping art form, and make it clear why this brand of imagery is such a successful advertising tool.

As I got to know Andreas and his partner Albert, I discovered that the creative output and company philosophy at Vienna Paint are true expressions of its founders' unique ideas. In their world, work is play. This was confirmed as our friendship evolved and I was invited to Vienna to "work". There followed a series of marathon mindmelding dinners, where the flow of ideas was second only to the flow of schnaps and second hand smoke. At these creative and gastronomic jam sessions, life often imitated art. One particularly memorable tableau involved a dinner guest who was so smitten with my brand of surreal cuisine that she proposed to reciprocate by binding and blindfolding me, then spoonfeeding me delicacies of her choosing. Ahh, the international language of art.

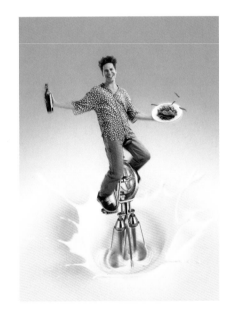

BOB BLUMER

(A.K.A. THE SURREAL GOURMET)

LOS ANGELES, MARCH, 1999

People 8

Hors-d'œuvre

The aperitif has stimulated the stomach nerves, lightened the mood, and broken the ice. A slight tension, a gently vibrating impatience settles over the guests like a fine veil. What will the Maître Eros create? Goose liver parfait, caviar blintzes, crab tails, breasts of duck? Or tender, rapidly hardening nipples, which may be nibbled at?

Voilà, the hors-d'œuvre is served! A tongue slides over arched lips in anticipation, teeth flash. A flood of warmth flows through each muscle. Touch is sensitive; electrifying tingles course through the skin. Goose pimples stand hair on end.

The hors-d'œuvres are gluttonously devoured. Pure adrenaline, mouths, hands, bodies, people . . .

Puzzled Paintbox.

A harmonic whole with uniform colour tone is created from the most diverse pieces of a puzzle. The difficulty with this work: the blending between hair and hand must be absolutely "organic". The shadows on the hand are sensitively retouched.

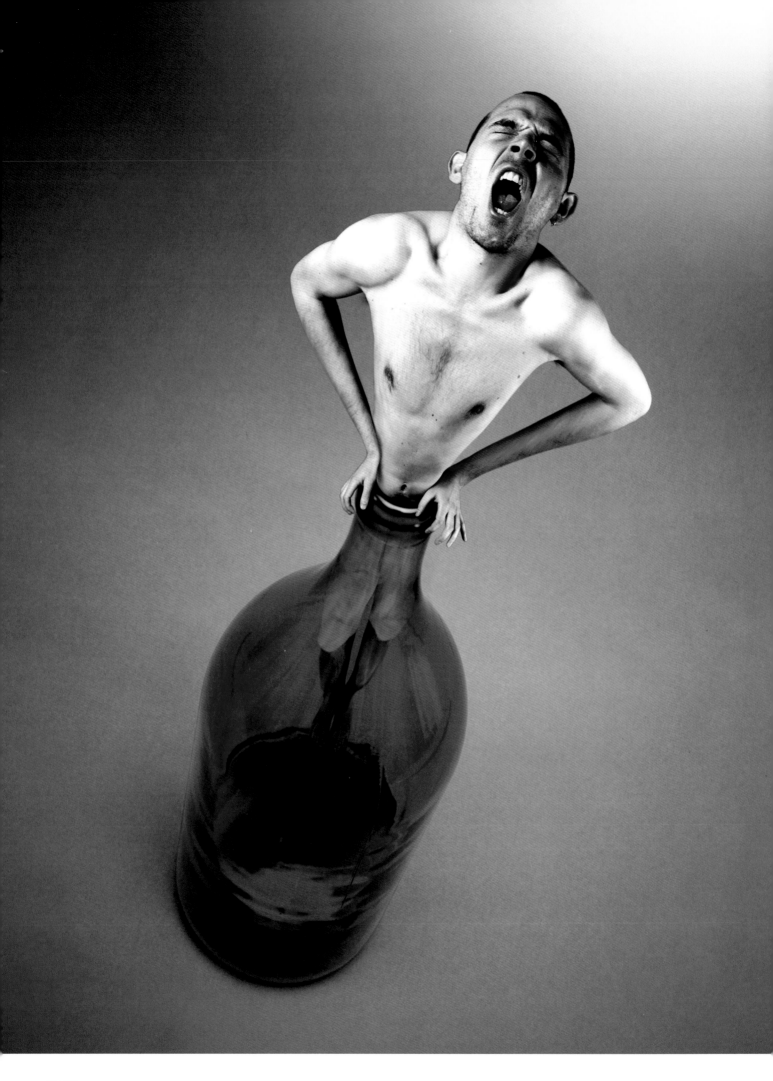

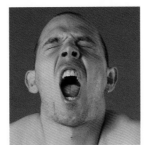

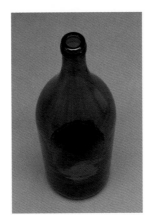

Message in a Bottle.

How does a person get inside the bottle? First, he is tenderly dissected, processed, and then no less tenderly put back together, piece by piece, in the new perspective. Last but not least, everything is "shifted" into the correct, colour co-ordinated light.

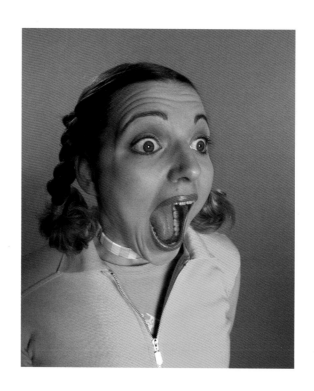

Leonardo di Caprio...Wow!

Outbursts à la comics? No problem. The Paintbox artist happily performs plastic surgery, unhindered by physical or medical limitations. Whether king-size, X-large, or petit: anything is possible. Welcome to virtual reality!

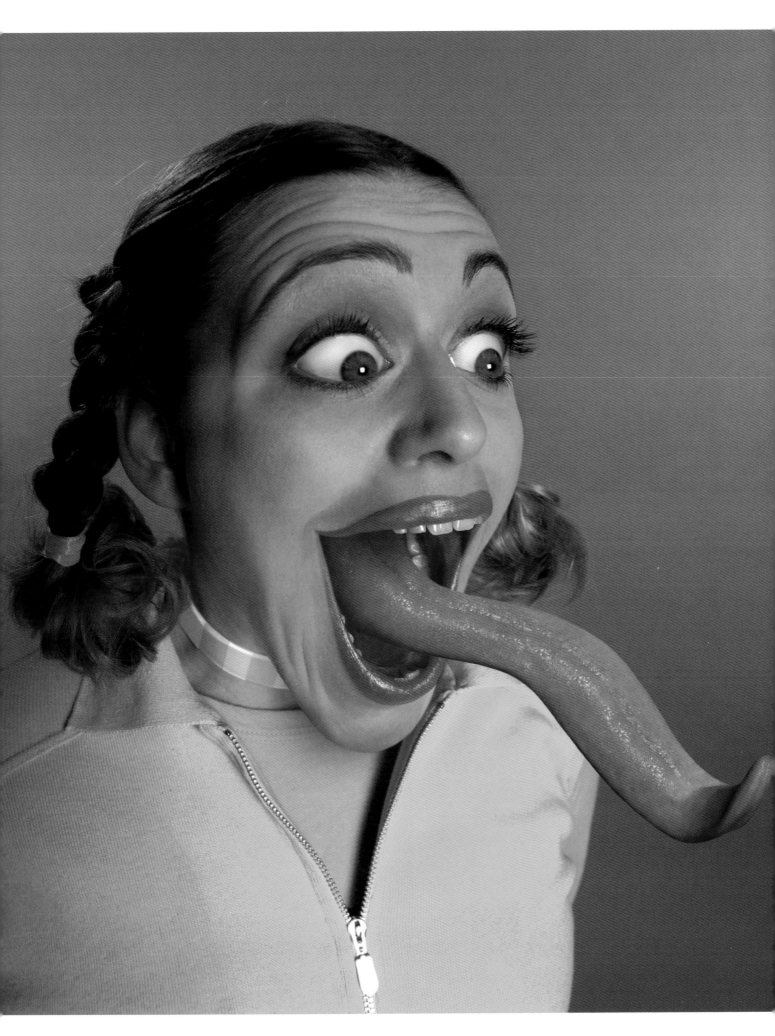

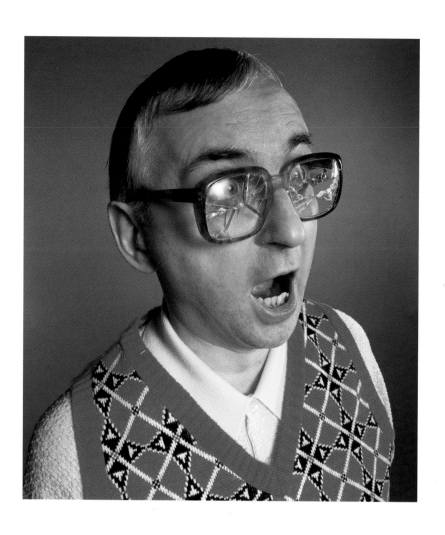

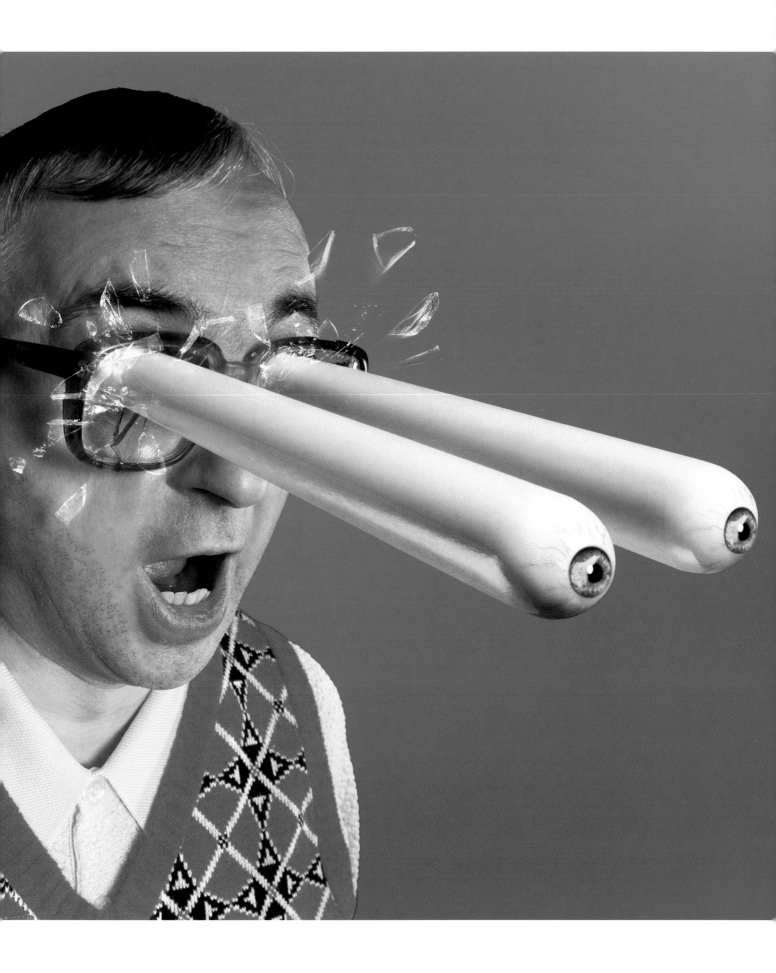

No Job for Dr. Frankenstein.

In order not to create "Frankenstein-like creatures", the Paintbox
artist must have a special flair for assembling body parts.

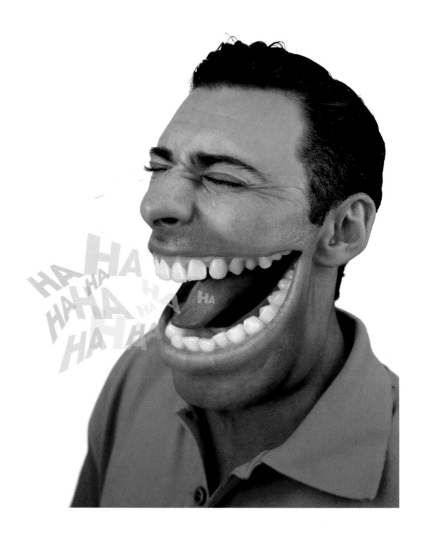

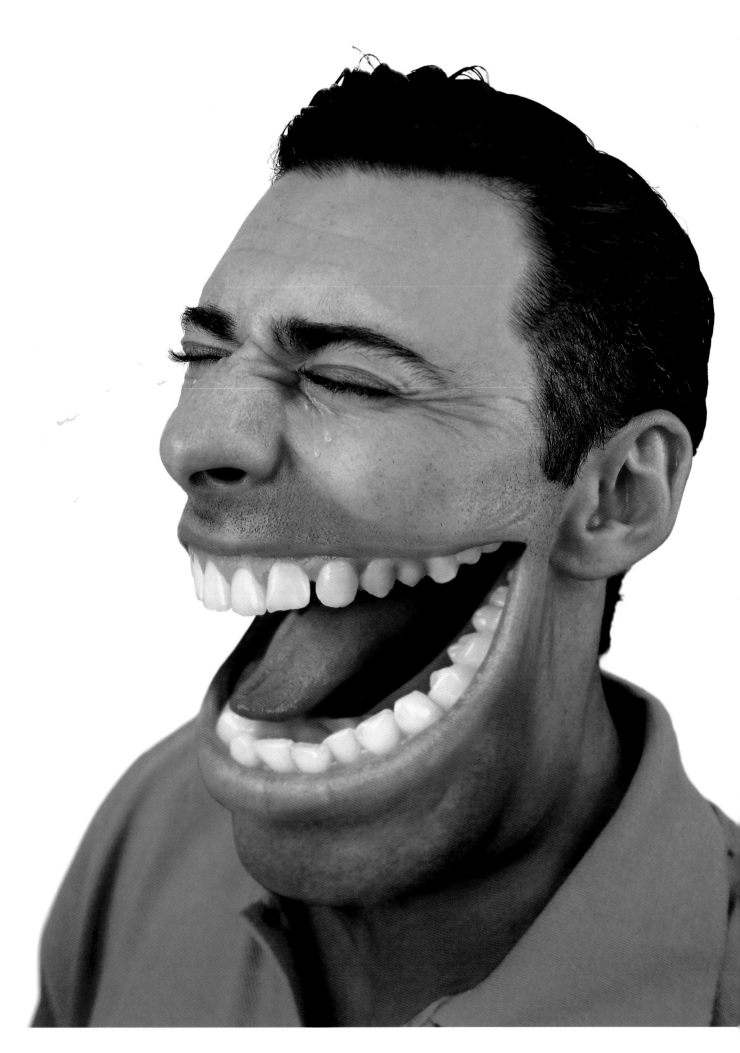

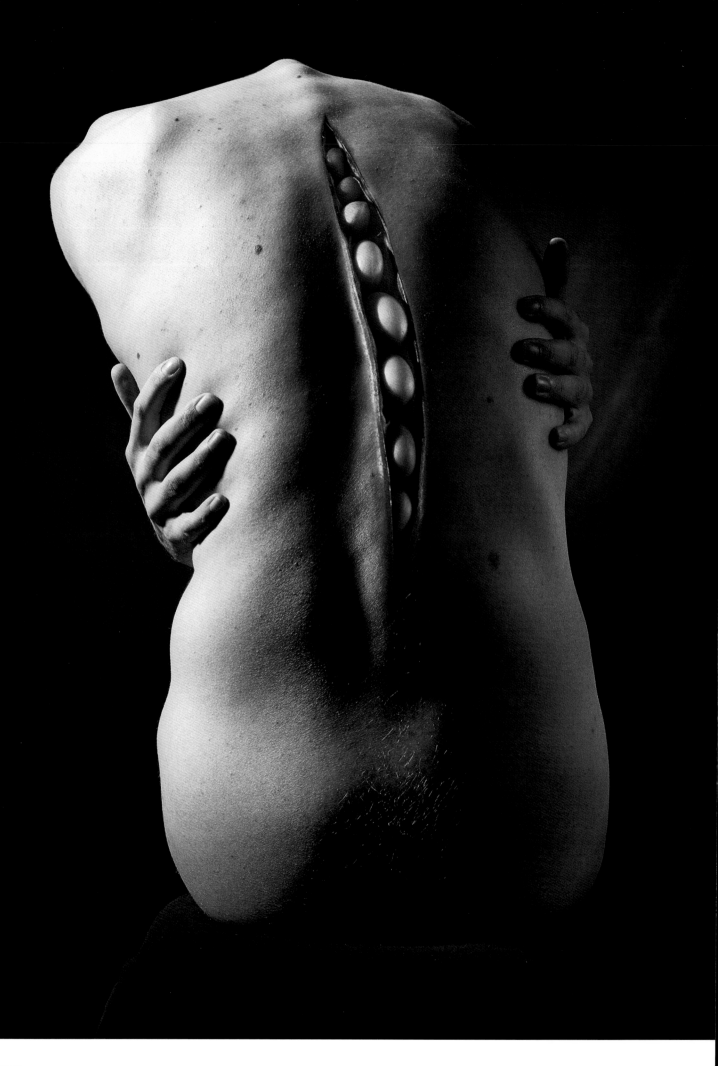

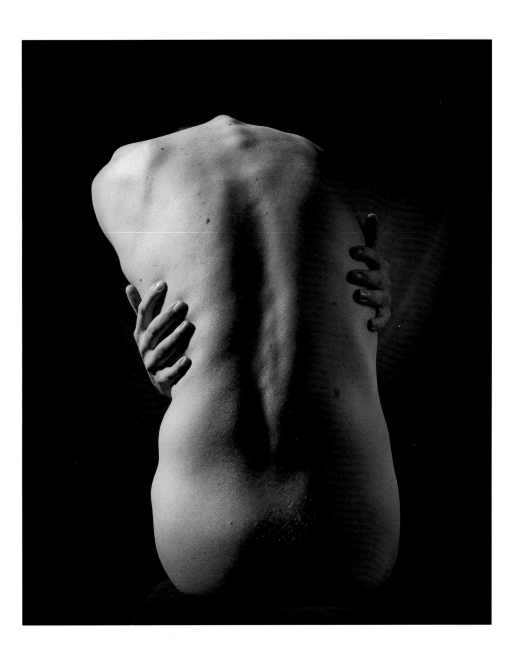

Background Information.

The art in this retouch is the perfect blending of two different surface structures (skin on the one hand and vegetables on the other) into a uniform, "skin-friendly" whole. The prerequisite is that both parts must be photographed under exactly the same conditions.

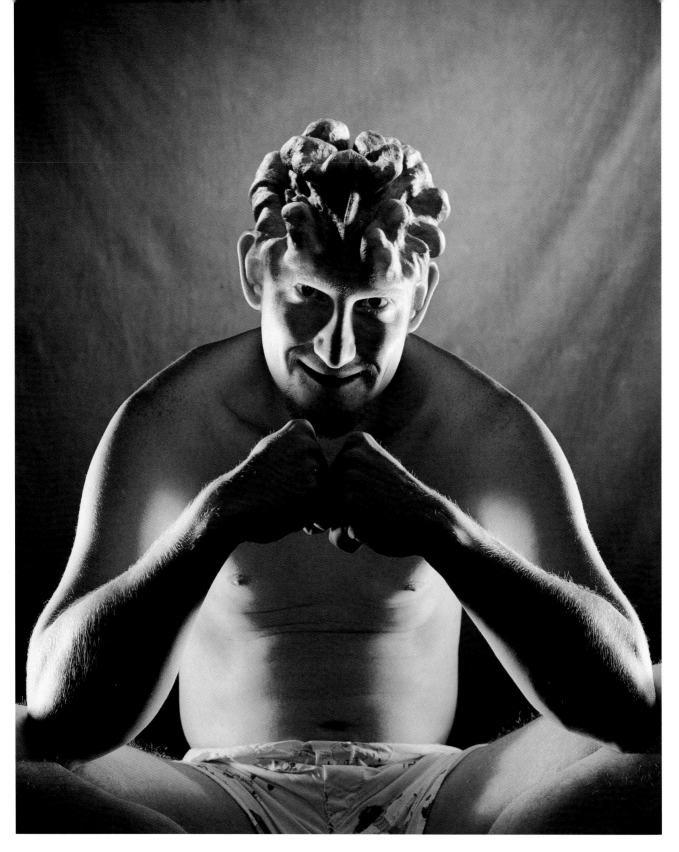

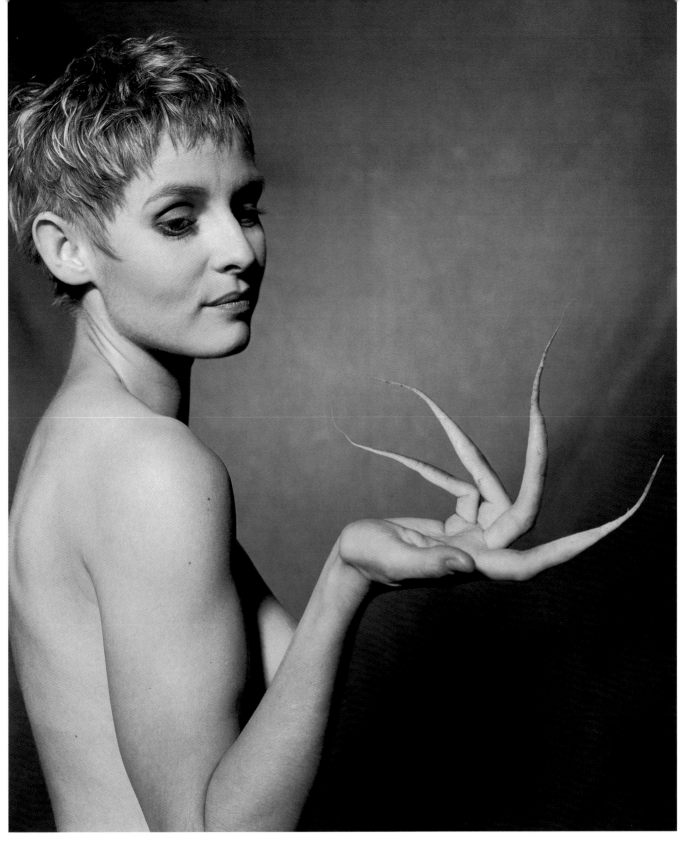

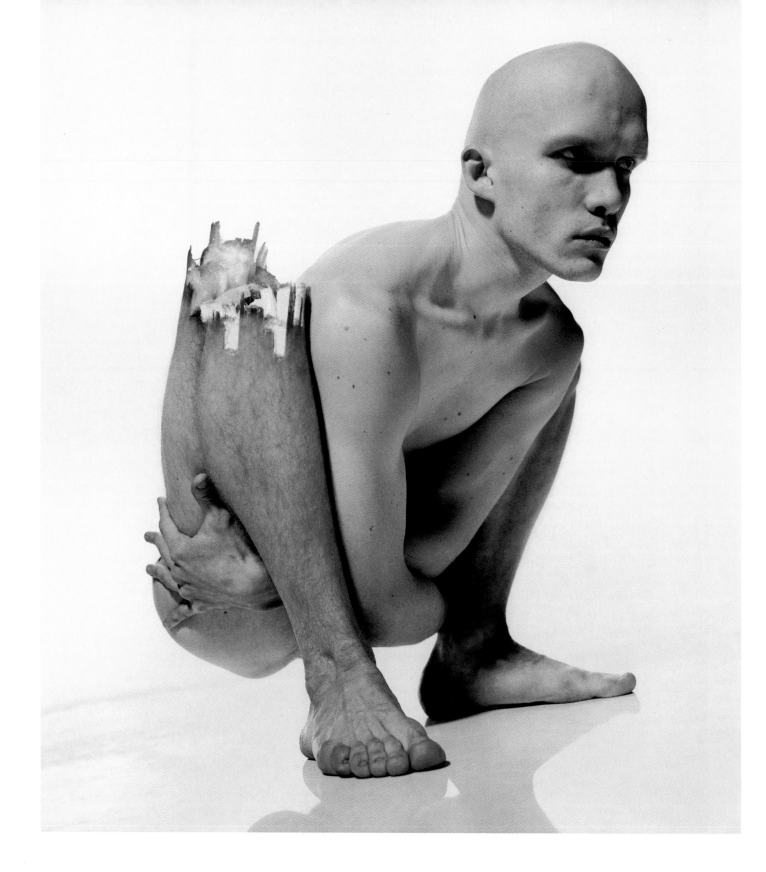

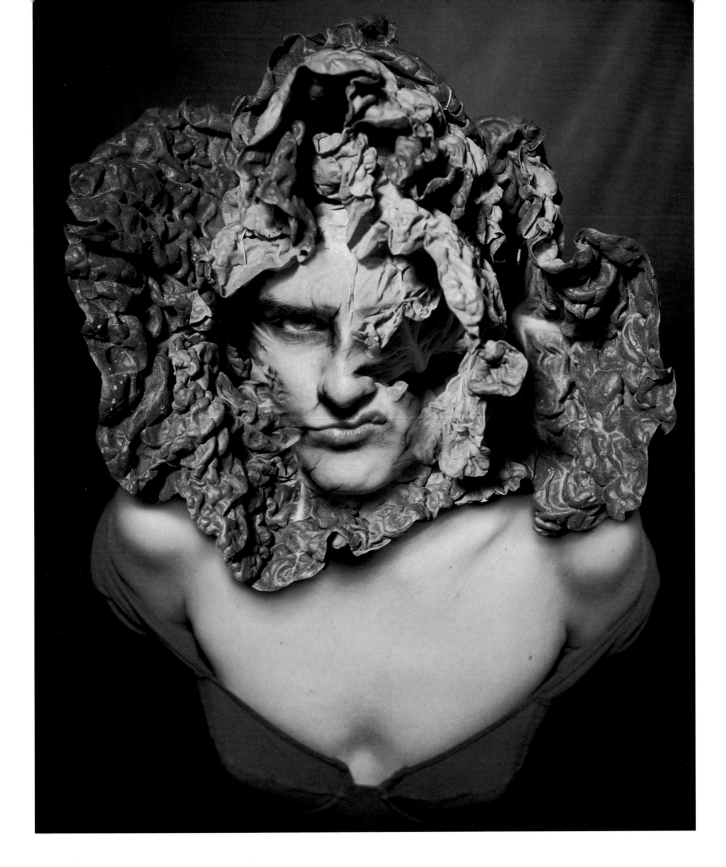

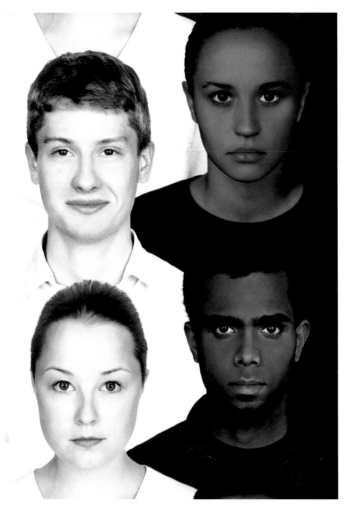

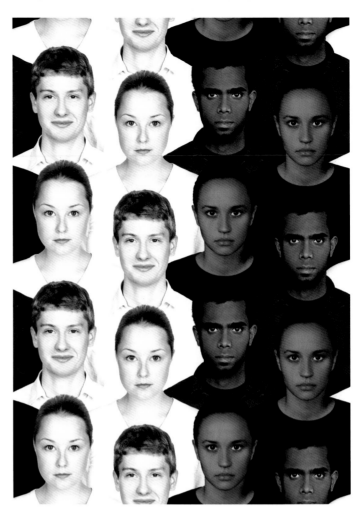

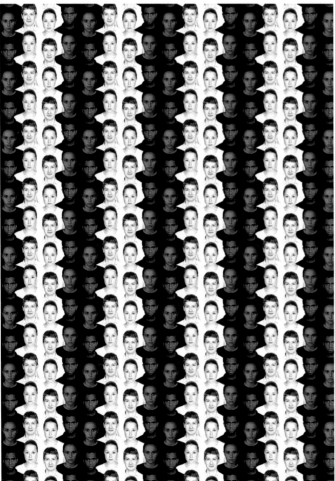

WE

B/W clones.

For this work, the contrasts of two different skin tones were greatly increased. That was the basic precondition for creating an unending, repeatable, richly contrasting, graphic pattern.

Ikebana.

The culmination of the art of close-up retouching can be seen here. Eyelashes were individually reconstructed, the flowers were arranged in the focused or out-of-focus area according to their position. All in accordance with the motto: flower to the people.

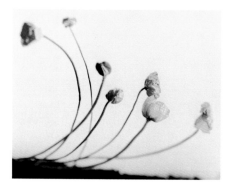 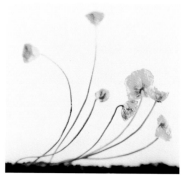

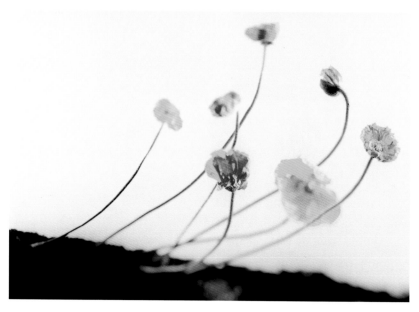

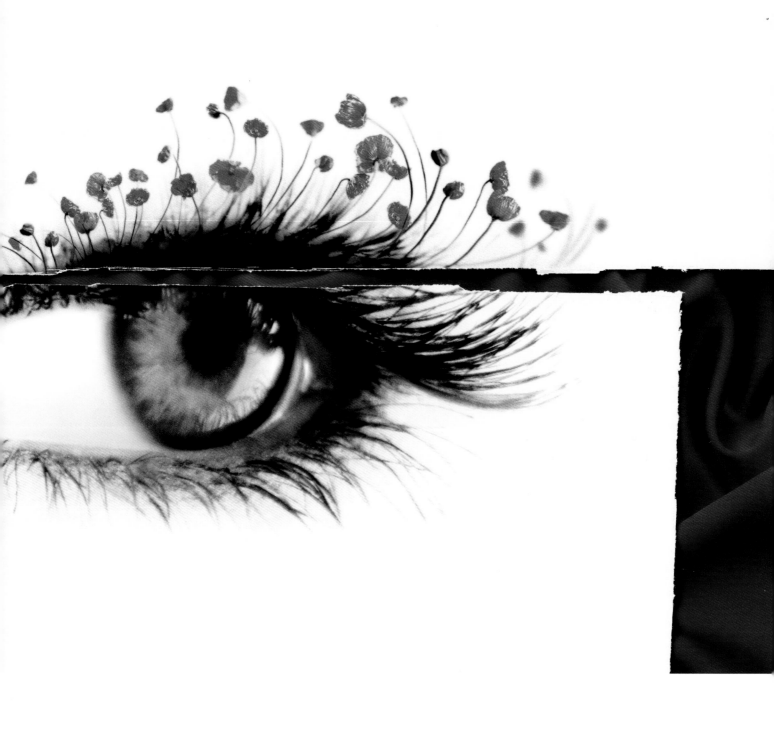

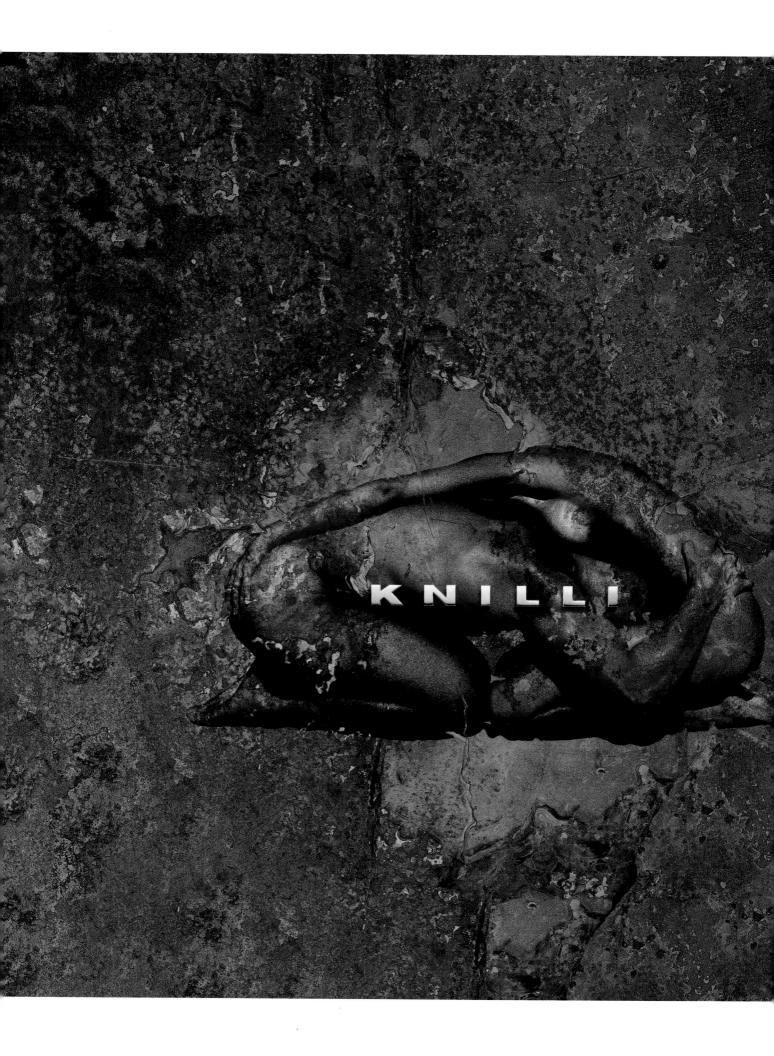

KNILLI

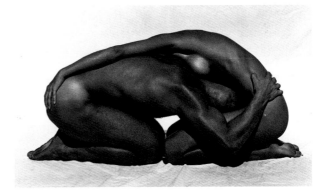

Get Rusty!

("Knilli" is the name of a house of fashion . . .)

$1+1=1.$

In order to achieve an optimal collage, photos of people must be taken under very similar conditions (perspective, light, etc.), such as the archive photos (Buddha, Statue of Liberty).

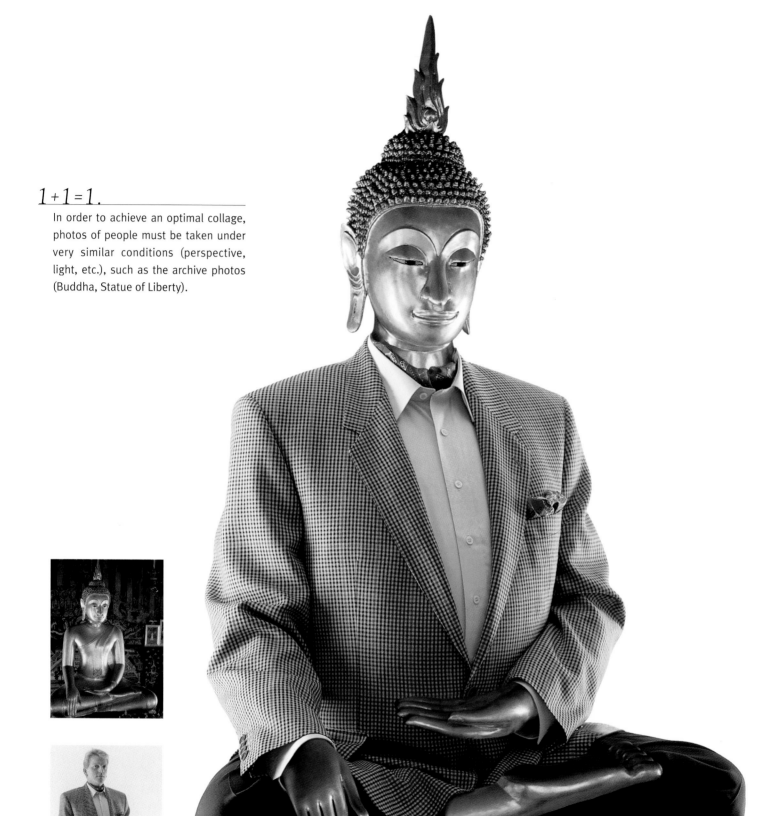

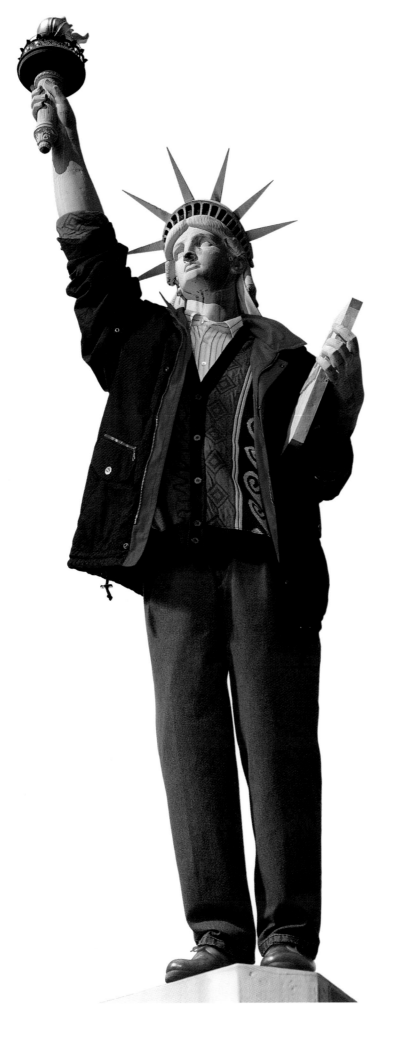

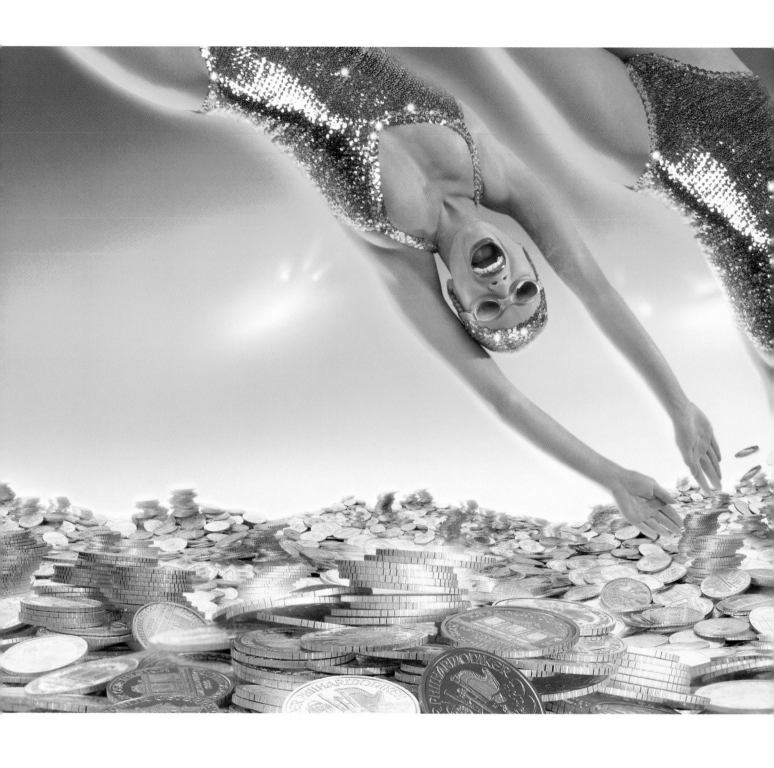

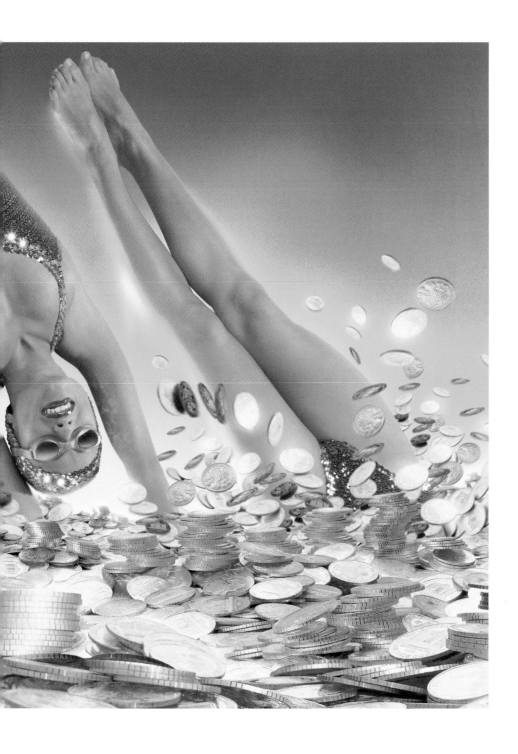

Olympic Games.

Since not enough gold was available to fill a swimming pool and make a realistic photo, the Paintbox artist employed his skills as an alchemist here. He created tons of gold, into which he, amazingly realistically, has the swimmers dive. And since an alchemist's gold must shine brightly, he placed several thousand highlights on all the coins. A truly Olympic performance.

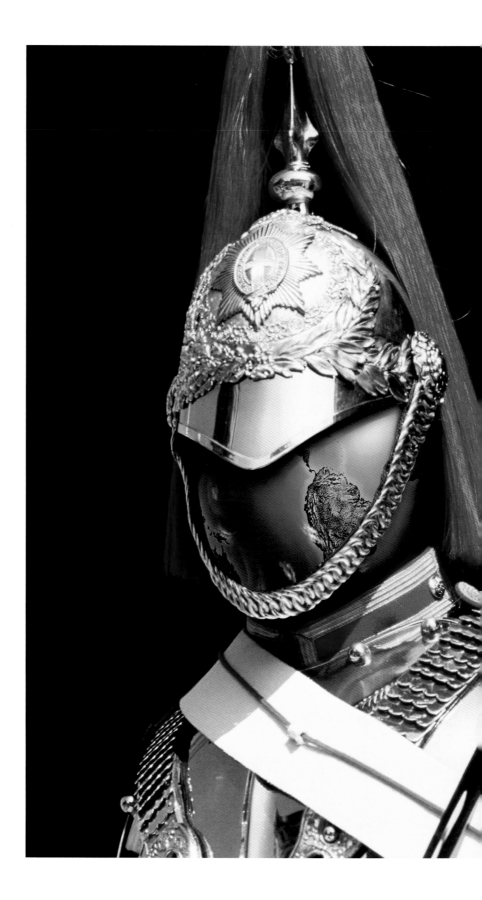

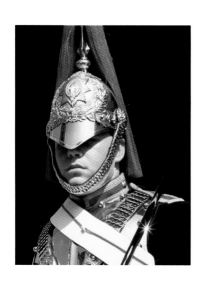

The World at your Fingertips.

A masterly Paintbox collage with perfectly placed light and shadow effects.

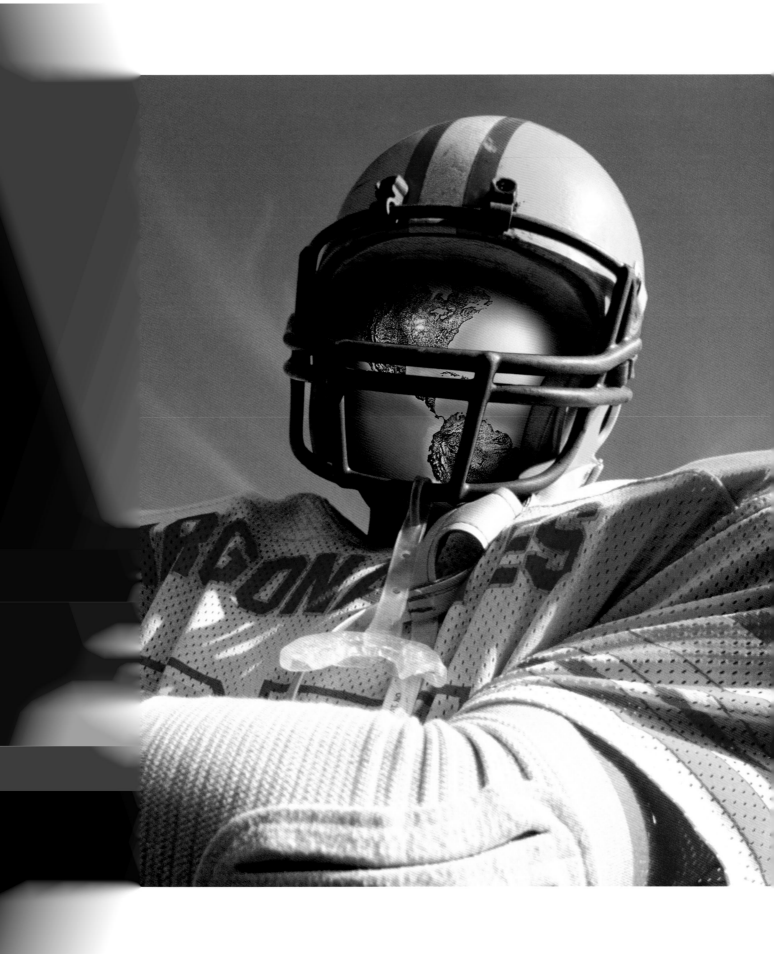

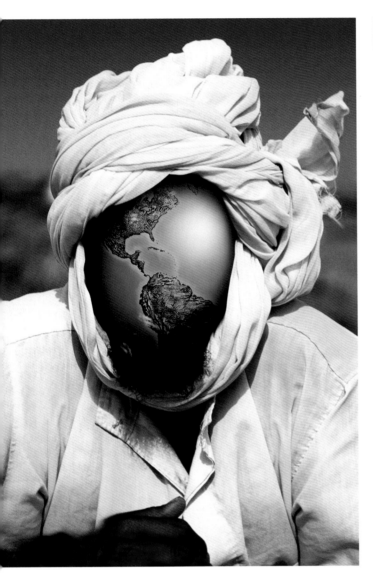

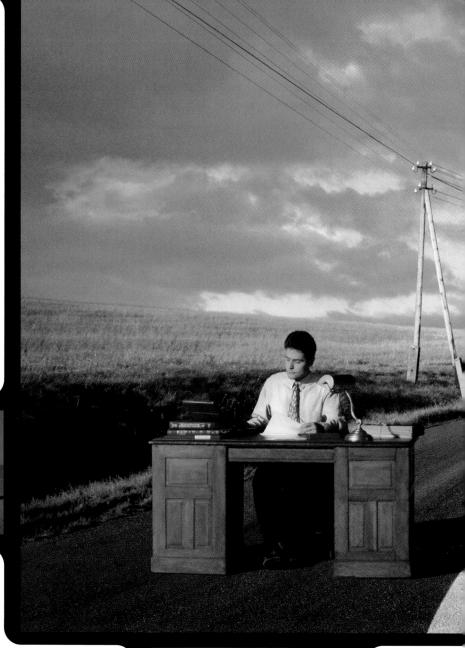

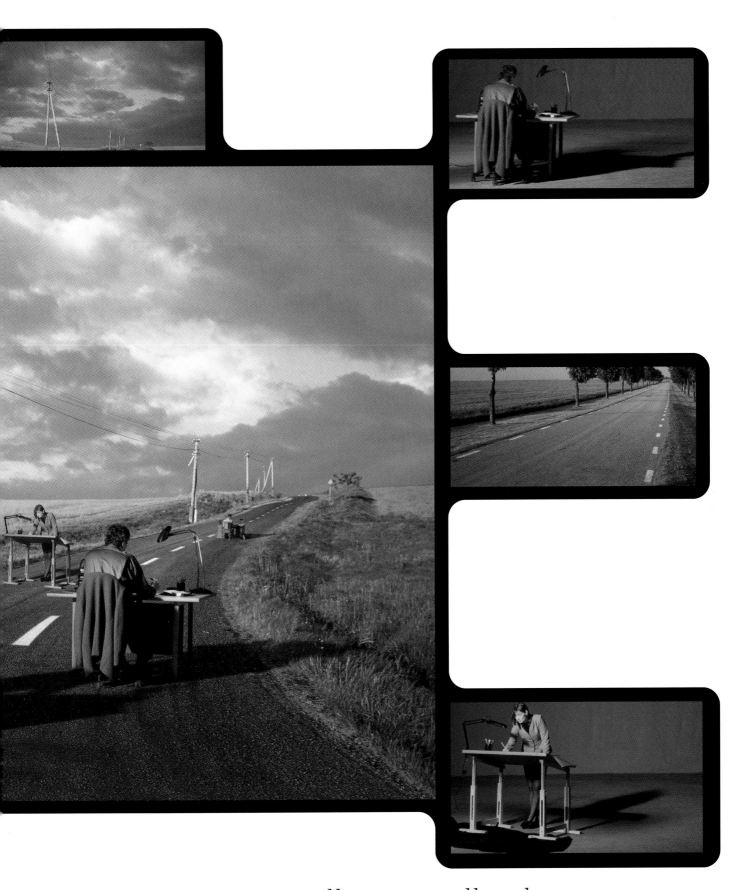

Call Boys & Call Girls.

The theme of a mobile telephone campaign, created from various individual photos, shot in the same light. The remarkable thing is that the absolutely realistic-looking background landscape consists of several individual photographs pieced together.

Forever Young.

A playful collage from perfectly photographed individual pieces, which then, with the addition of realistic shadows, were unified into a harmonic whole in Paintbox.

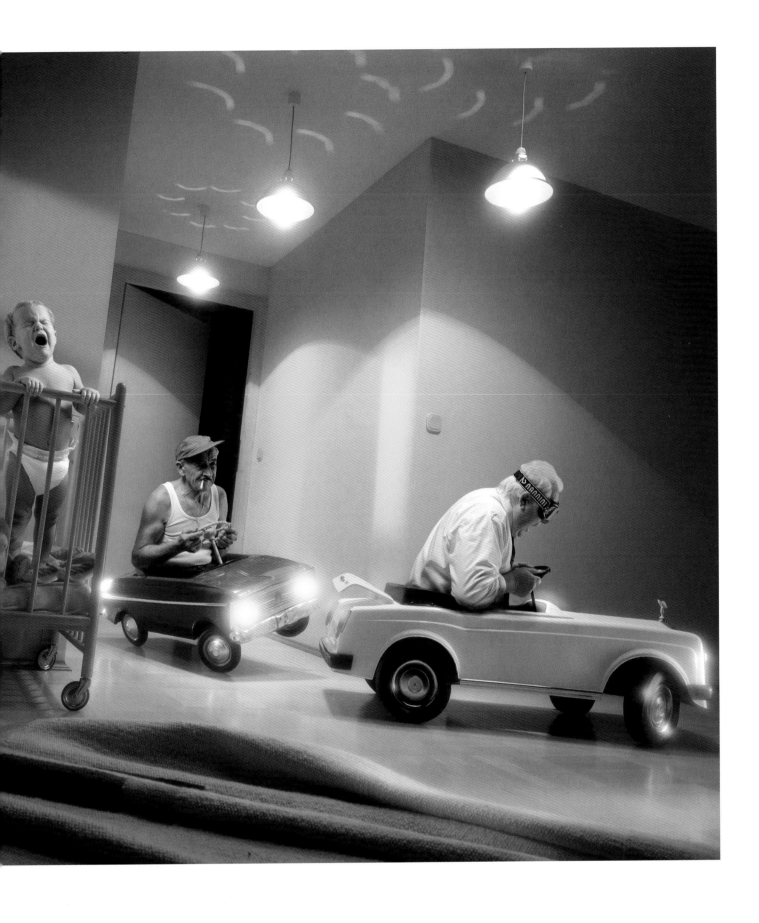

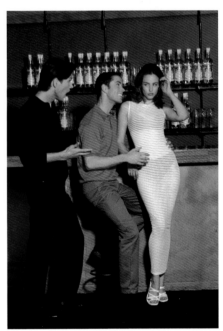

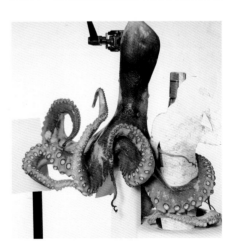

The Devil Finds Work . . .

There's a devil of a lot of work in this masterful montage of trifles, for example, in the detailed reworking of the squid's tentacle. A time-consuming and elaborate work, which shows it takes more than simply mounting three pictures together.

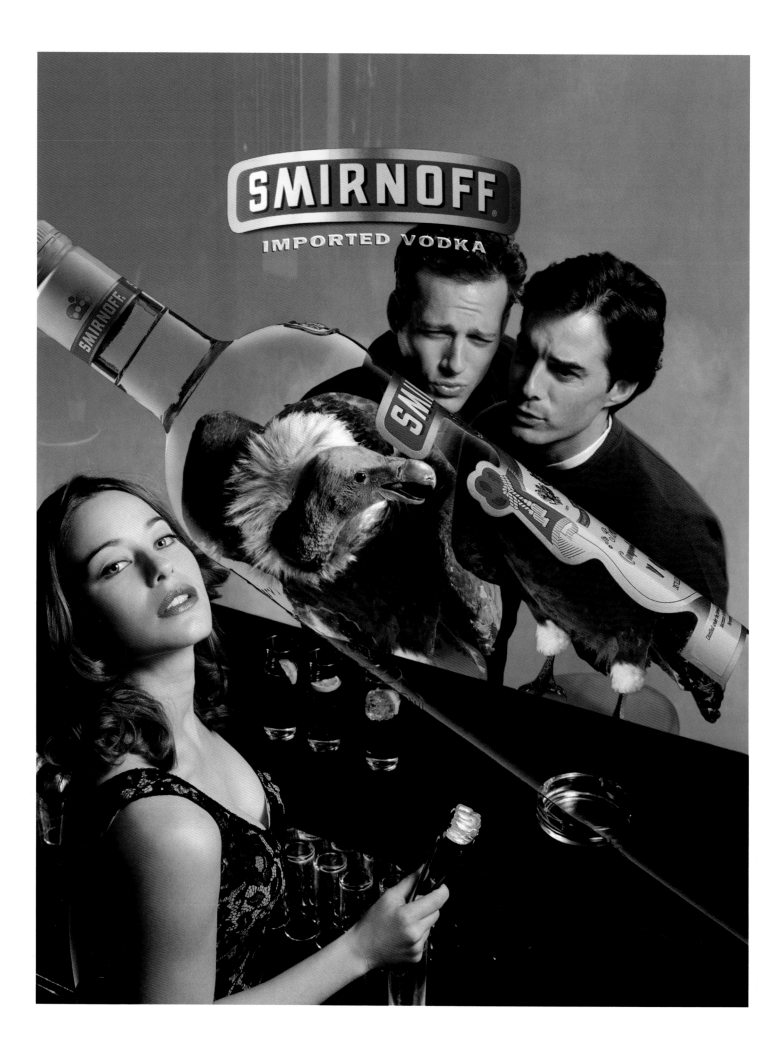

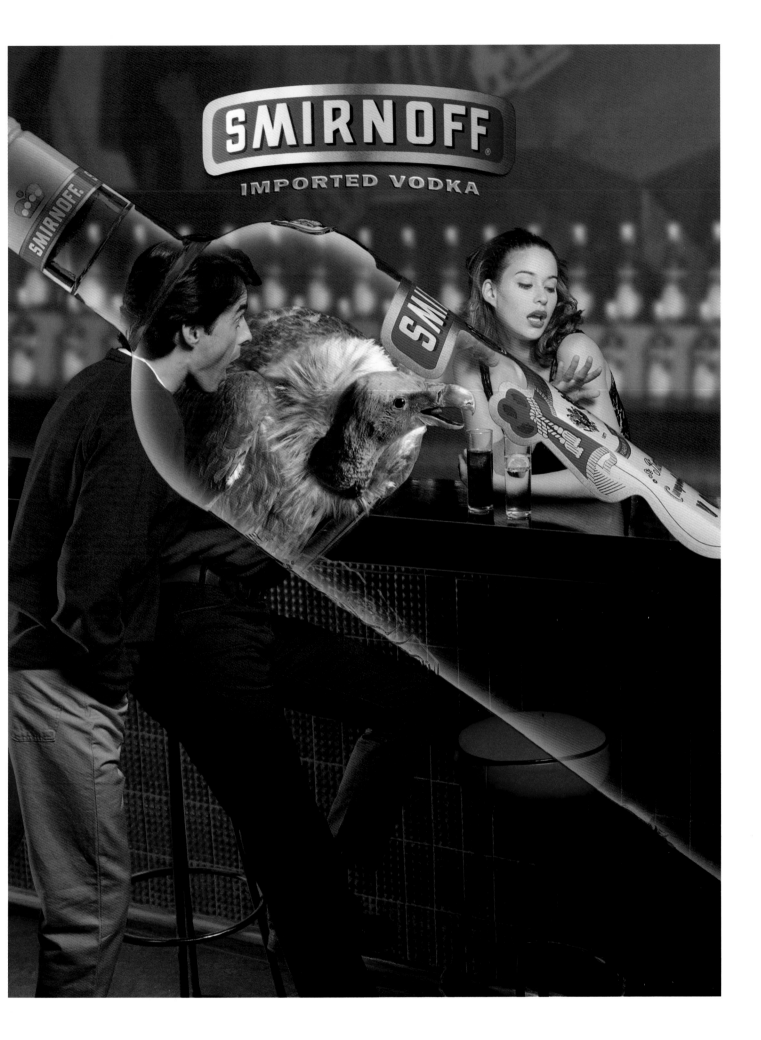

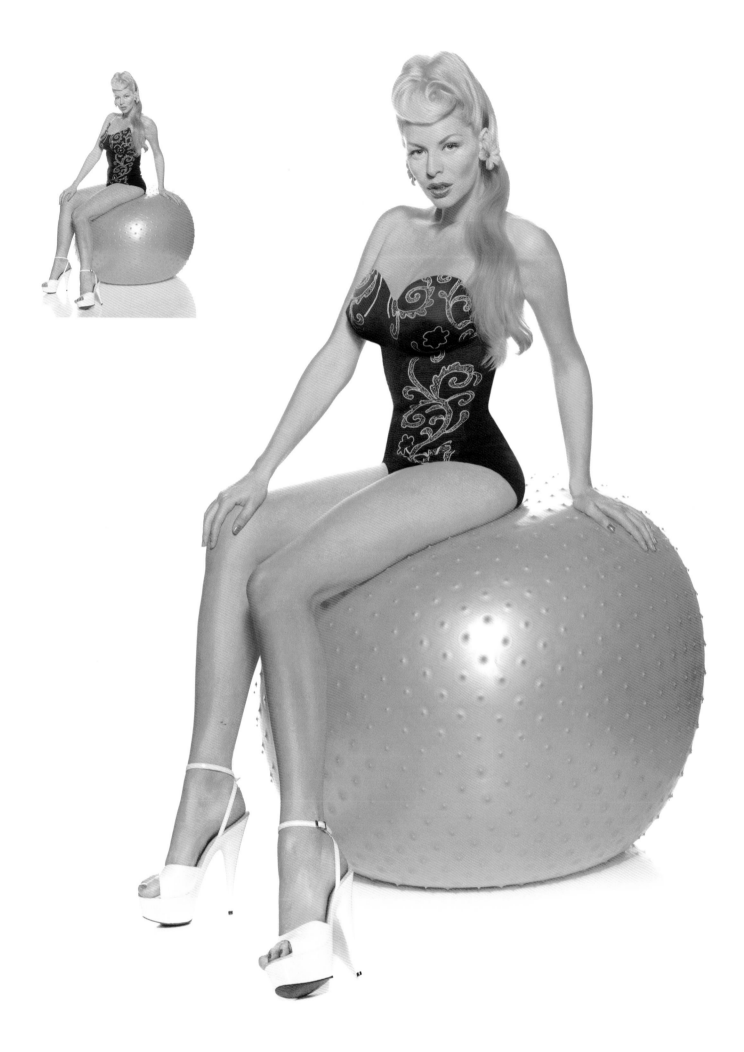

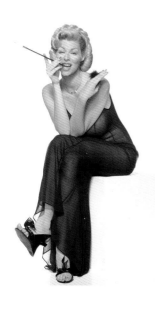

Virtual Surgery.

Based on the classic airbrush model, intricate cosmetic surgery was performed here with the electronic airbrush. In order to achieve the desired erotic impact, the girl's skin must be perfectly smooth. And the body shapes? Oh boy! Those curves must be so perfectly engineered that companies of GIs loose their sleep.

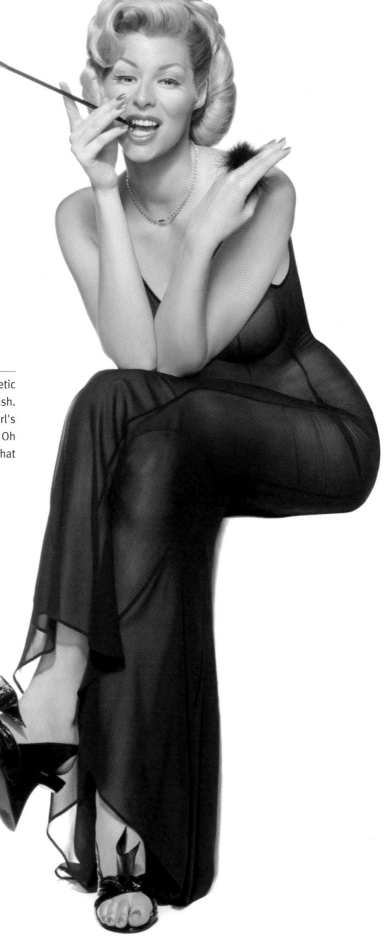

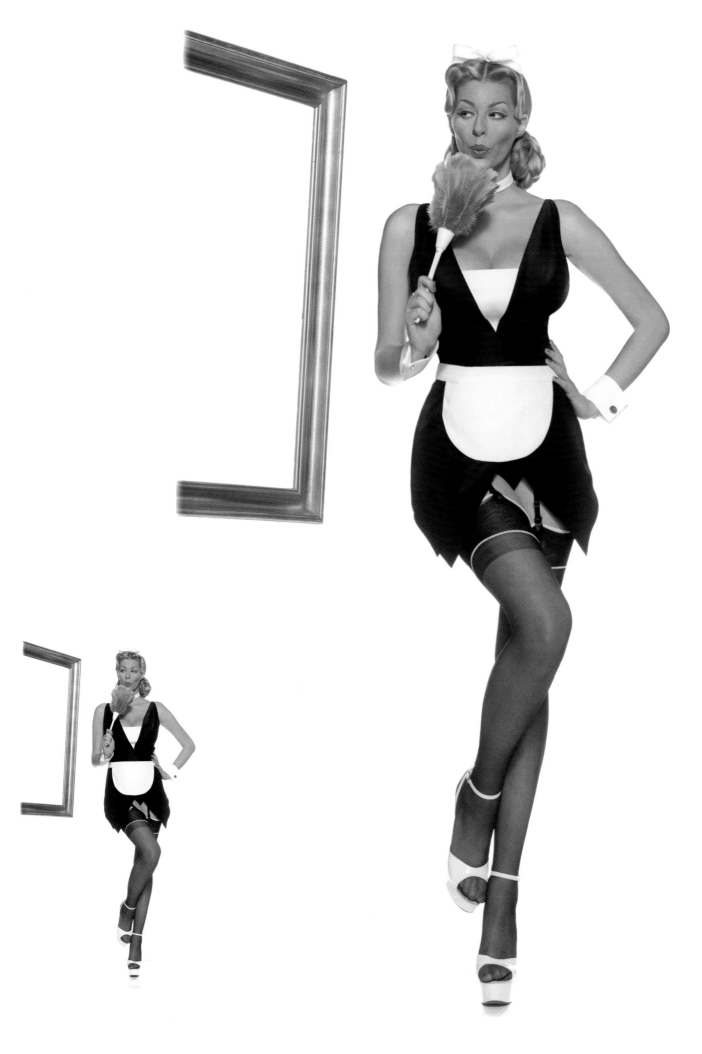

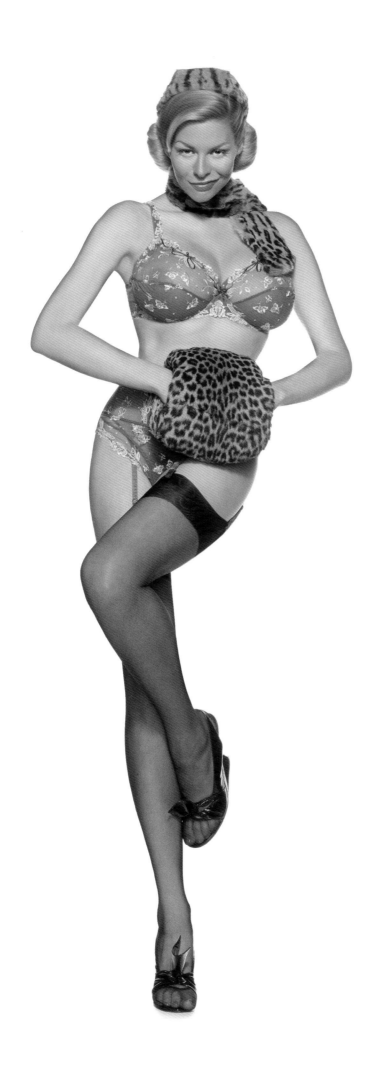

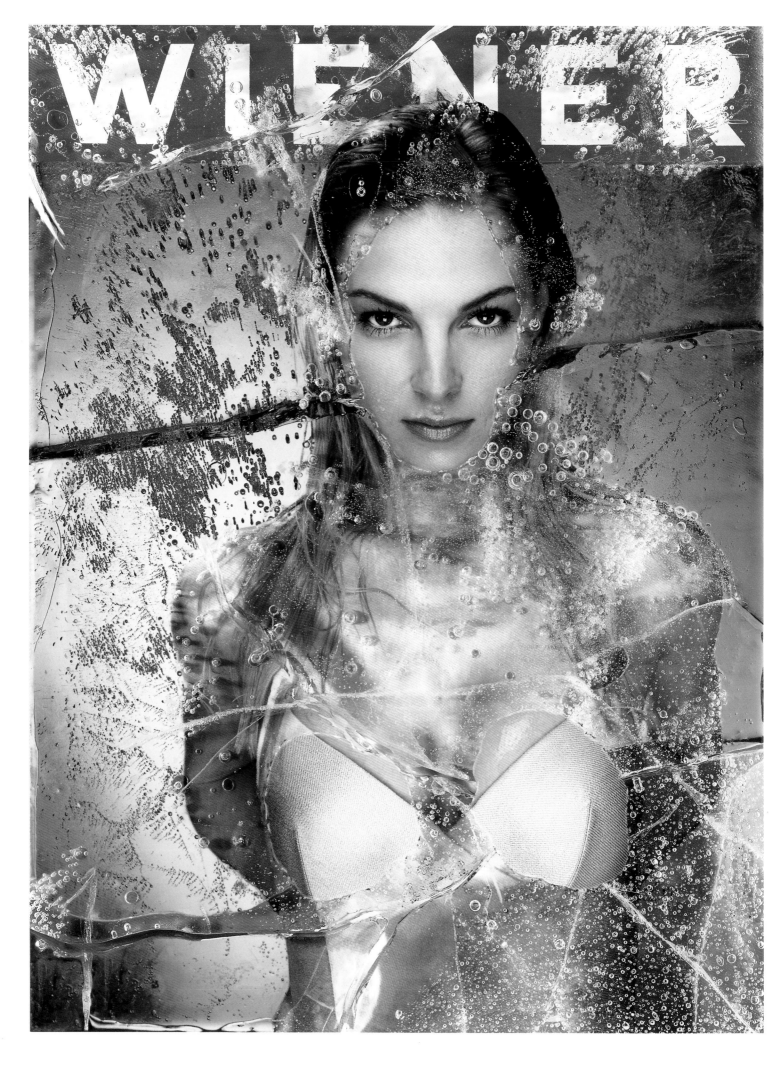

WIENER

Cool it Baby . . .

This totally cool girl was created for a magazine cover by means of a collage. The transition from body to ice is what creates the appeal of this picture: the ice is very gently melted onto the body.

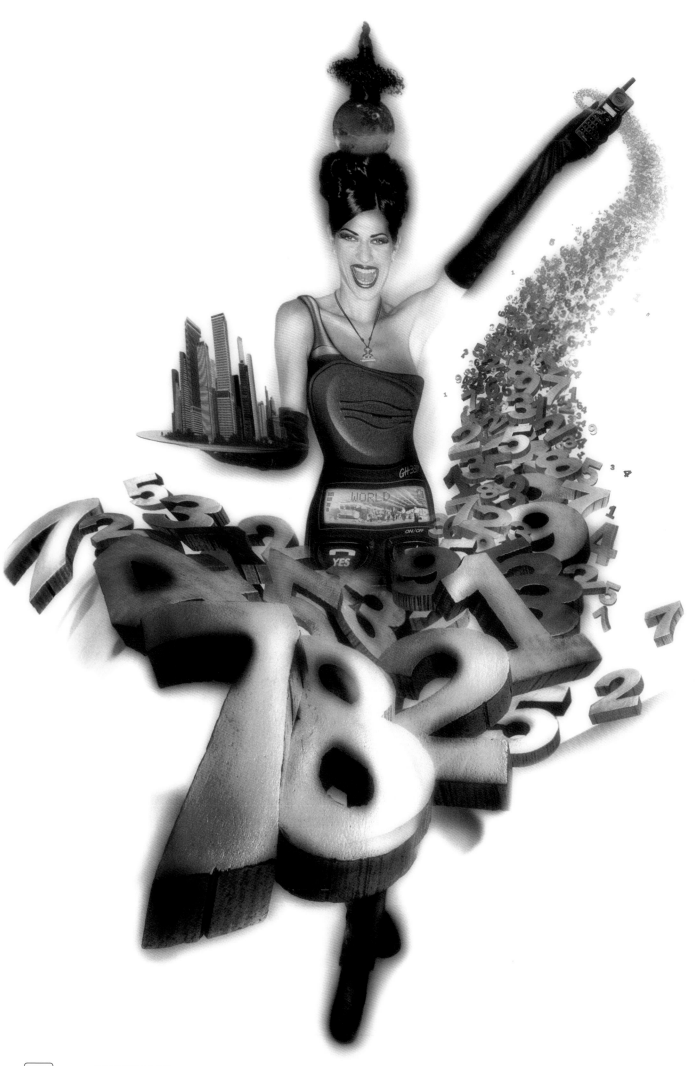

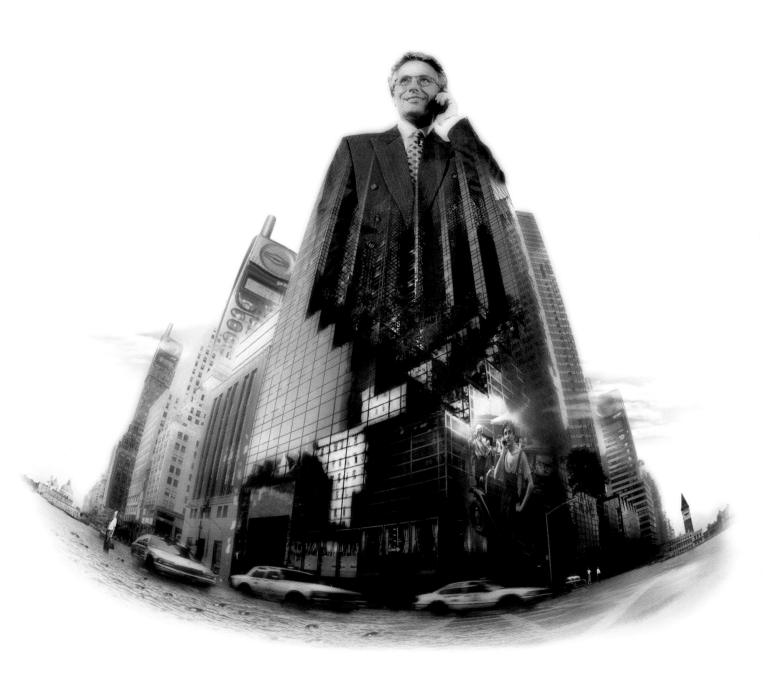

Mixed Pickles.

A completely new composition was created from dozens of different photos
and a richness of visual details. The trick is to create a new, perfect world.

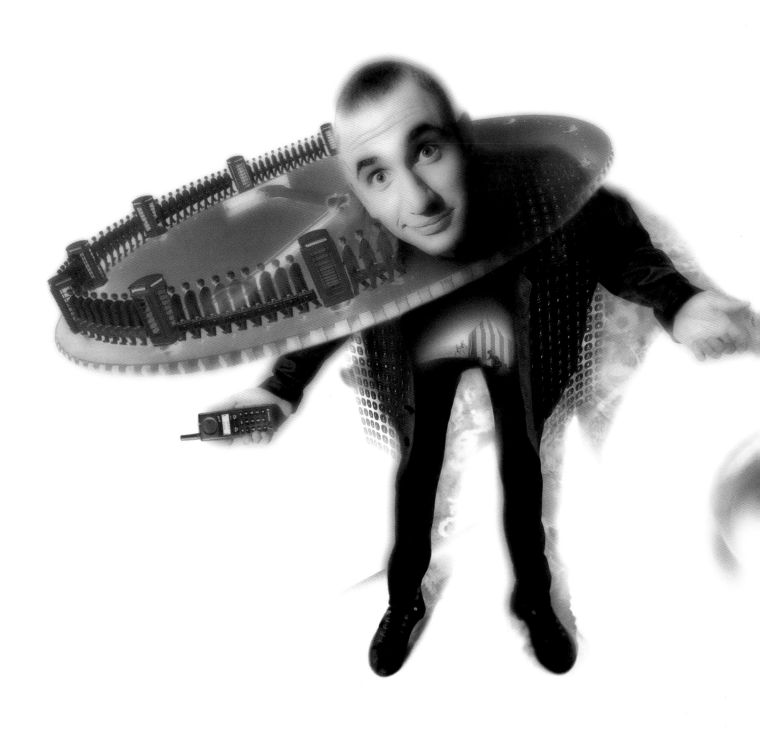

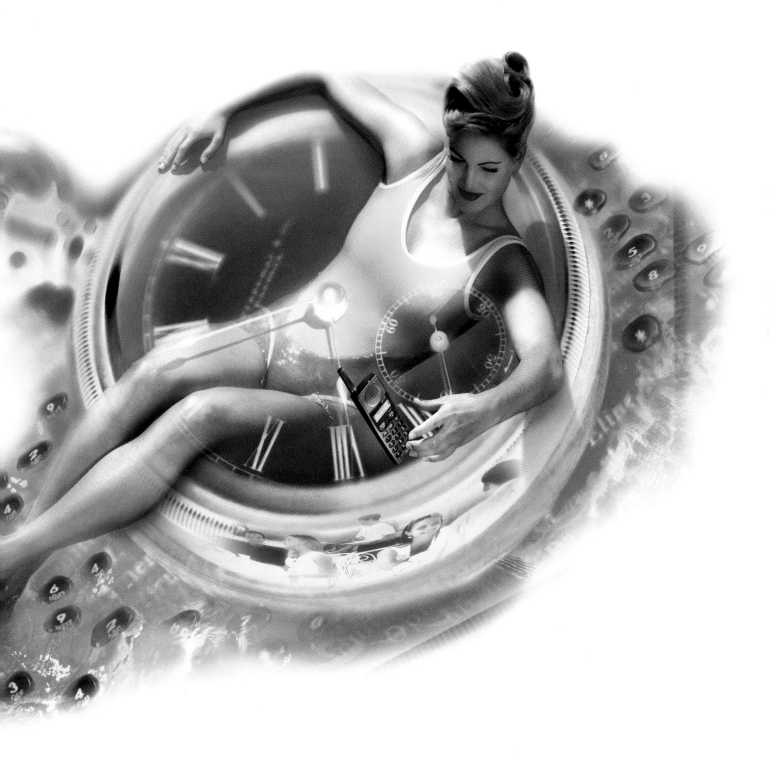

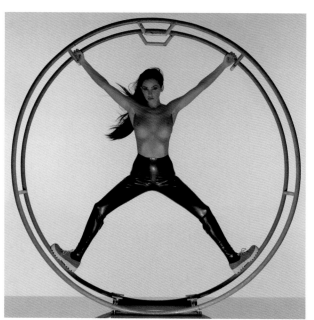

Equilibrium.

What photography cannot accomplish is effortlessly created here. The interesting light and shadow
effects retouched in the picture cannot be achieved photographically. Also, thanks to the collage,
the models do not run the risk of losing their equilibrium.

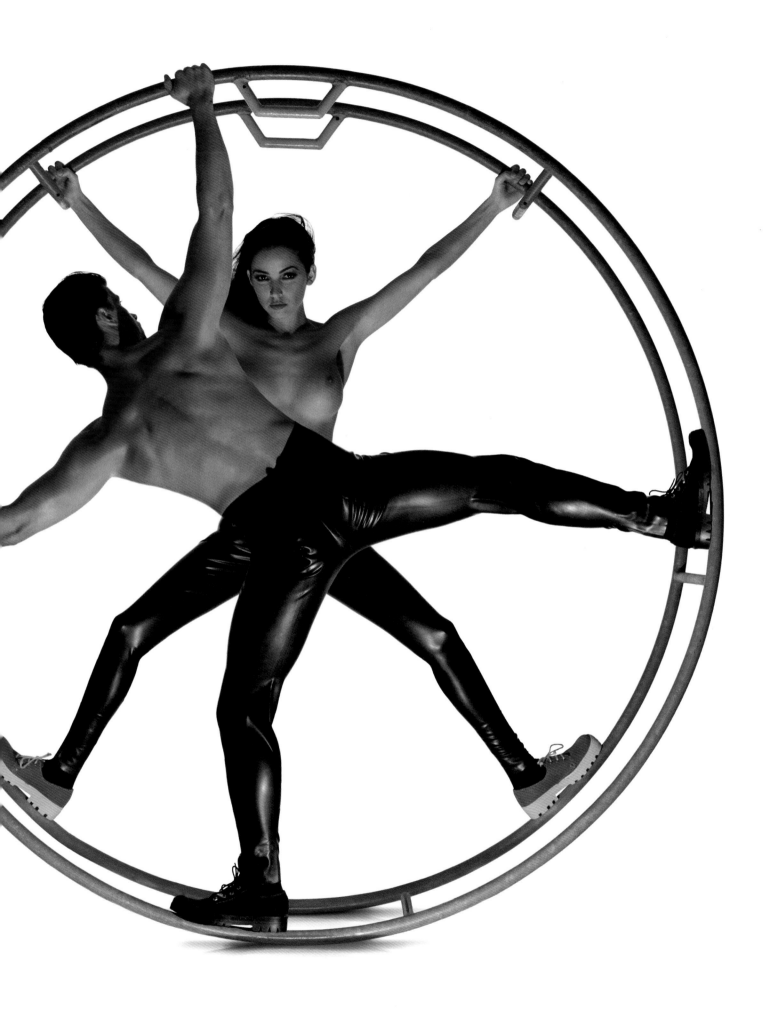

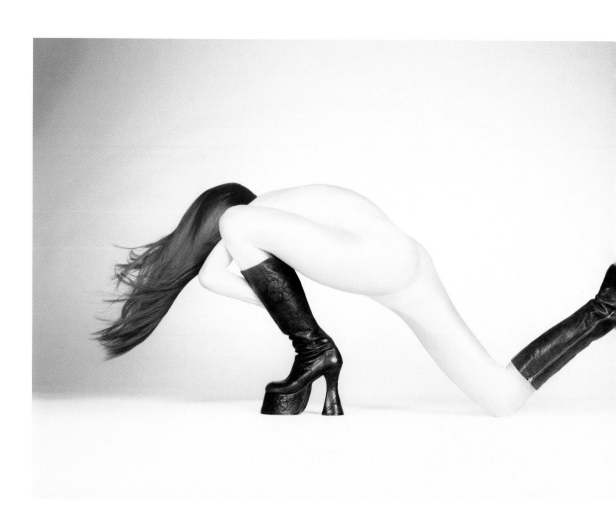

Shoebedoo!

The most beautiful shoes come out of Paintbox. Contours, shapes, colours are dramatised here. Thus the shoes create a striking contrast to the background.

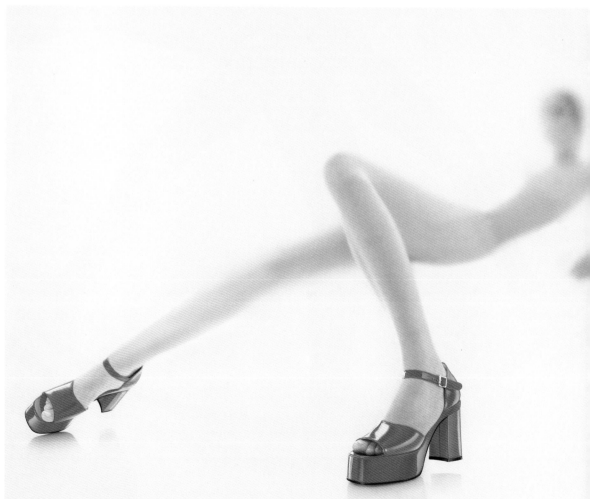

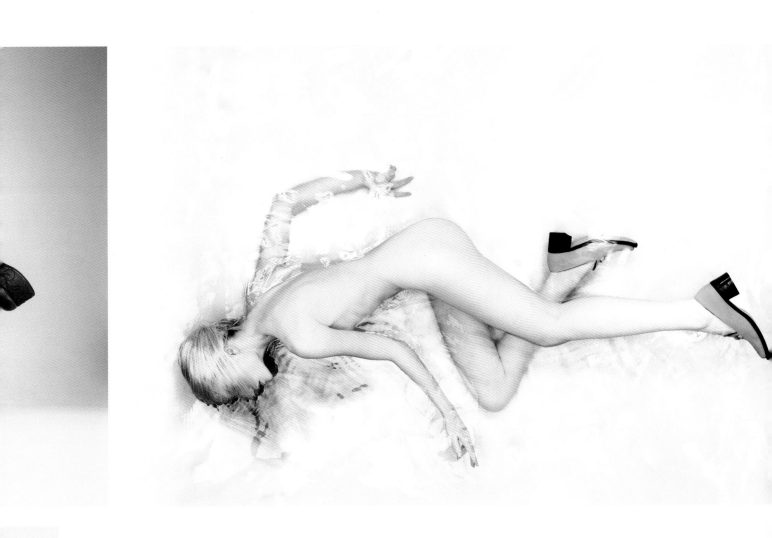

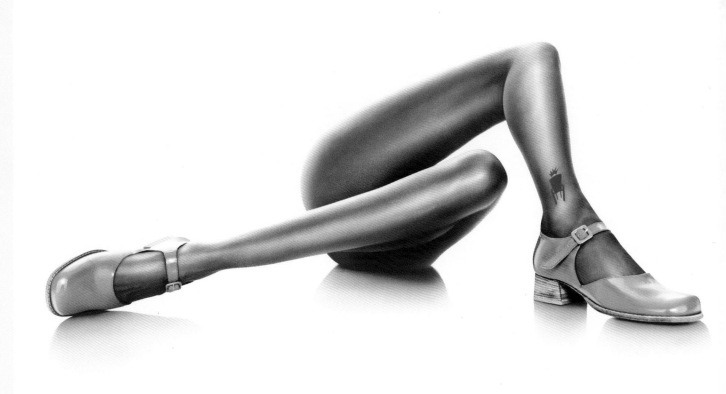

Time Machine.

Paintbox as a time machine: three different people of different ages became a single person at various stages of life. A work in which details must be carefully changed, step by step, in order to realistically represent the human ageing process.

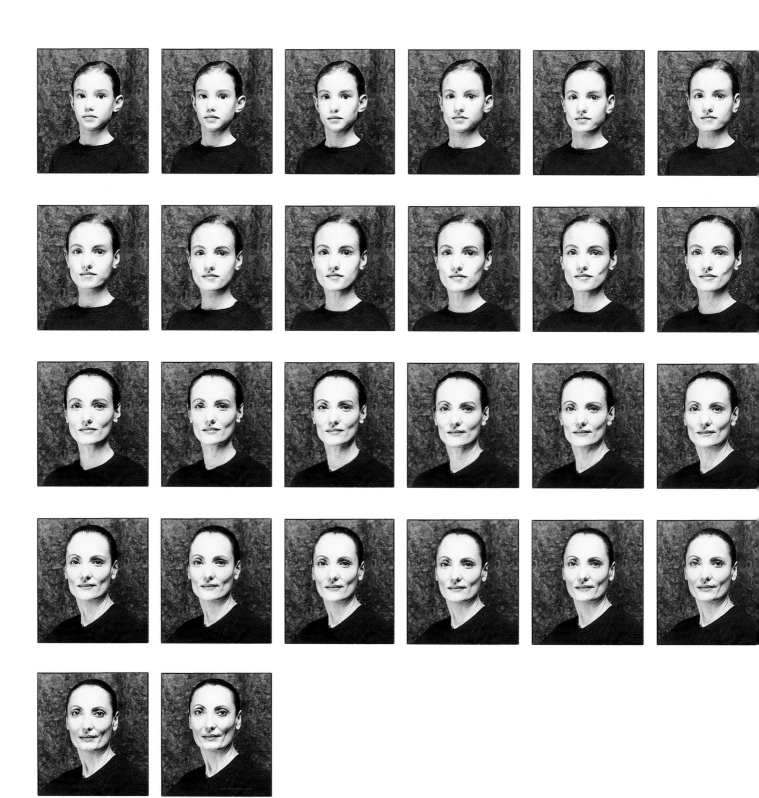

People

Brave New World.

What a remarkable effect faces have when they are absolutely "perfect" ...
All the wrinkles, irregularities, and individual characteristics were removed
from these faces for an art project. Special attention was paid to the eyes,
nose, and mouth.

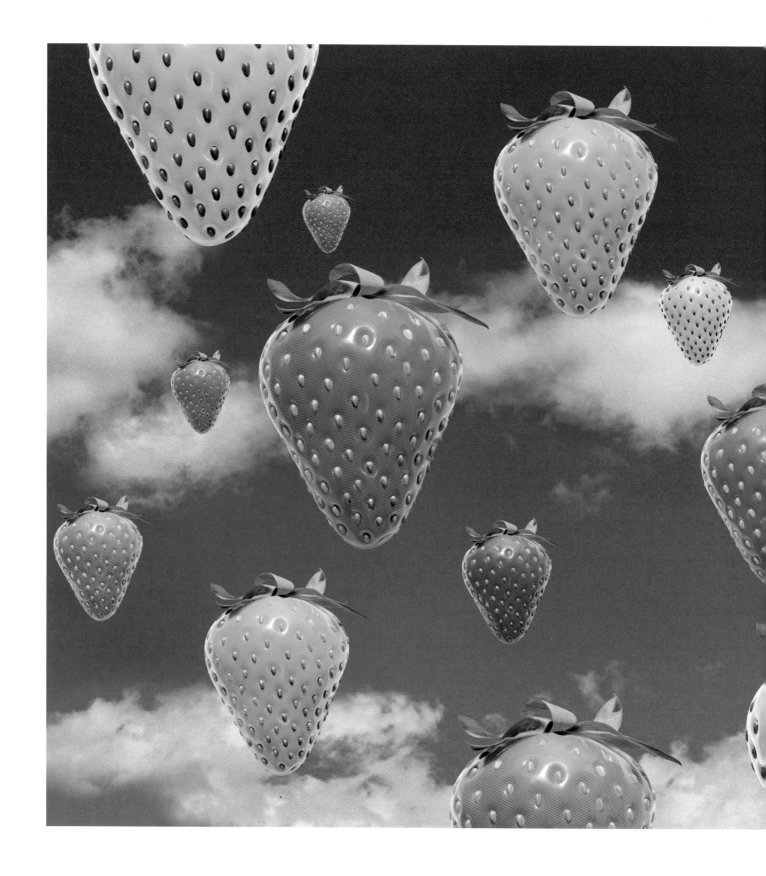

It's Been A Hard Day's Work ...

An unbelievable amount of work and a great deal of visual feeling were used to retouch faces into the strawberry. To do so, it was necessary to photograph the faces in the same perspectives as seeds on the strawberry.

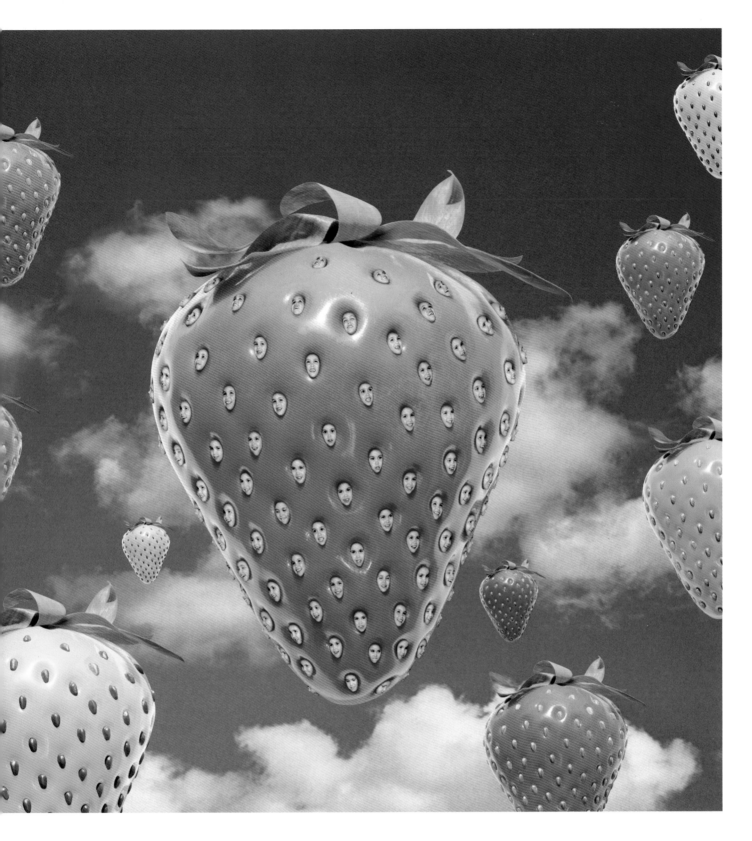

Welcome to the Hall of Mirrors!

Here the original photos were skilfully distorted. The artist required a detailed knowledge of the world of comics coupled with a feeling for optical effects so as not to create "zombies".

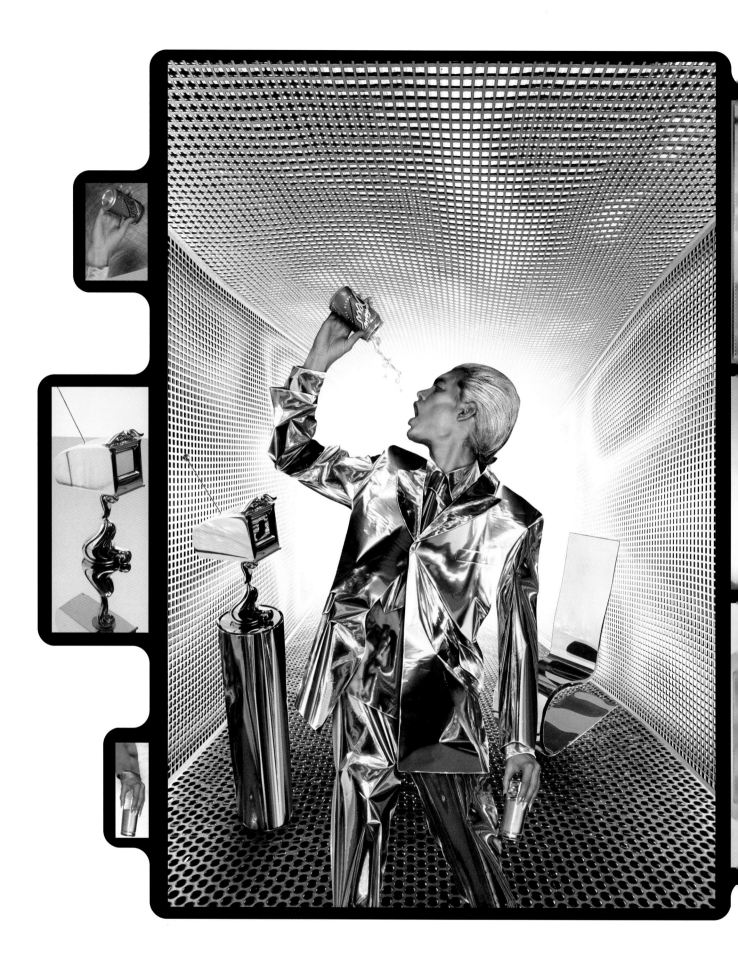

People

Heavy Metal.

An artificially created space was furnished with a wide variety of objects. The character was then added and his garments given a "heavy metal" surface.

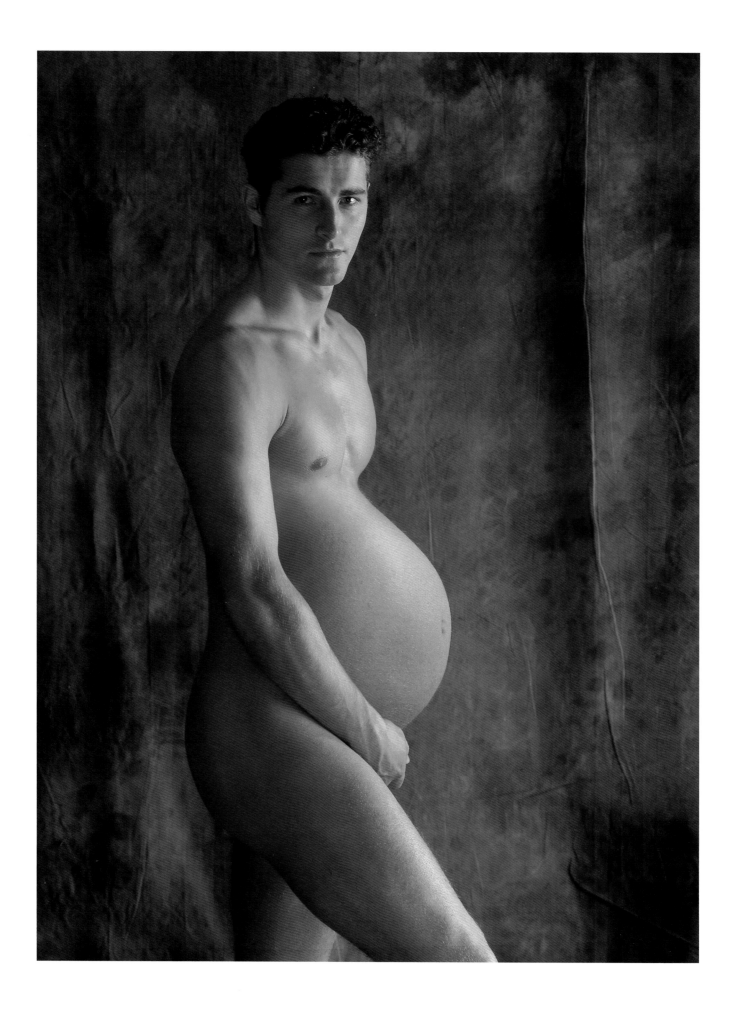

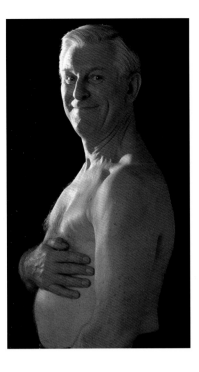

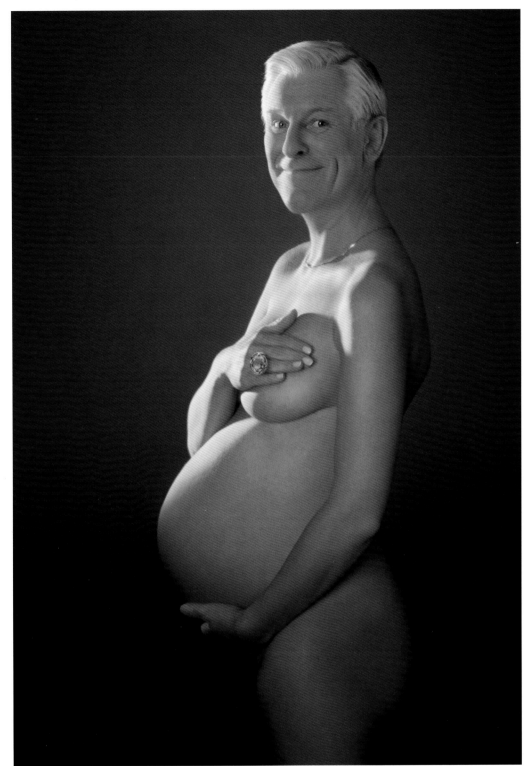

A Man's World . . .

All is revealed: the feminine side of the male sex. The art in this collage lies in the harmonious blending of masculine and feminine skin types. It is also remarkable how the skin still retains its natural qualities even when deformed.

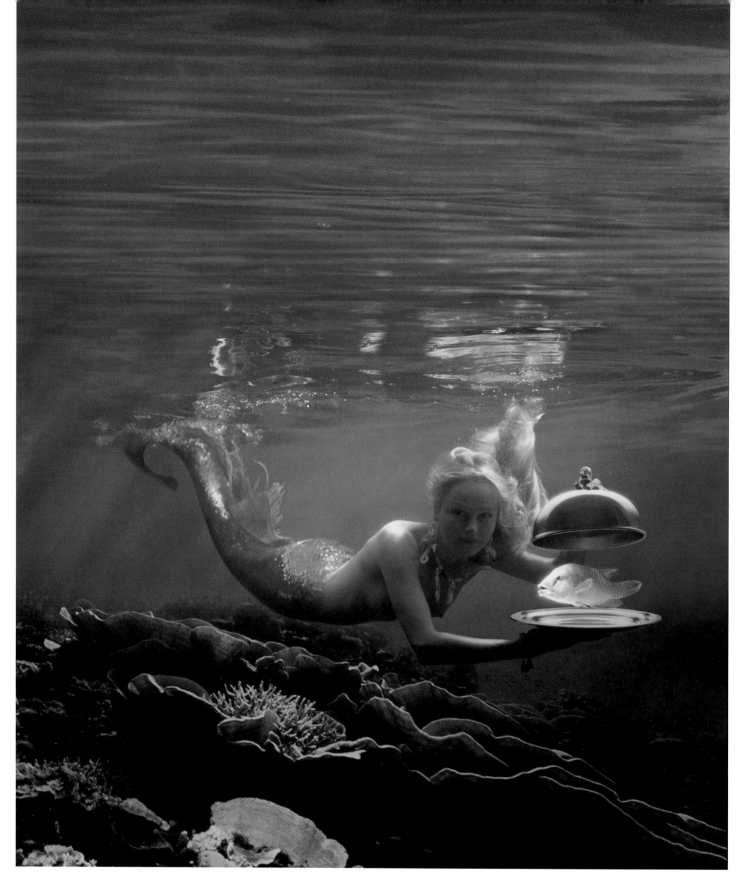

Mermaid Cuisine.
If you like to dine underwater, don't forget to use a Paintbox.

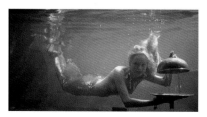

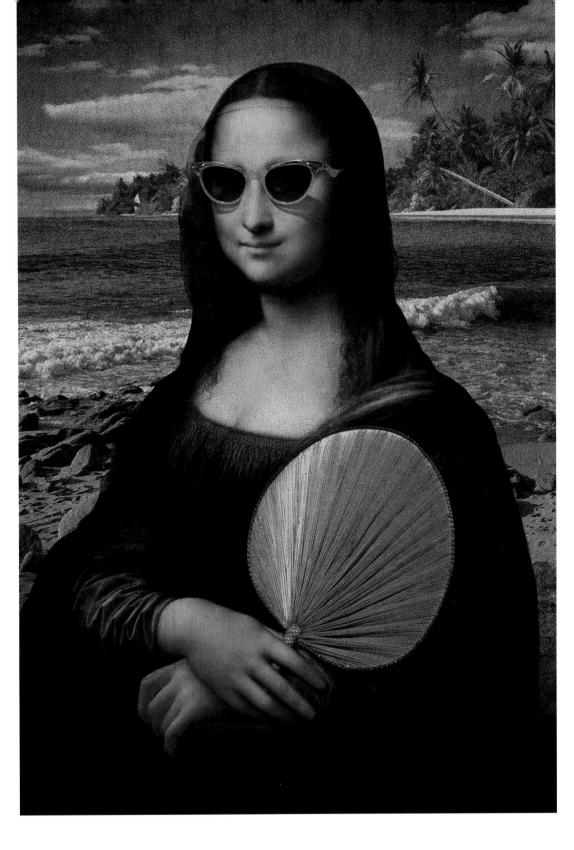

Vamos a la Playa!

The antique colour tones and the delicate cracks in the surface of an old oil painting were transferred onto a new background in this work.

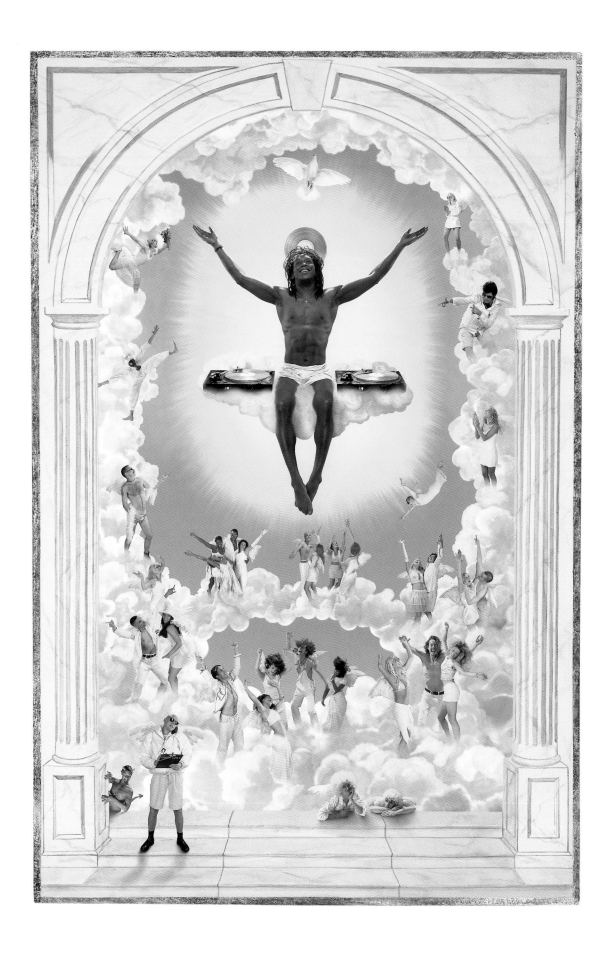

Glory land . . .

Good Paintbox artists will probably go to heaven. Bad ones, on the other hand, will probably go to bars and other nice places more often (since a good Paintbox picture takes a hell of a lot of time . . .).

This picture required elaborate photo shooting sessions, a skilled Paintbox collage, and any amount of digital airbrush work.

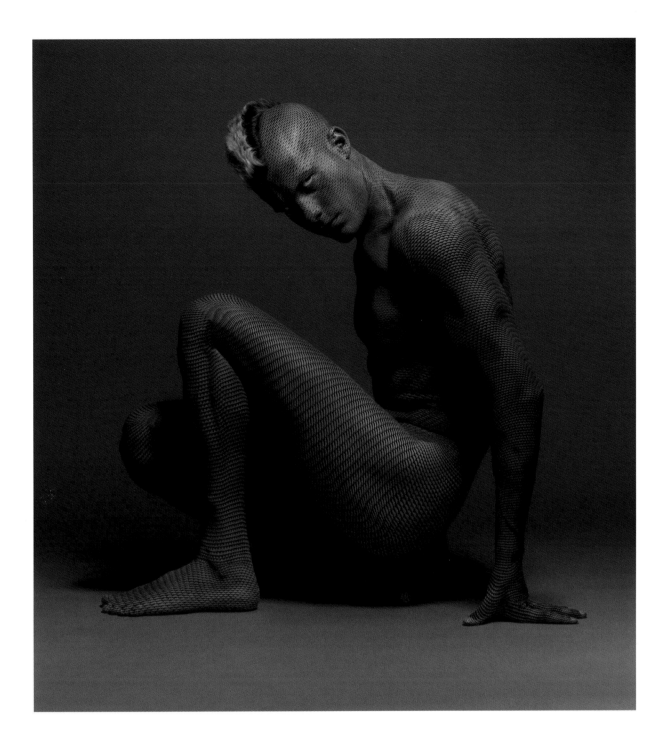

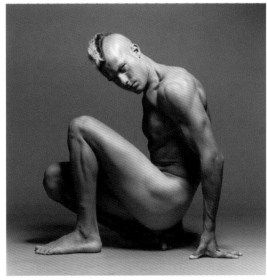

Under my skin.

An interesting picture really gives you goose pimples!
This picture in particular, since every single ripple of
the muscles has been covered with the new structure.
A demanding and very detailed piece of work.

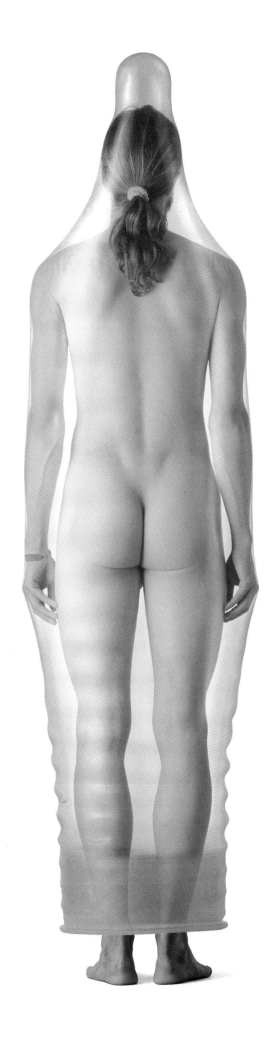
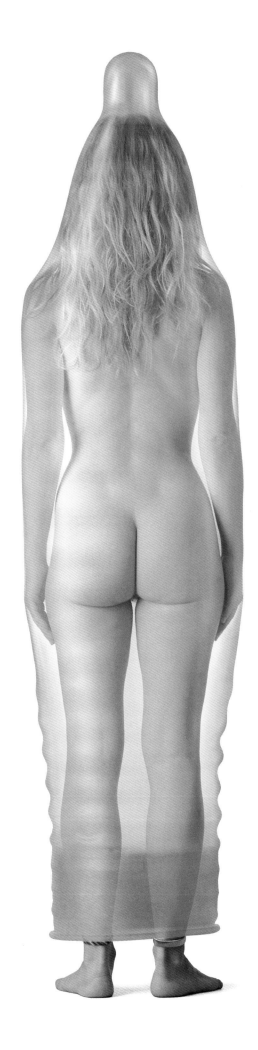

Safety Instructions 2001.

Paintbox collage for the environmental organisation "Global 2000".

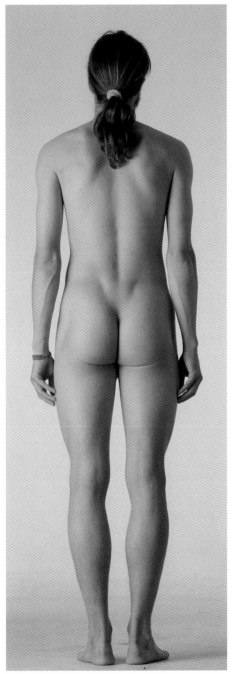
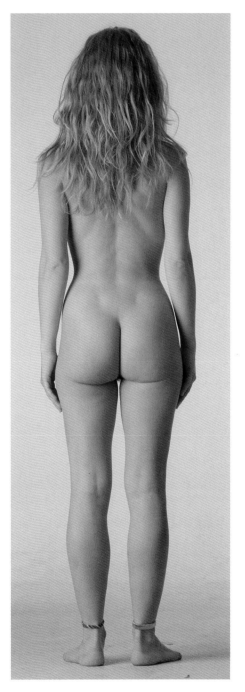

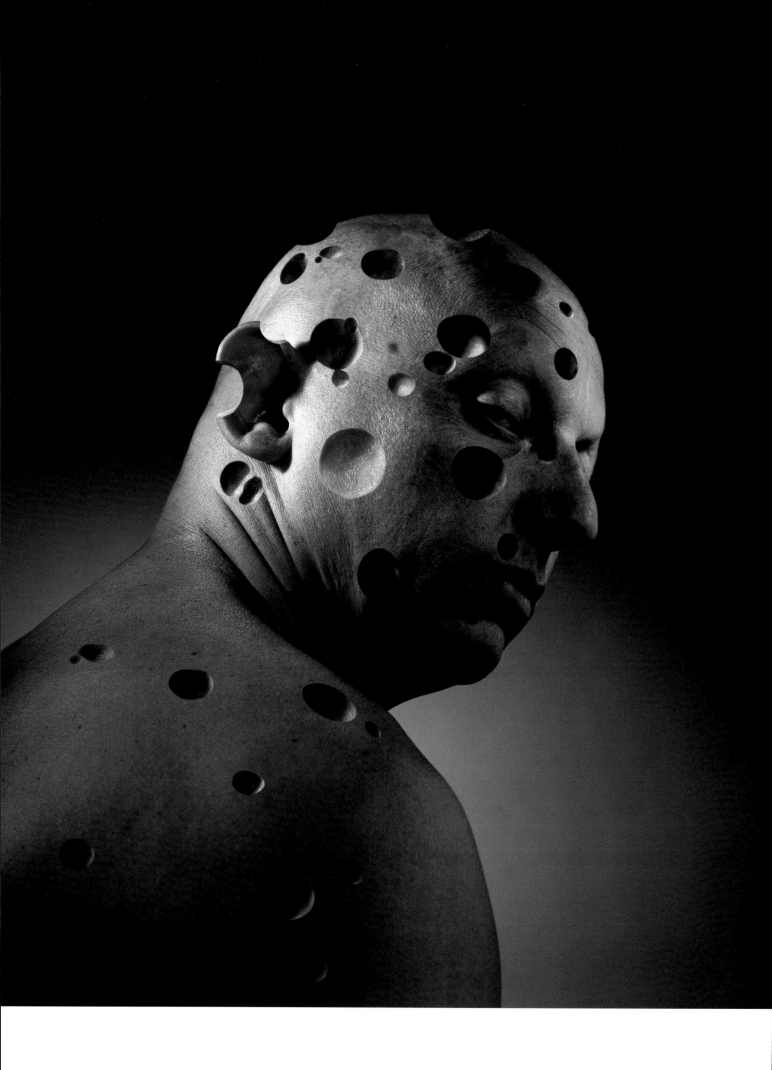

Cheese!

A disconcerting, truly effective collage of illustration and photographed skin structure. Note: the subject is not necessarily a Swiss national!

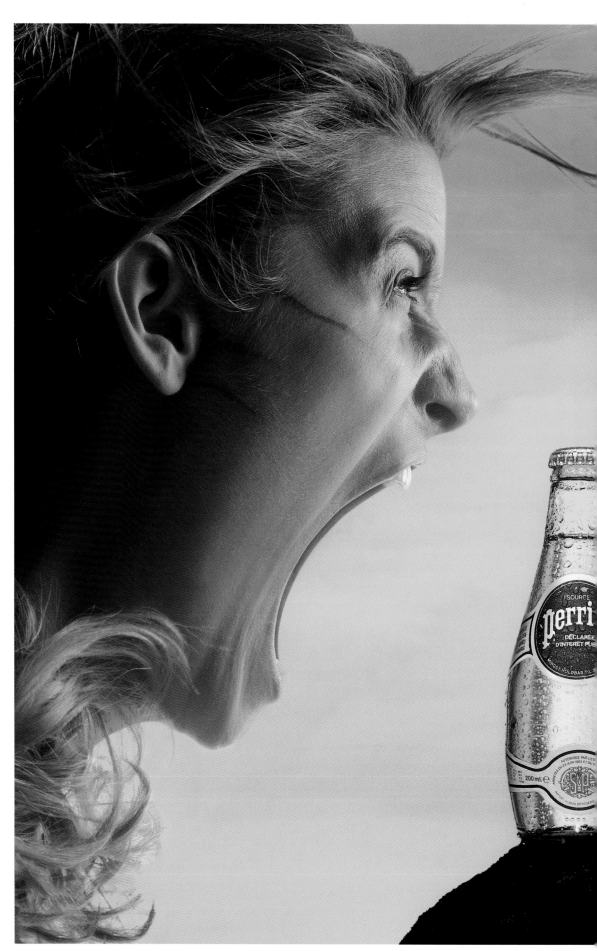

Woman or Cat . . .

Who would the Paintbox artist rather encounter? The lion or the woman, whose mouth was enlarged to leonine proportions? It's fairly obvious that this picture could not be shot live!

People

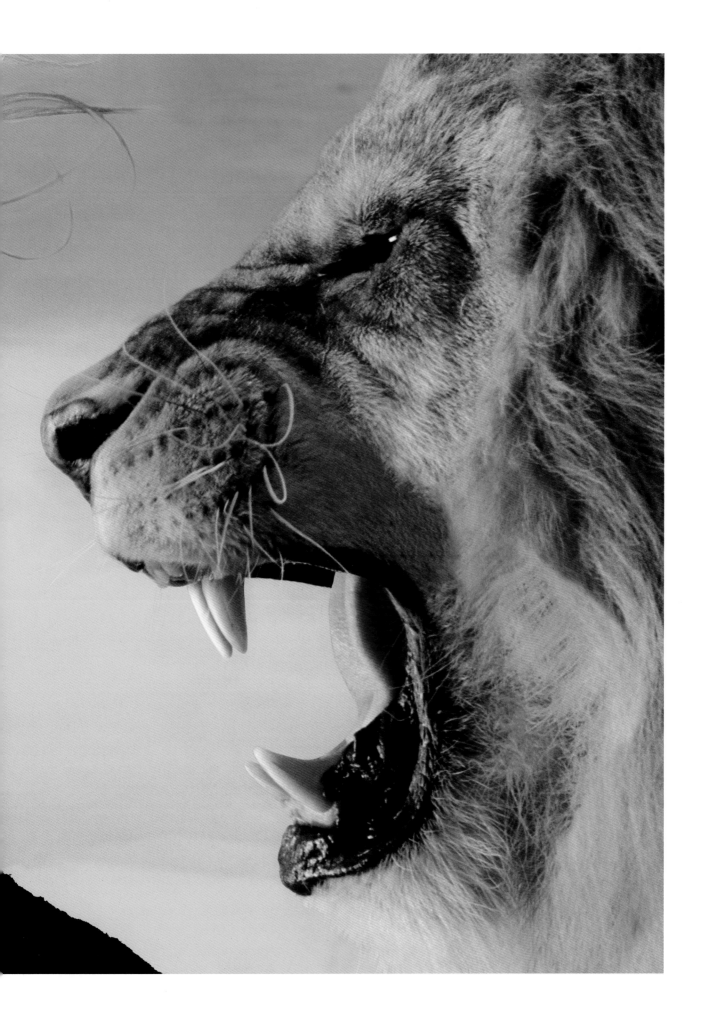

Animals
84

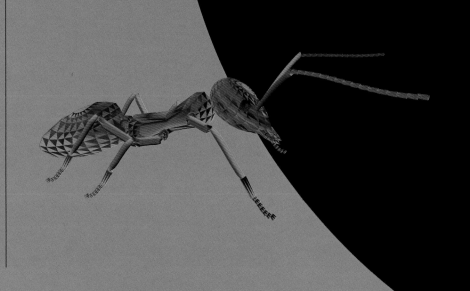

Potage

*I*n the beginning was the soup. Bubbling, boiling primal soup, in which life gradually took shape. Life that became larger and larger, more and more complex and stratified. Life that grew fins and finally crept onto dry land.

Having barely emerged from the soup, animals developed diverse body shapes and forms. From microscopically small to gigantically large. Creeping, crawling, running, hopping and flying; animals conquered our planet. And in the primal soup, which had mutated into the oceans, animals continued to develop.

The soup - so it seemed - had almost been left behind by evolutionary process. Until Homo sapiens learned to harness fire, and subsequently learned to fire ceramic pots and forge iron kettles. And soup experienced a revival as a result. Herbs and roots then went into the pot, as well as everything that crept, crawled, ran, hopped, flew, or swam. And suddenly, there it was again, the primal soup, with all its animals.

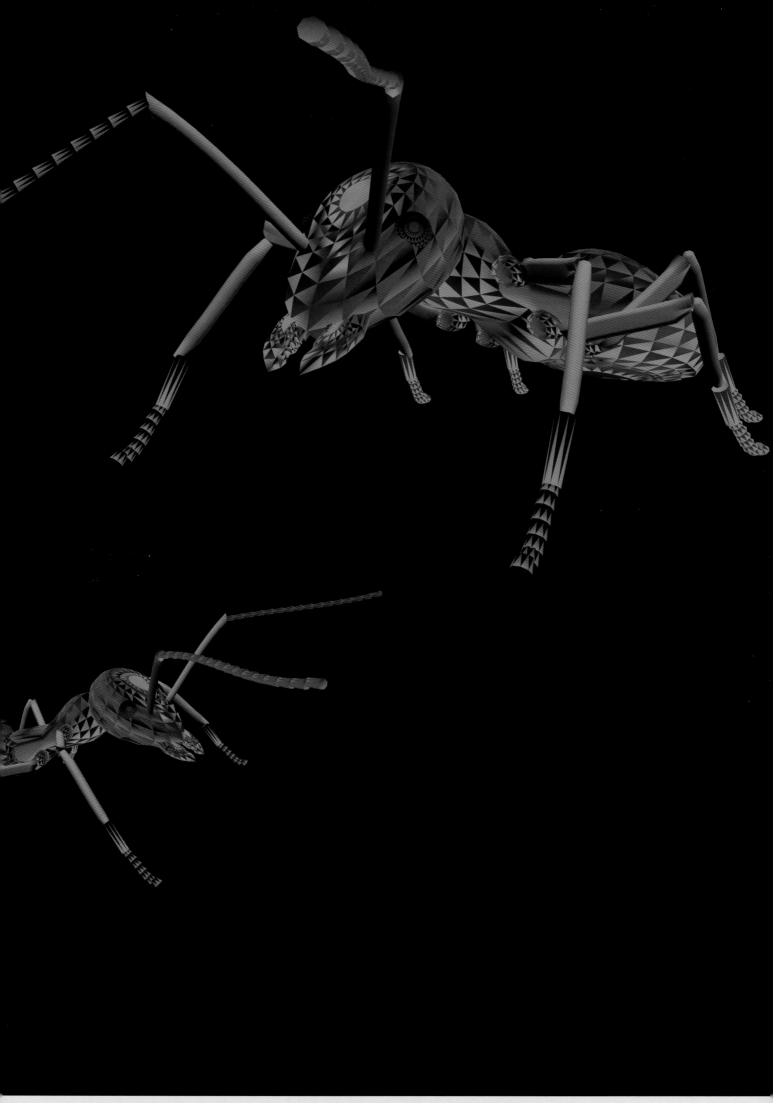

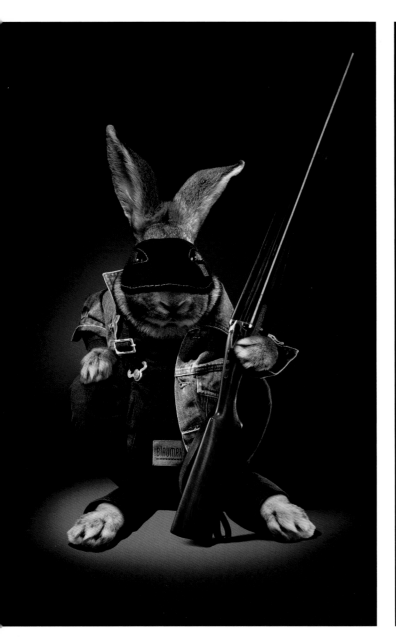
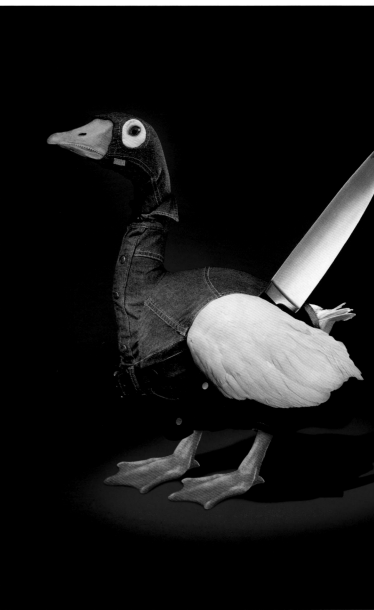

Pulp Fiction.

If you run into a pig, a rabbit, or a goose in tailored jeans, then you had best cross to the other side of the street. Because we're not talking about nice "toon" figures here, but original gangsters.

By the way, their jeans are hand-sewn. The figures are modelled in clay, and the figures dressed in jeans were photographed. The individual animal body parts were then added by digital image processing.

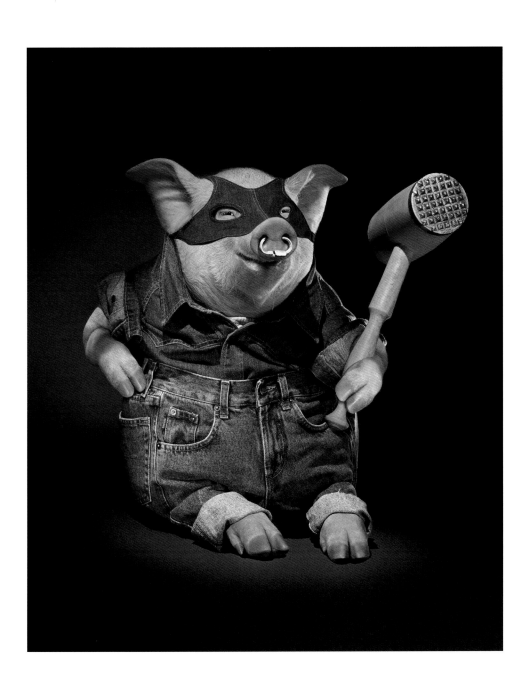

High-tech Piranhas.

Created by a Paintbox wizard, who combined real photos, excellent, digital airbrush illustrations, and individual three-dimensional components. The artist skillfully pieced together hundreds of these elements.

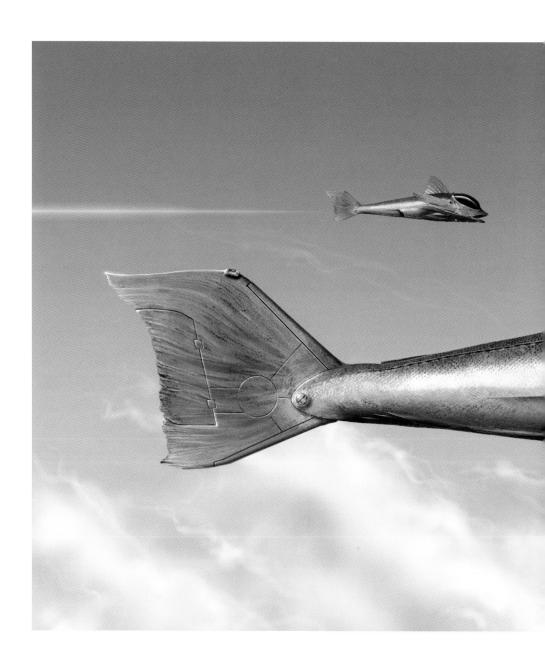

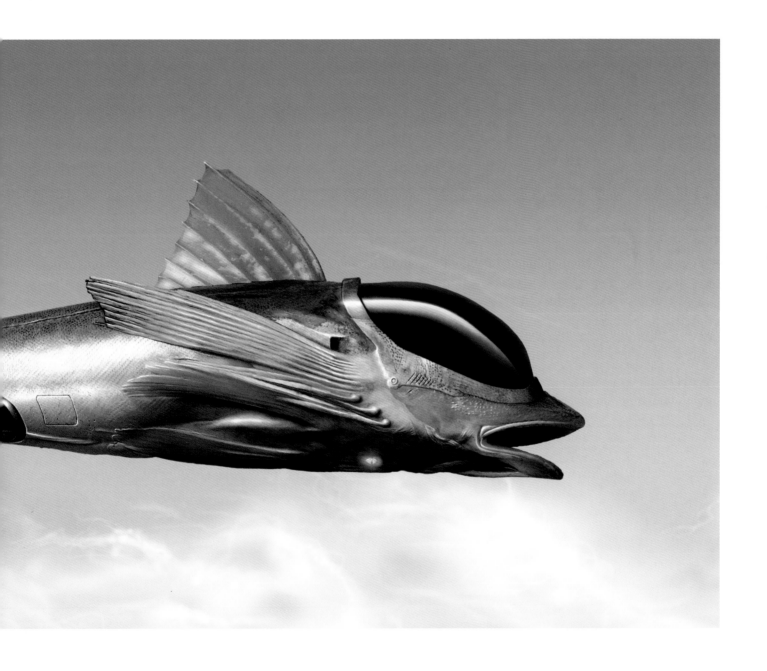

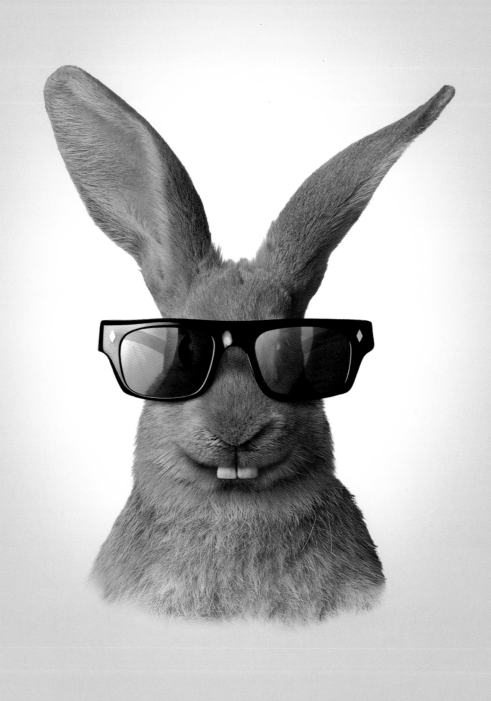

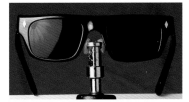

The Sunshine of Your Smile.

What are we particularly fond of? Sexy bunnies saying "cheese".
This is exactly what the artist contrived here with the rabbit starting
from a plain illustration.

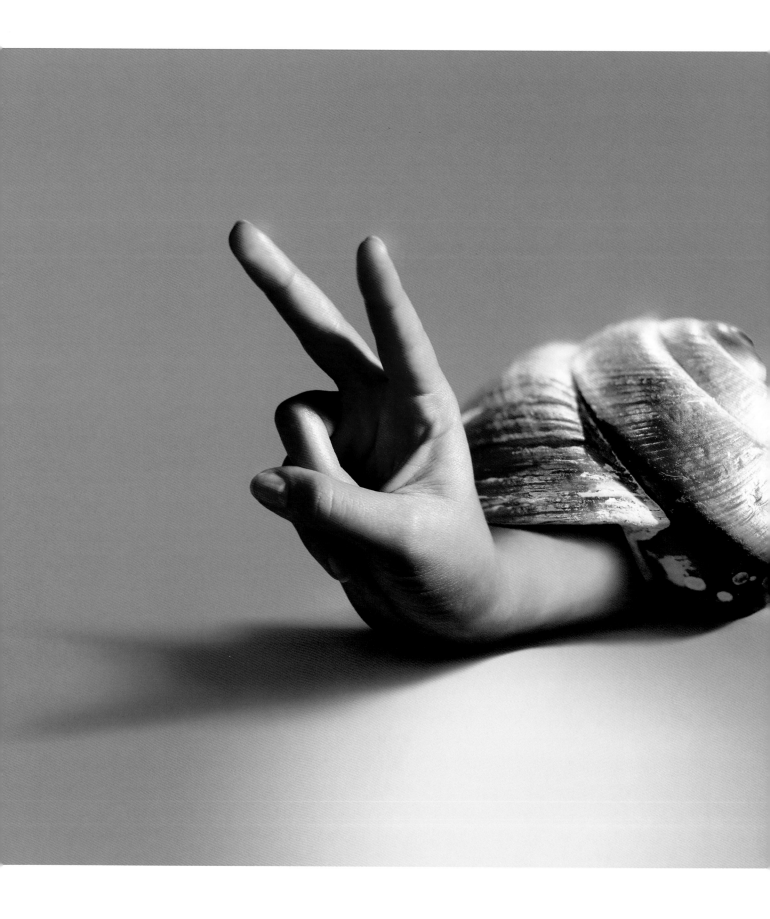

Animals

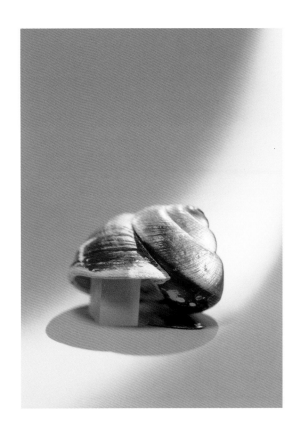

Give Peace a Chance!

Anyone who wants to create a peaceful harmony in his collage must ensure that all the component parts are photographed in the same lighting.

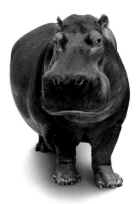

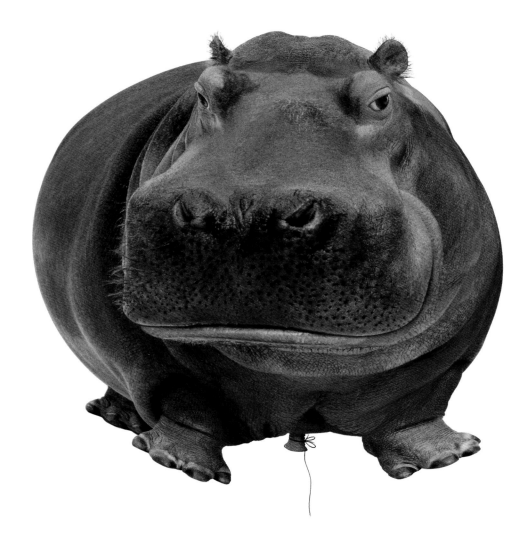

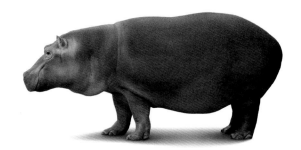

Hip hip hurrah!

Here you see what the BBC animal documentaries have shamefully kept secret until now: the Flying Hippopotamus.

In order to ensure an aerodynamic surface, first, dirt, scratches, etc. were removed from the animals' skin and a bit of make-up was applied. Then the hippos were given larger eyes, and their faces lent a friendly, stewardess-like appearance. And finally, before take off, some of the parts of their body were moved, distorted, and disjointed.

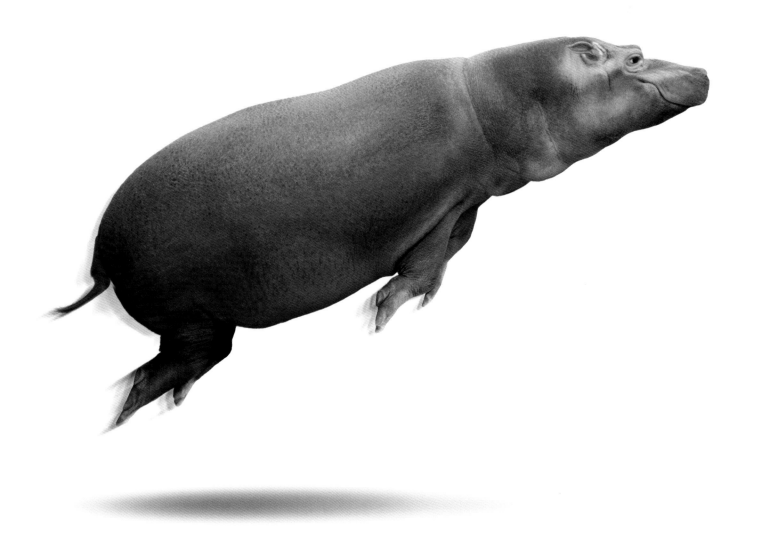

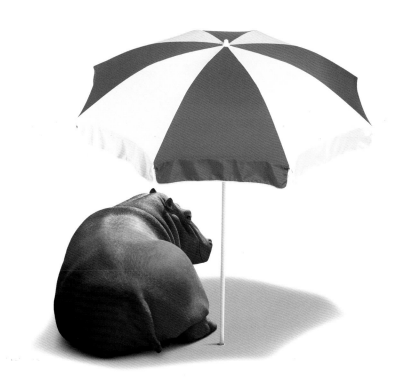

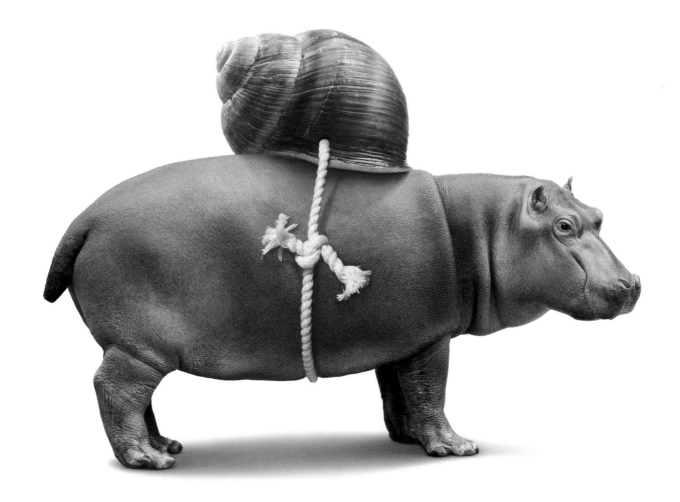

Birds and Bees . . .

Where does delicious, golden-yellow honey come from? From Paintbox of course! That's where, after compiling the individual elements, the picture was composed and set in a wonderful, honey-coloured light.

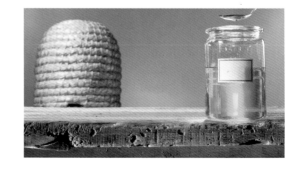

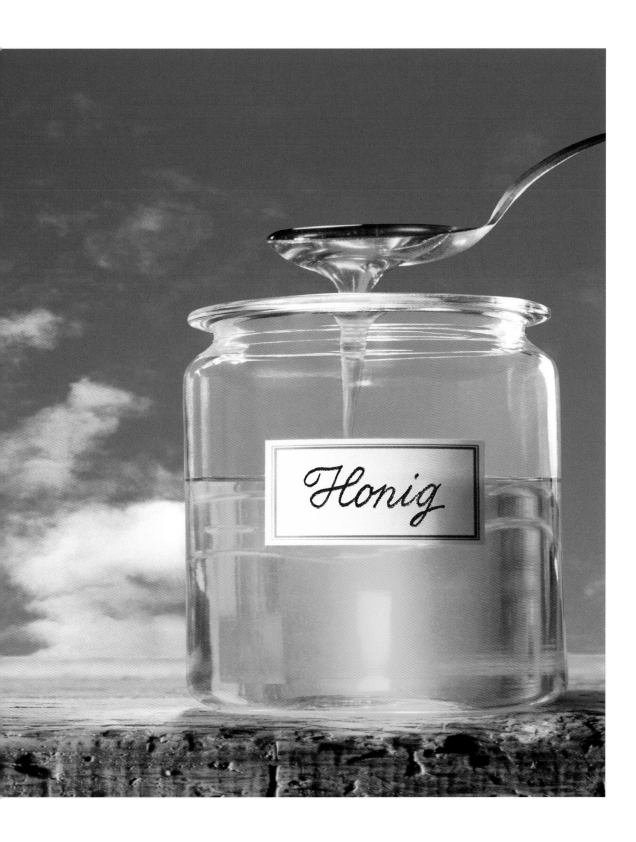

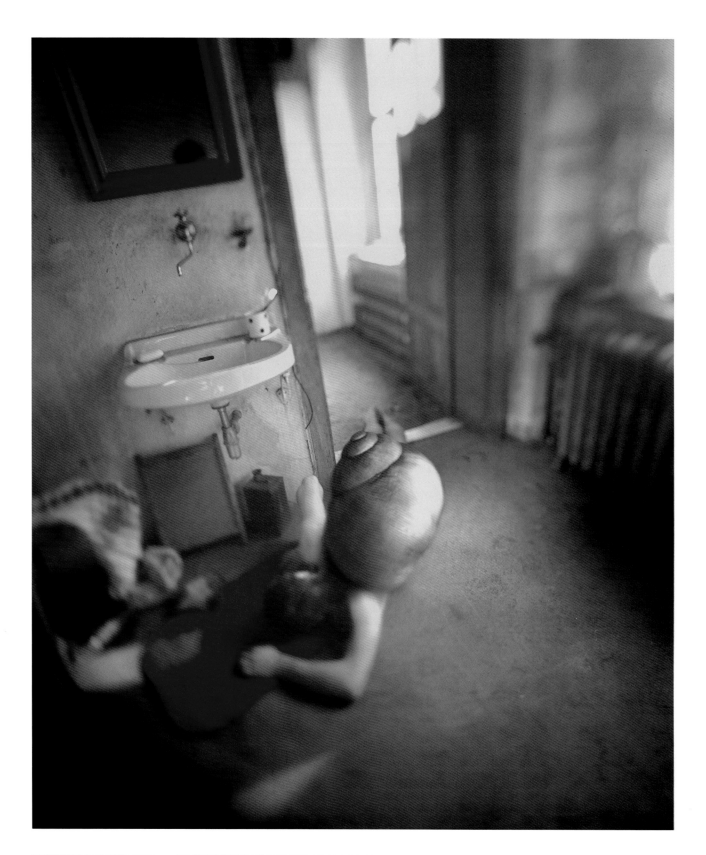

Home Sweet Home.

Here you see the latest achievement in the pre-fabricated housing sector: a 100 % biological snail shell, in which any environmentally aware human would be happy to crawl. Before he does so, however, the colours in the composition must be digitally matched.

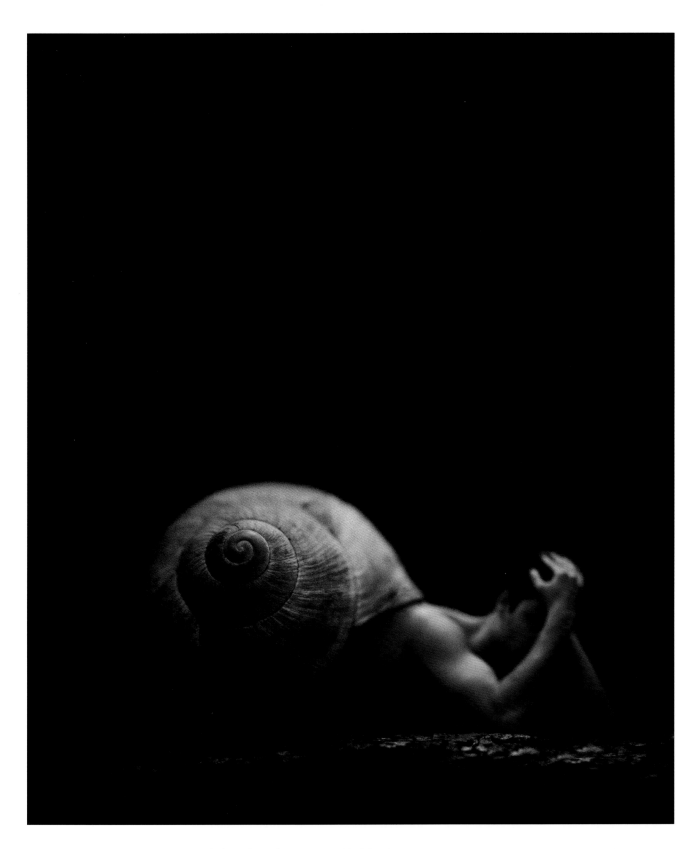

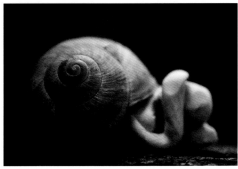

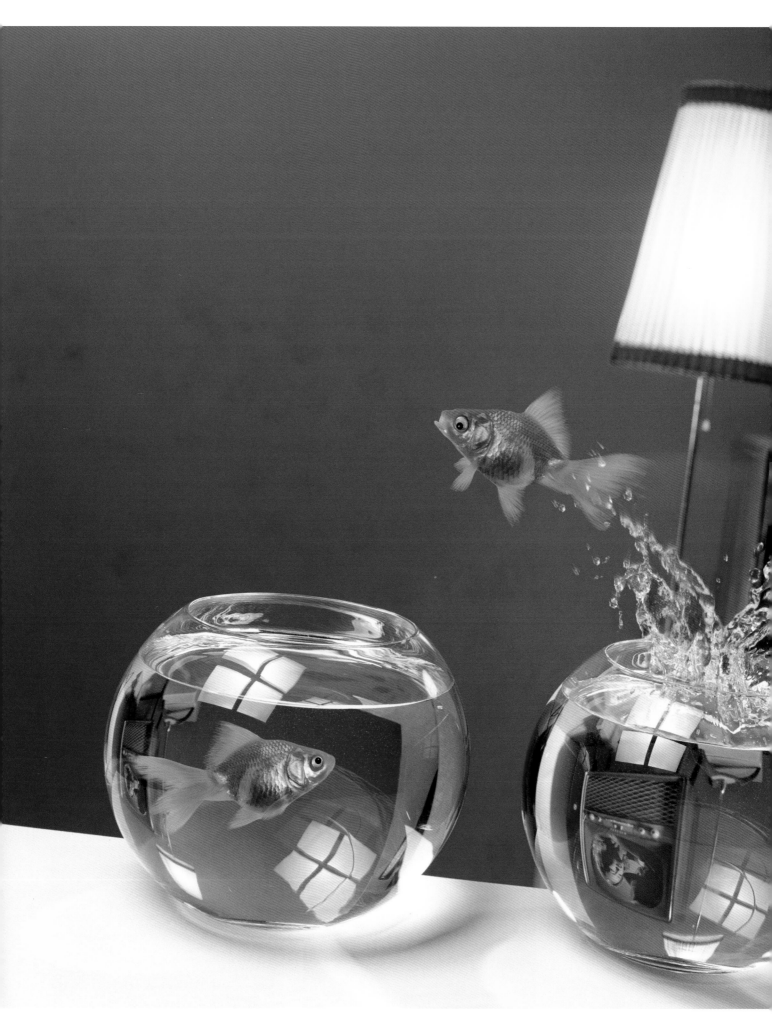

Animals

Ginseng or Viagra?

What could have induced the goldfish manikin to display such a feat of strength?

All the component parts had to be prepared before they could be painstakingly pieced together to create the digital collage in this picture.

It's a Watery World!

Everything appears in a different, filtered light underwater. Movement in the water also distorts visual impressions. All this has been taken into consideration in this photo collage to create a time-consuming, richly detailed work.

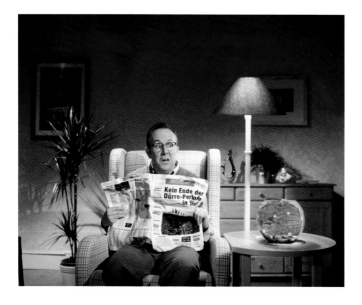

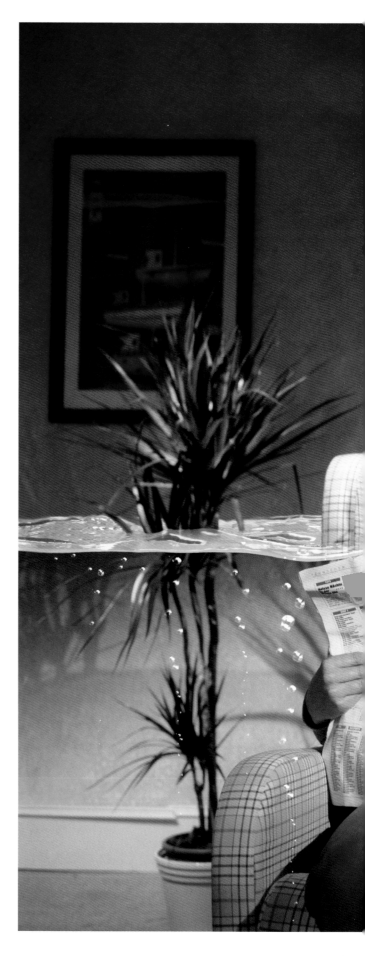

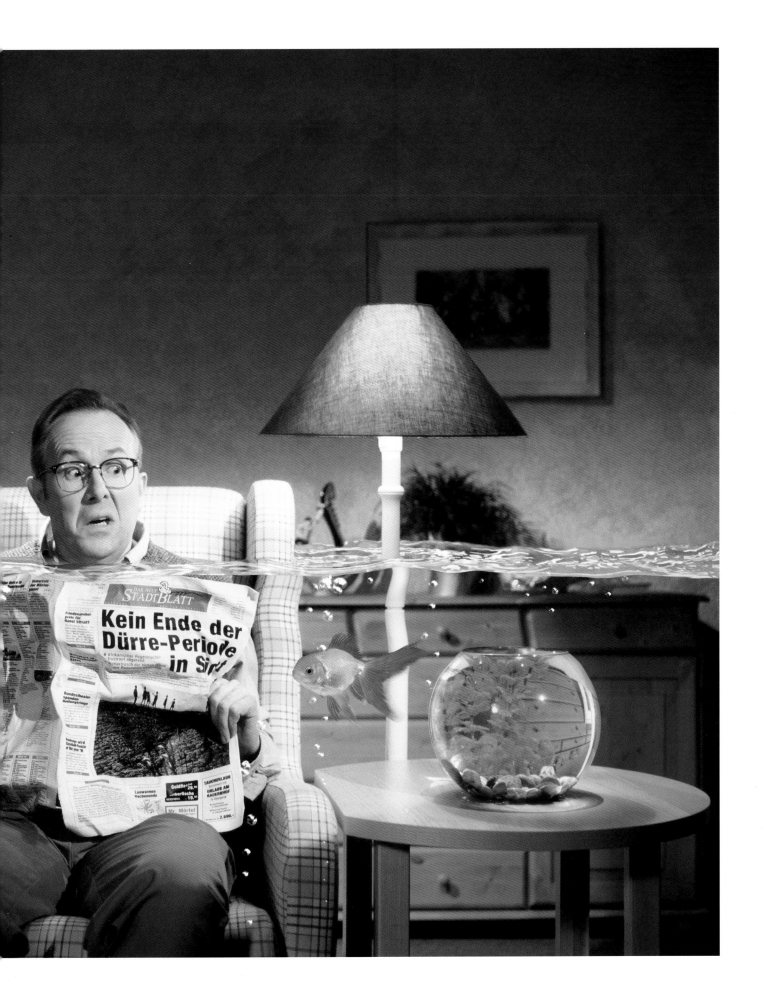

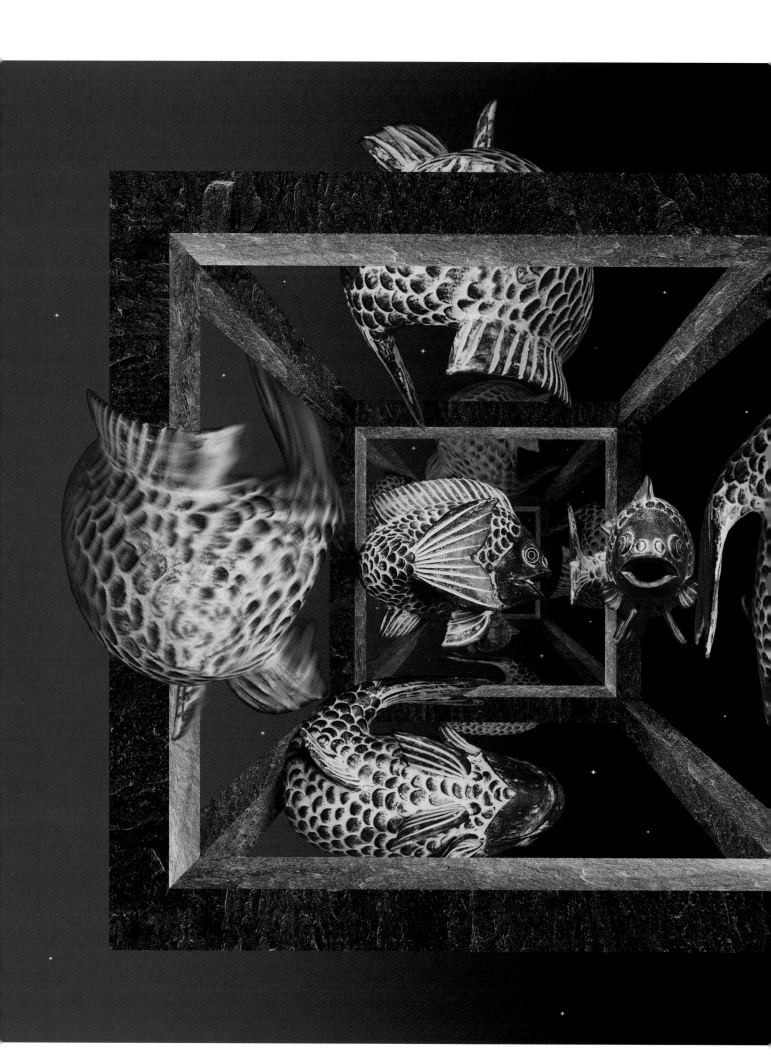

Animals

20,000 Leagues Under the Sea.

Captain Nemo welcomes you on board the Paintbox and invites you to a little underwater adventure. Provided you have a boarding card, of course.

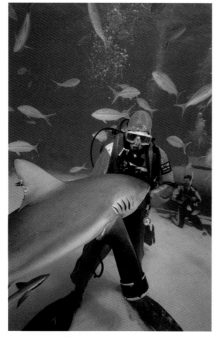

Dentist's Pets.

The living room, together with the appropriate pets, is assembled from various individual elements. An immaculate set of teeth was inserted in a second shark's jaws.

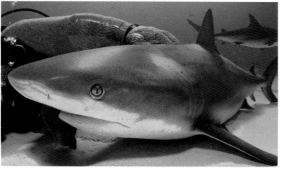

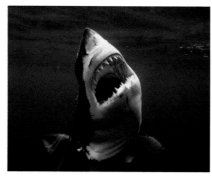

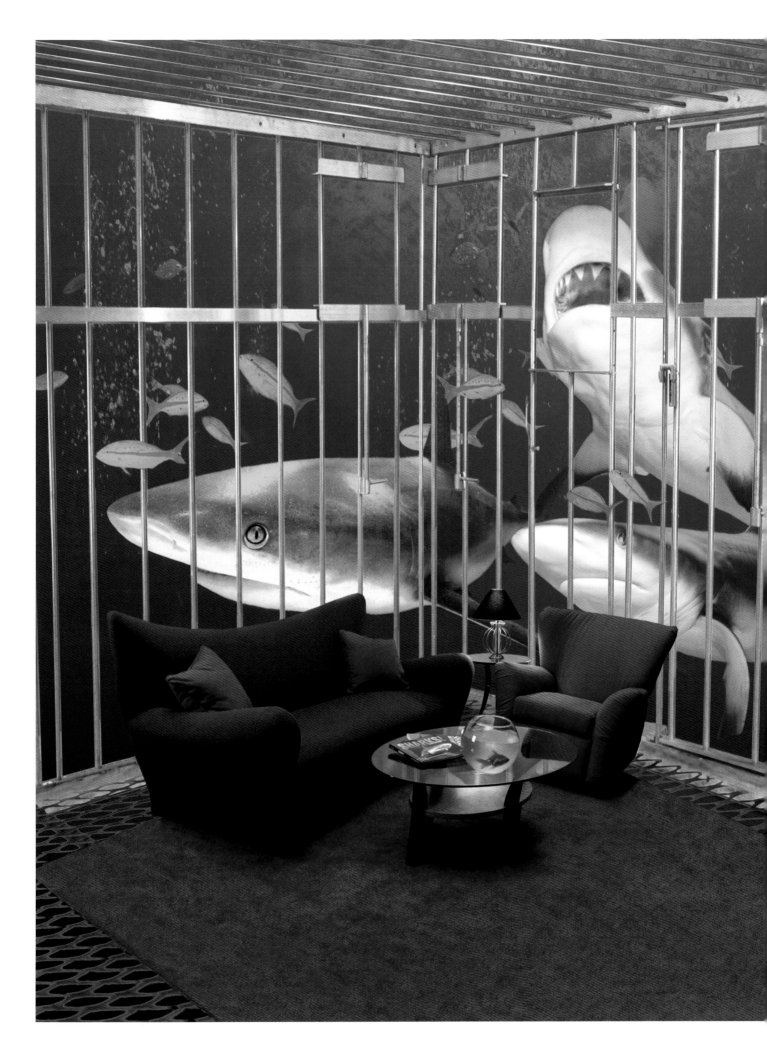

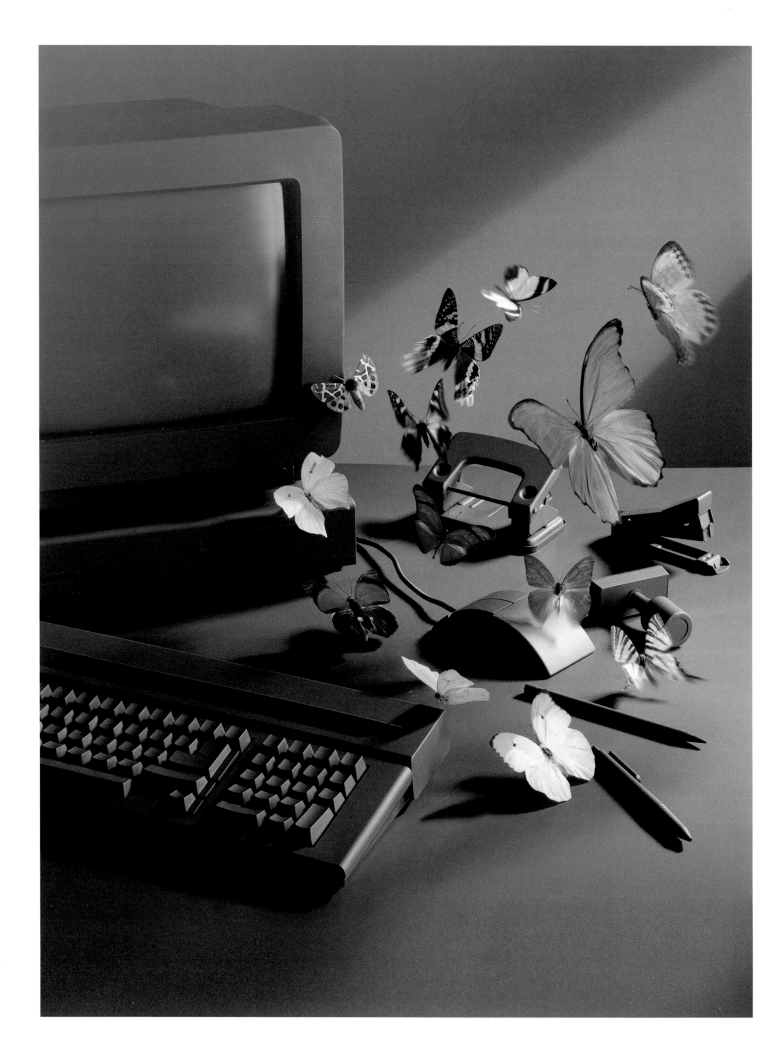

Animals

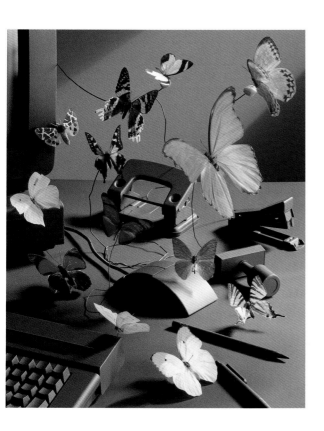

United Colours of Butterflies.

Butterflies of the world - unite! Conquer the drab expanses of the global office, so that they may become colourful and cheerful . . .

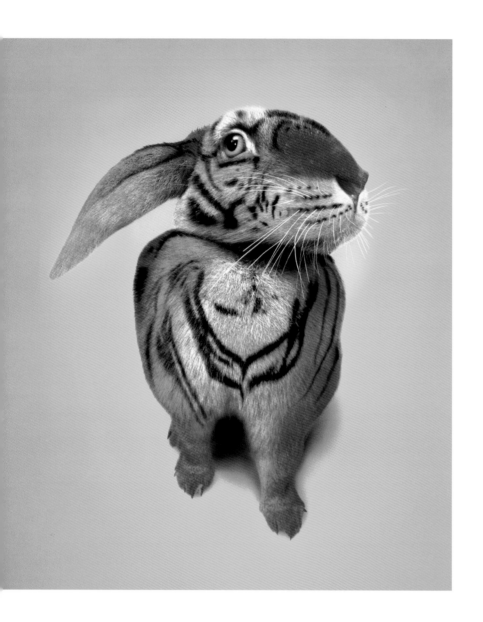

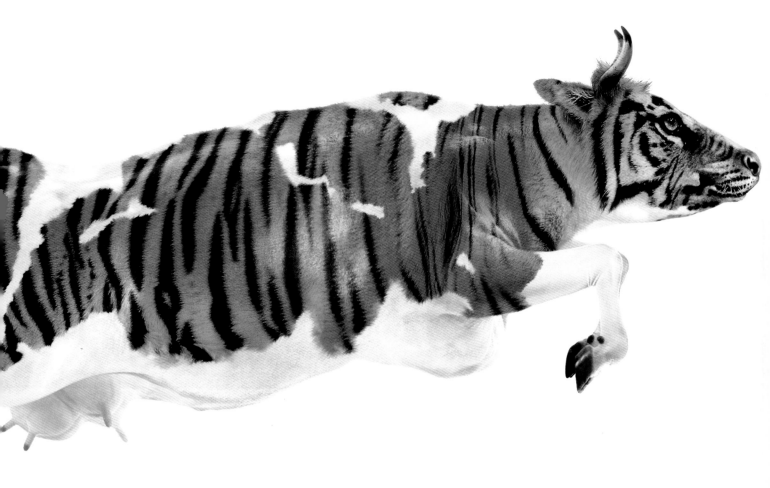

Skinhead.

The Paintbox artist who created this picture did not have anything on his mind except skin and fur. He simply exchanged the furs and skins of the animals. He then went on to distort individual parts of the animals' bodies. The essential thing here is to have a good sense of proportion.

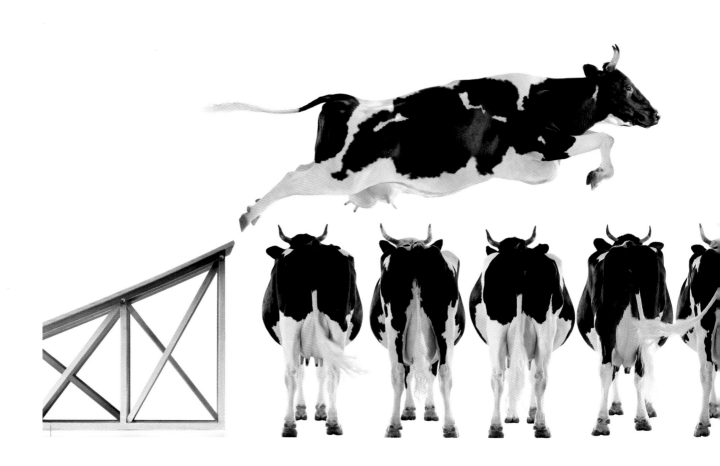

Jumping Champion Cow.

If you want to get a cow this animated, you first have to re-define the cow's body and assemble it out of lots of tiny pieces. A total rebuild! But pay particular attention to getting the proportions of the body right.

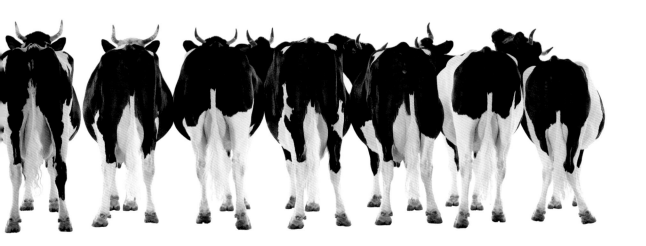

Animals

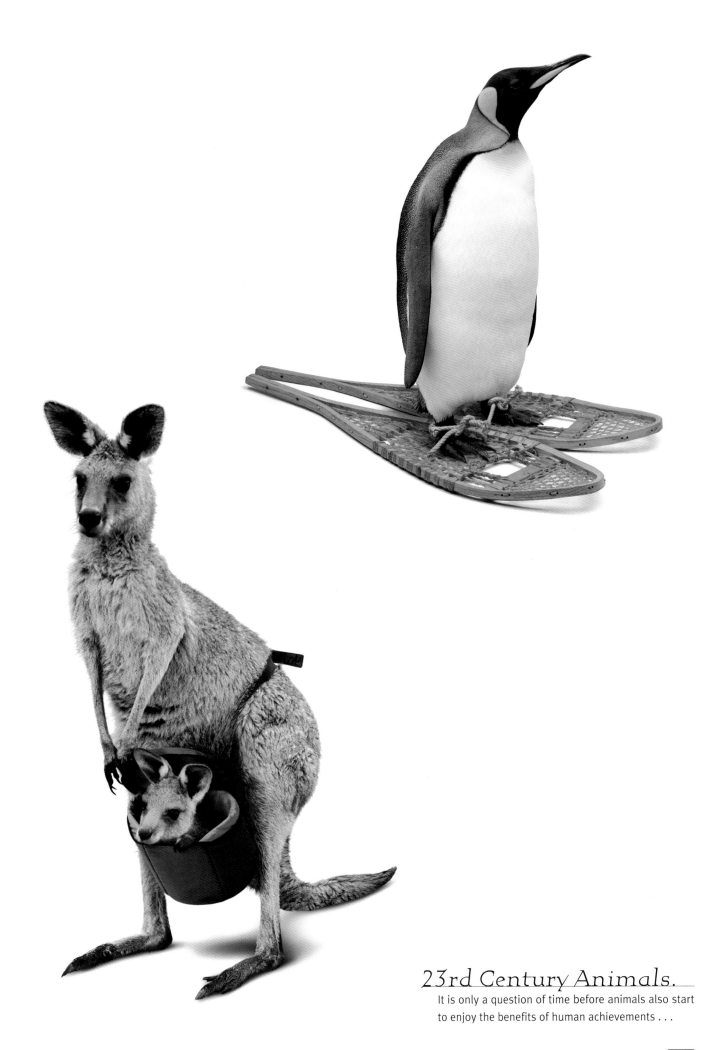

23rd Century Animals.

It is only a question of time before animals also start
to enjoy the benefits of human achievements . . .

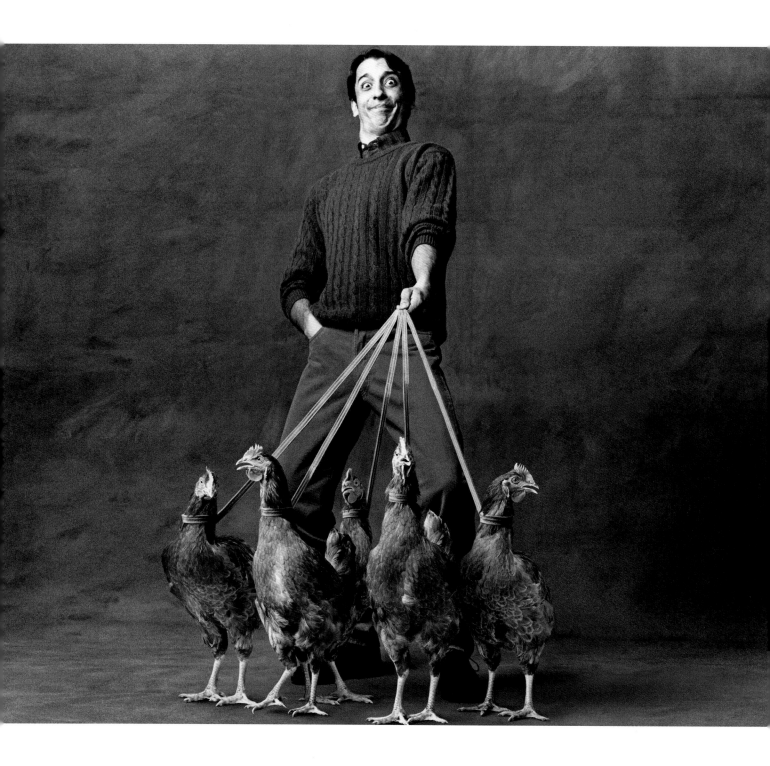

Animal Action.

The digital animal trainer can accomplish just about anything! He may be sure of the envy and jealousy of any real-life animal trainer.

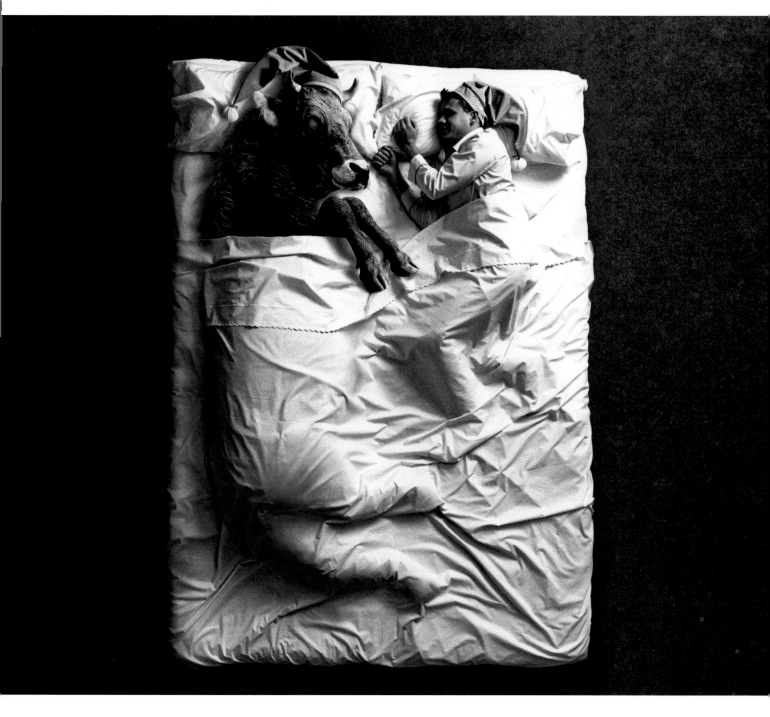

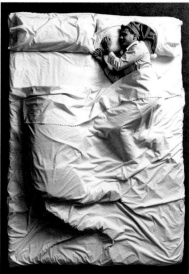

Technology

Poisson

Allow me to invite you to a little Fata Morgana - Imagine all around you is nothing. Nothing but sunlight. The glare is so bright that you have to keep your eyelids tightly shut, because otherwise the scorching rays threaten to vaporise your eyeballs in their sockets. Unfortunately your eyelids are already somewhat inflamed, because grains of dirt and dust, blown by the white-hot wind, have become plastered to your dried-up tears. Even the slightest twitching of an eyelid chafes mercilessly. Yet none of that bothers you any more, because your brain, boiling beneath your scalp, your naked, blister-covered feet, scorched by the burning earth, your brittle, itching, dry, cracked skin, your swollen tongue, covered with a sticky mixture of dust and spittle, your whole body, your tortured soul all demand just one thing: water.

And now you are ready for our mutual Fata Morgana, which suddenly rears up before you in the shape of a foam-crested breaker. Mad with joy you stumble in and relish how the spray crashes over you. The current snatches your feet from the seafloor and suddenly you are drifting to the rhythm of the tides, as lightly and effortlessly as a fish. Without water wings, without a boat, without assistance, without technology . . .

Virtual Money.

How does plastic money become virtual money? By pulling the surface
of a credit card like a skin over mousetraps, globes, etc., in Paintbox.
Of course, when you do so, the mousetrap must remain clearly recog-
nisable; in other words, you must not change the nature of the object.
In the processing of these digital images, it was essential to retain the
original lighting of the objects.

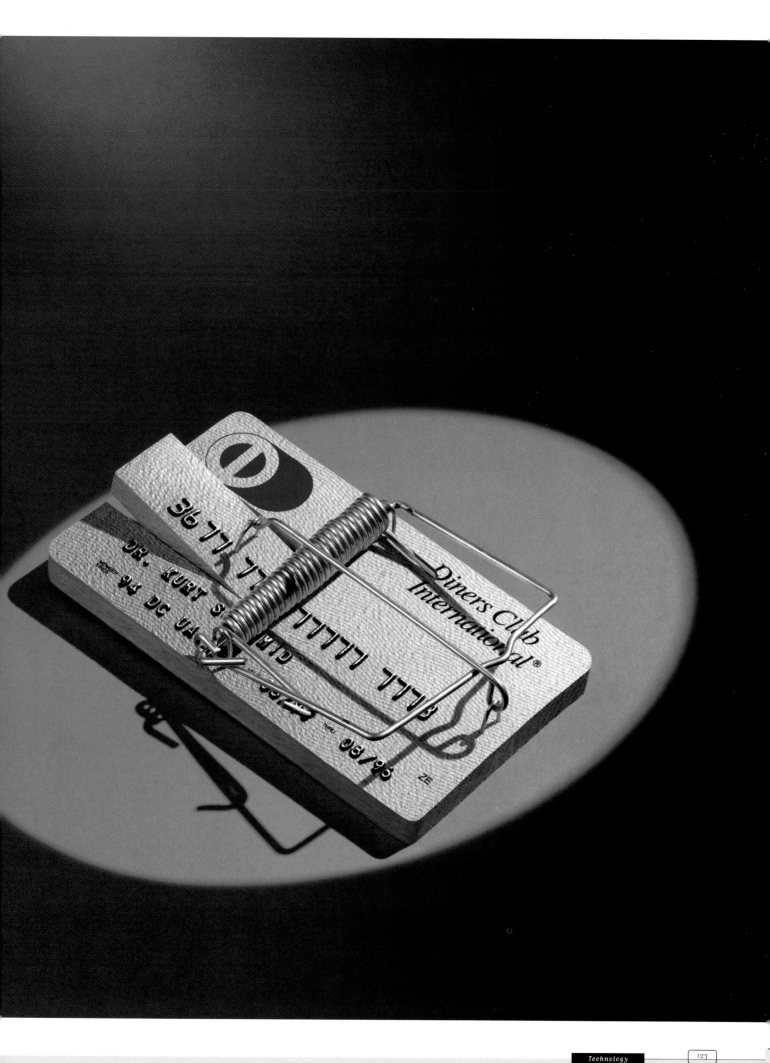

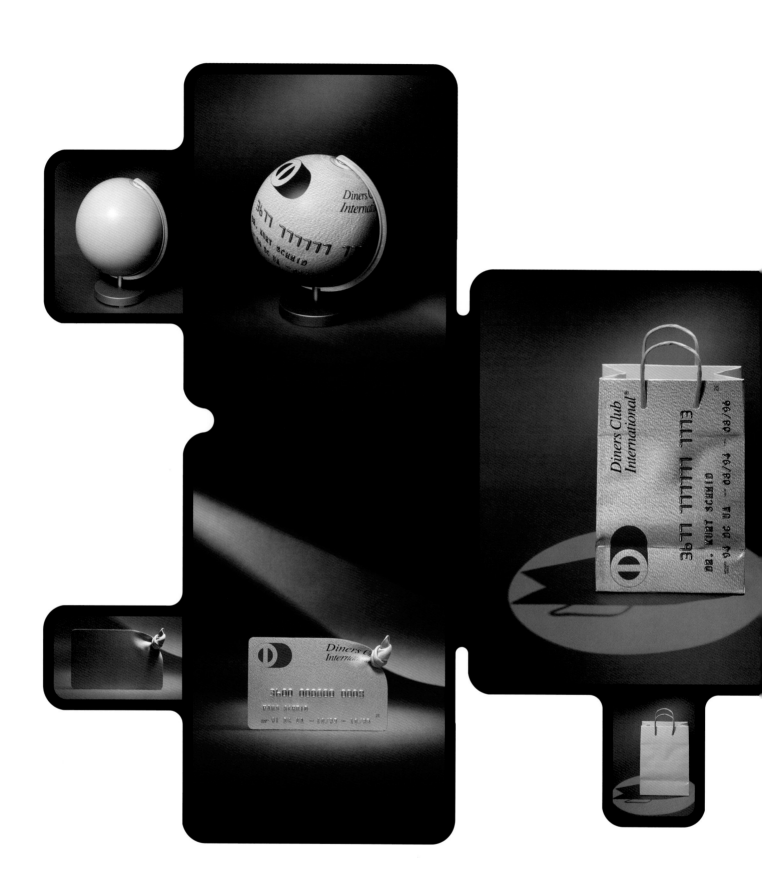

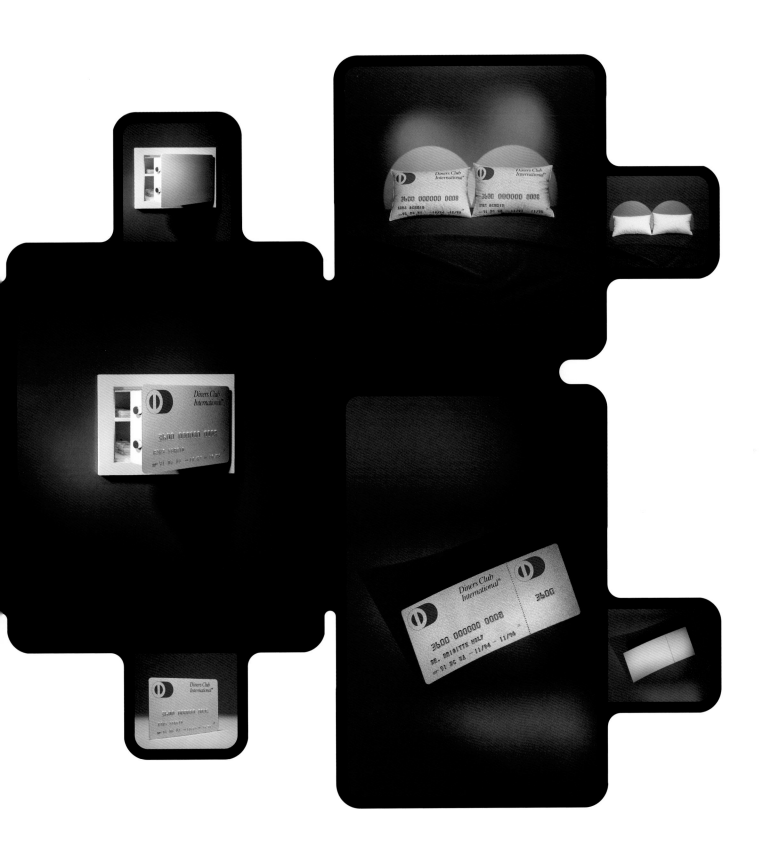

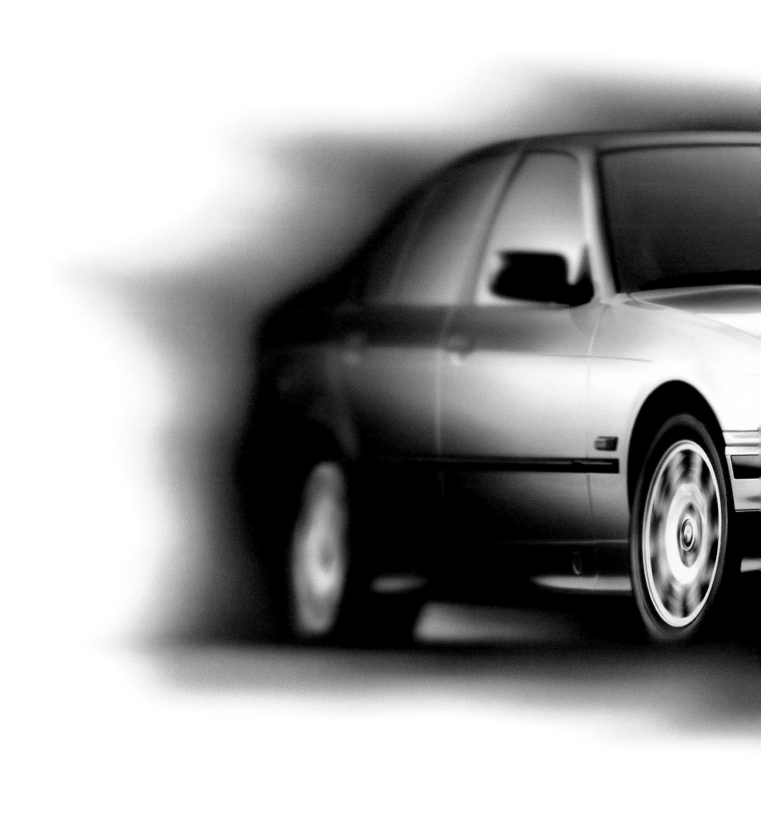

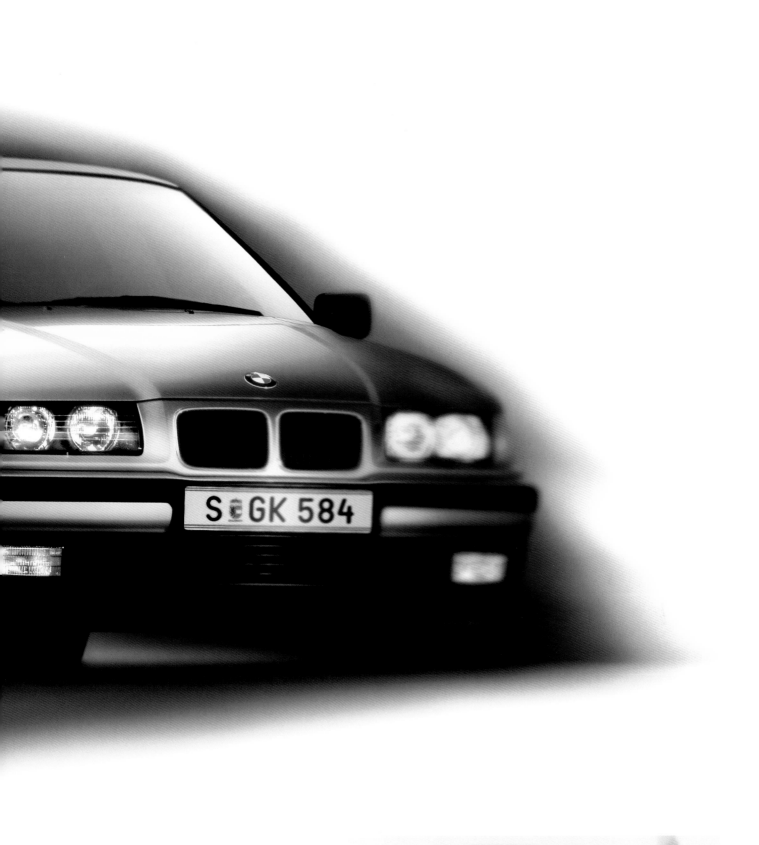

A Wild Thing.

This digitally processed image shows what can be done with a simple photo. By means of a dramatic projection of light and shadow, as well as a dynamic depth of focus, a genuine BMW was made out of a common-or-garden automobile.

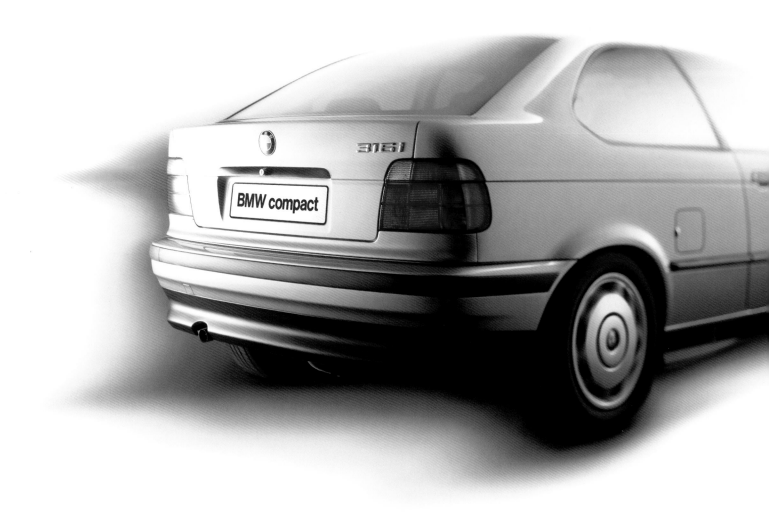

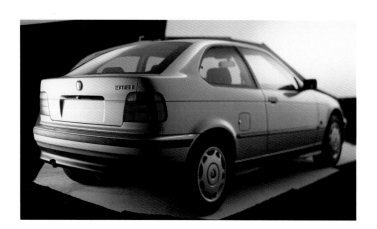

Rocking Around.

After all identifying characteristics of the two cars in the margin had been erased, they could be properly shaken and stirred. It was done like this: the cars were cut up into individual pieces, caricatured, and then rebuilt.

Streetcar with a Difference.

Yearning for surrealism?

No problem. As a result of a digital montage and a lot of flair, the car appears to be travelling on the rails. Details such as the reflection of the headlamps on the rails serve to lend the montage a more realistic impression.

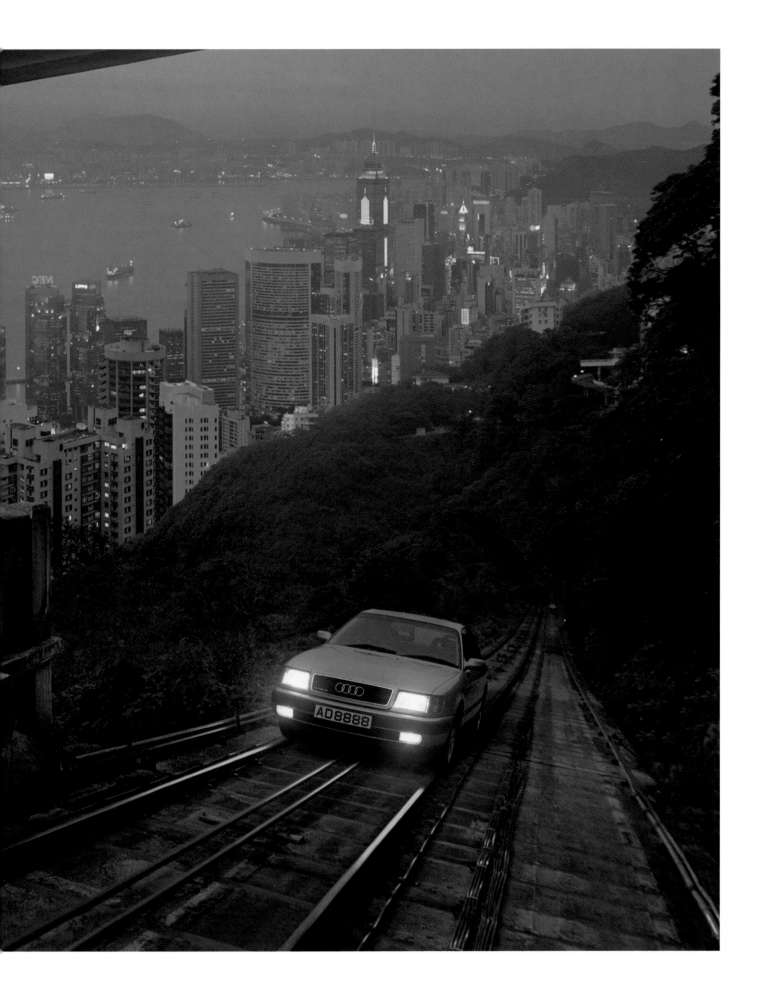

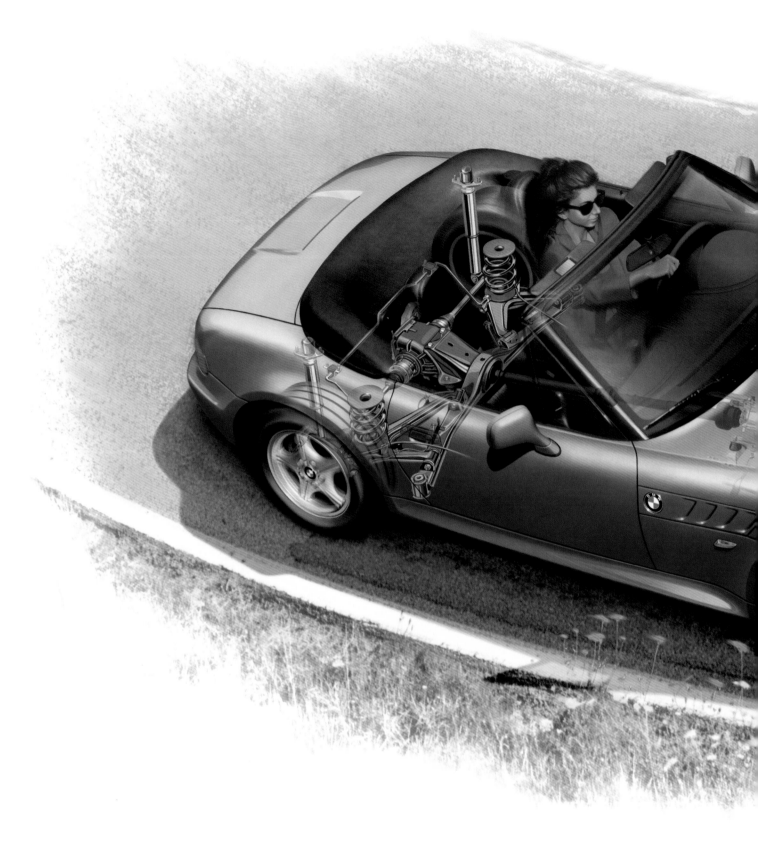

Crazy, Man!

Crazy, the amount of detailed work that went into this lavish, digitised, airbrush artwork. The individual elements were painstakingly pieced together and then overlaid with a thin, transparent surface.

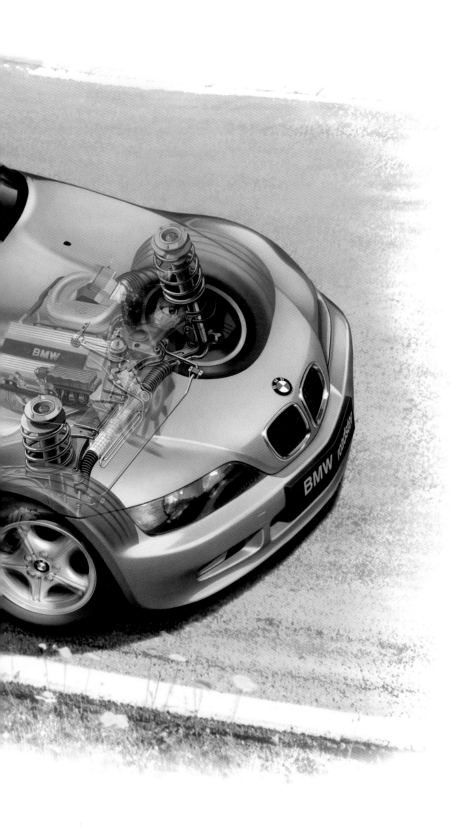

Mountains Made to Order.

How are typical landscapes reflected in the paintwork or windows
of a car? By digitally distorting them, so that they fit the contours of
the car perfectly. And so you create a perfect illusion of reflection.

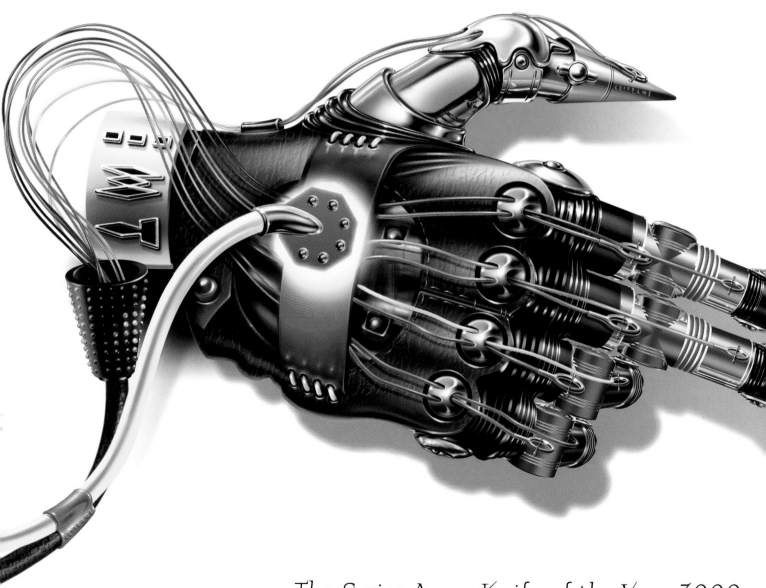

The Swiss Army Knife of the Year 3000.

Compared to this, today's electrical appliances are like Stone Age flint tools.

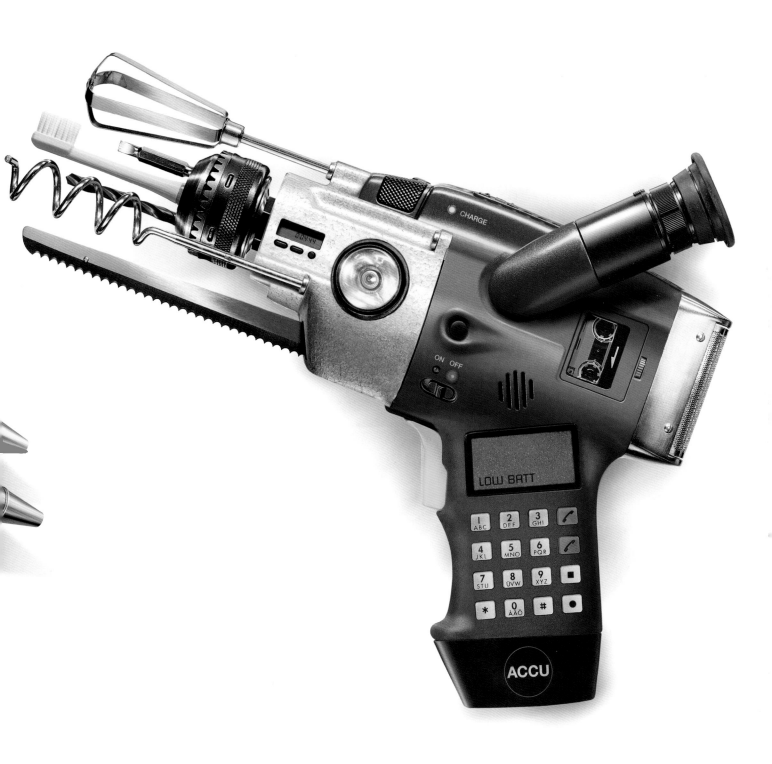

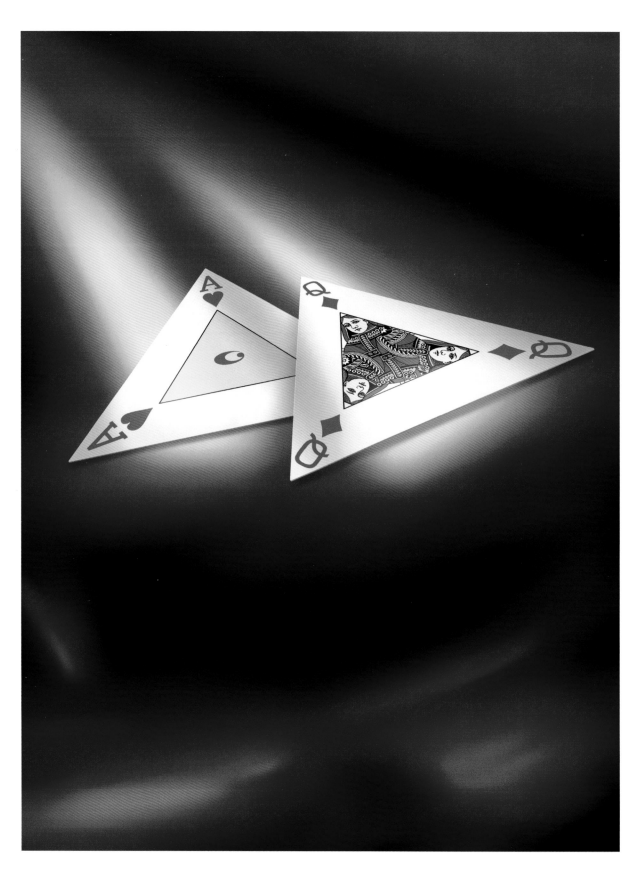

Faites vous jeux!

The cards were made otherworldly in Paintbox. The rectangular roulette wheel was created using a 3-D program. The picture was then polished and perfected by means of digital retouching. The backgrounds and reflections in both pictures are pure artwork.

When the casino advertisement with the triangular cards appeared, there was a huge demand for such cards. Subsequently, they were actually produced. A case of virtual reality . . .

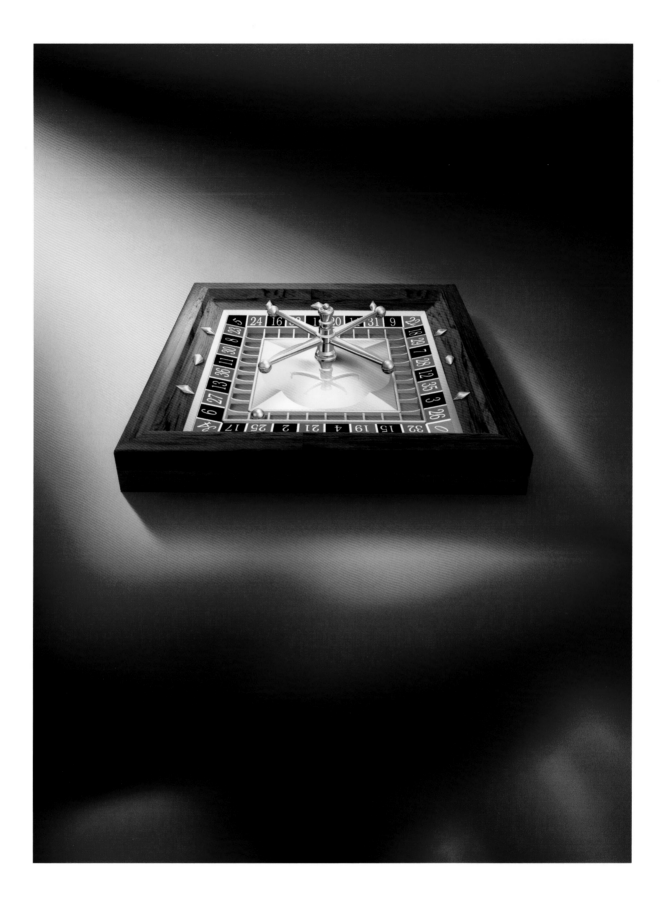

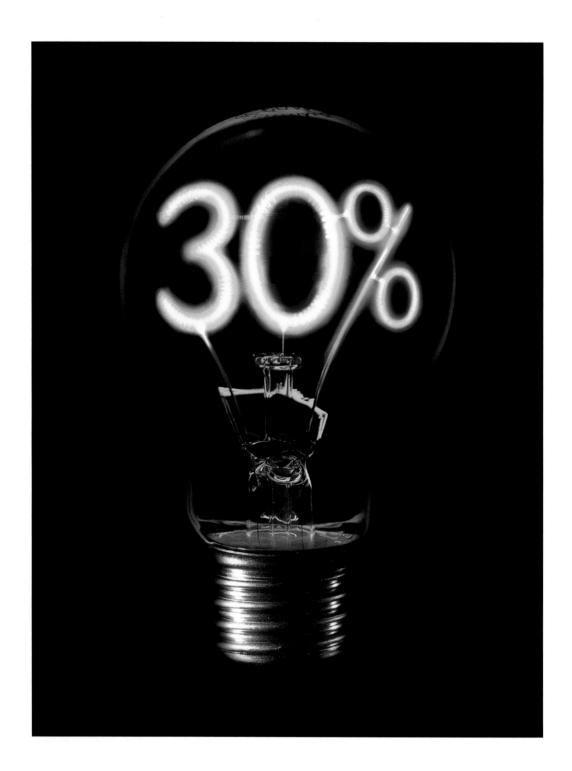

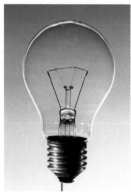

Brightly Shining Fire!

Light doesn't come just from light bulbs, but also from a Paintbox.
However, don't get any ideas about hanging a Paintbox from the
ceiling instead of a chandelier . . .

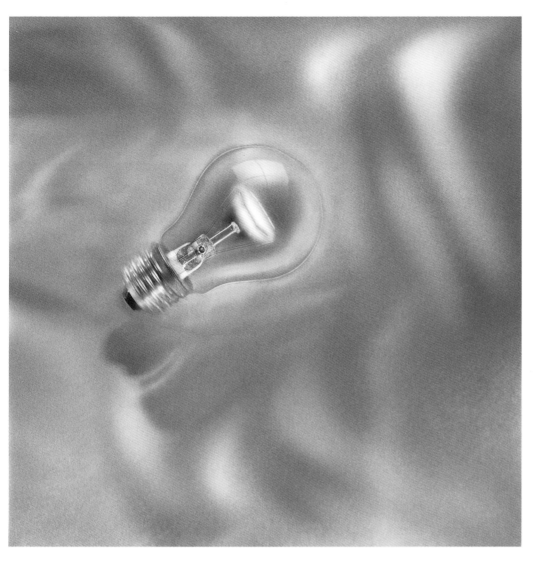
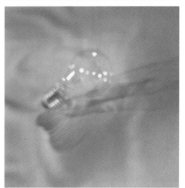
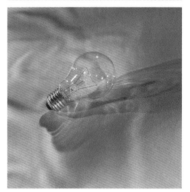
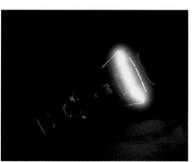

STOP

PL

STOP PLAY F.FWD

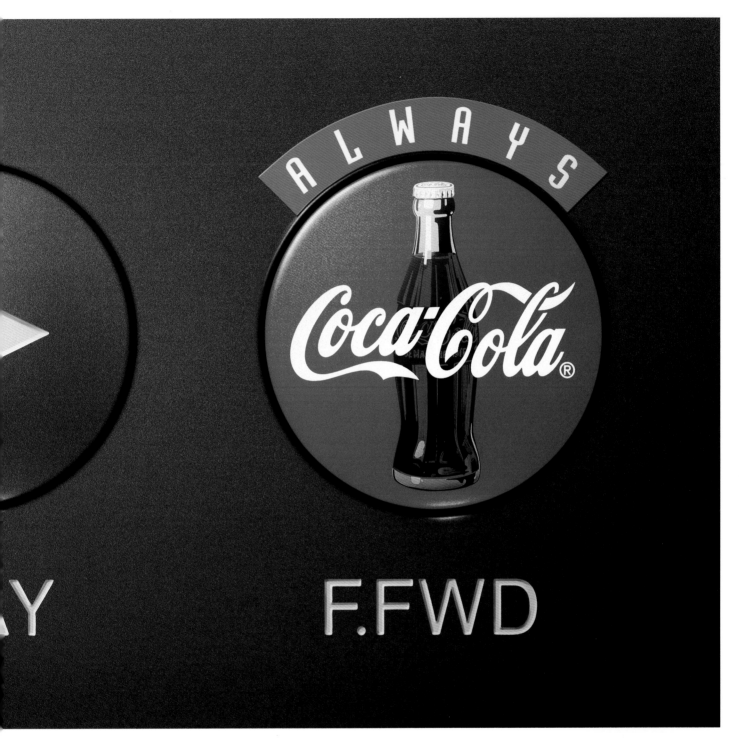

A Pictogram Is a Pictogram Is a Pictogram.

This Paintbox illustration was created from the three pictograms on the left. Everything in this picture was illustrated, even including the finely structured surface.

All together now.

A completely new composition was created from dozens of different photos and a richness of visual details. The trick is to create a new, perfect world.

Flugplatz Johannisthal
Halle
Parseval VI

Cellular Creatures.

Here we see what we were always afraid would happen: these cellular phones have come to life and are able to gambol around. Producing such crazy cell phones requires a great deal of distortion as well as great illustrations.

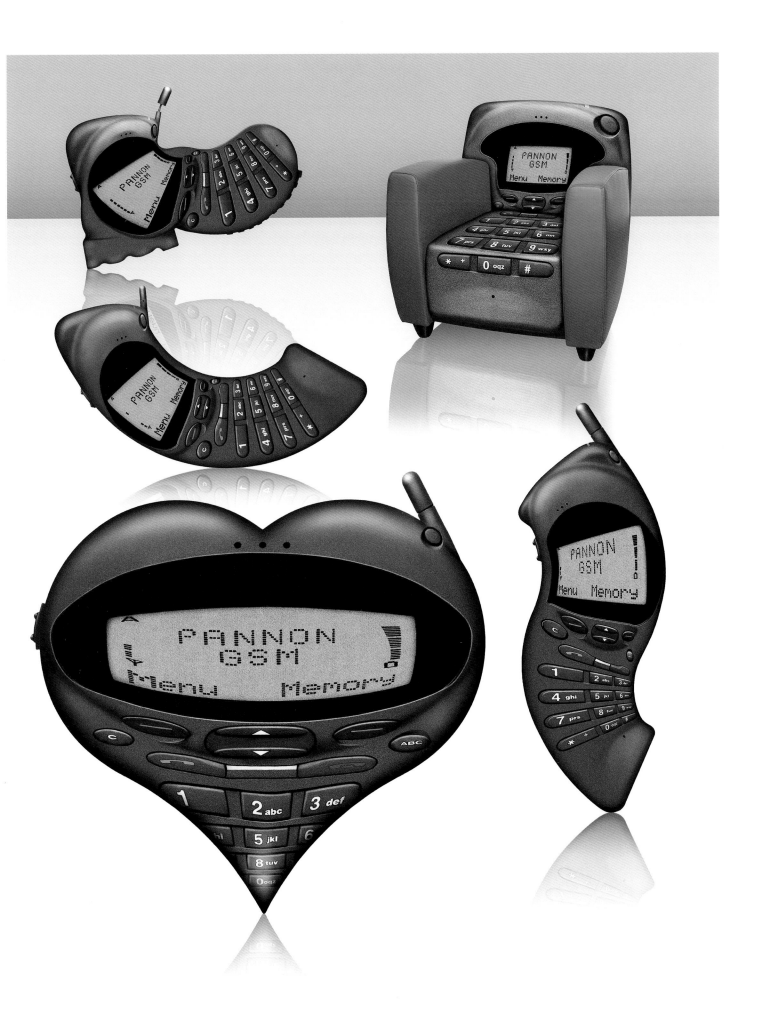

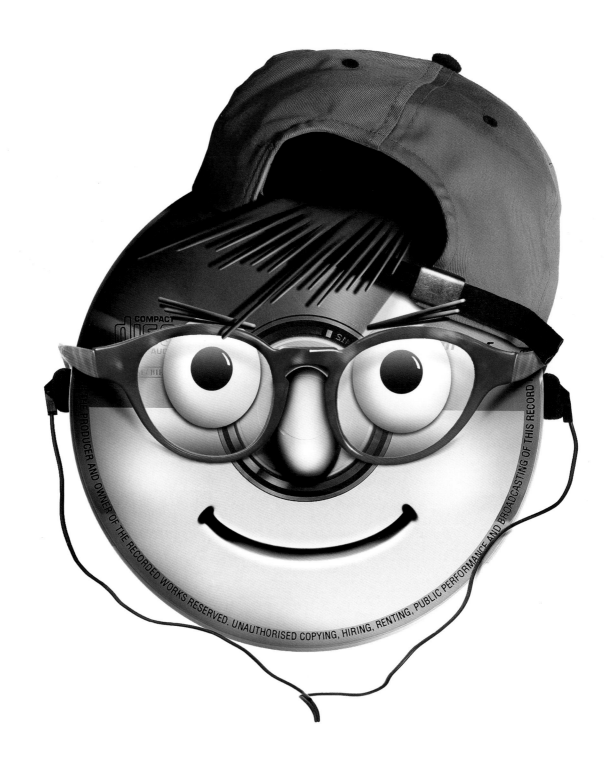

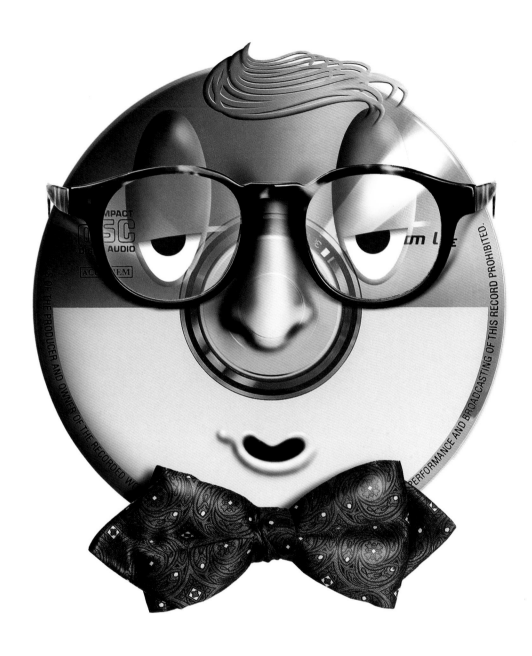

Digital DJs.

The quality of this work lies in the comical nature of these facial expressions. In order to achieve this, one must not only do a fine job of assembling the component parts, but also have the instincts of a good cartoonist.

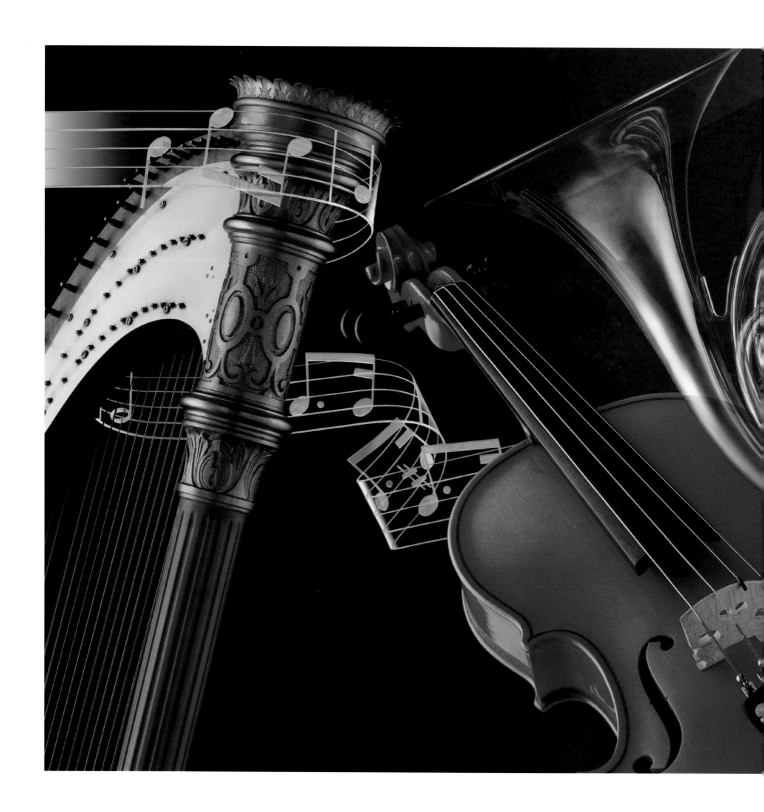

Roll Over Mozart!

Any amount of creative thought, time, work and love of detail went into these collages portraying the spirit of classical music.

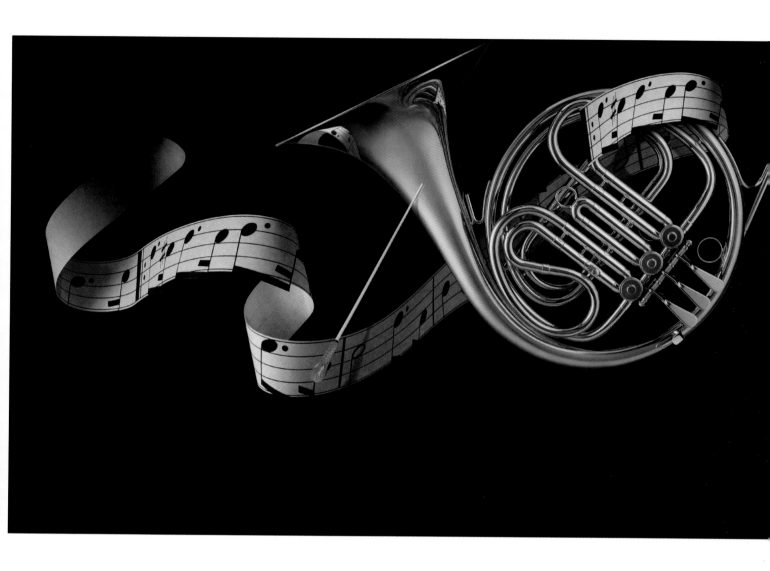

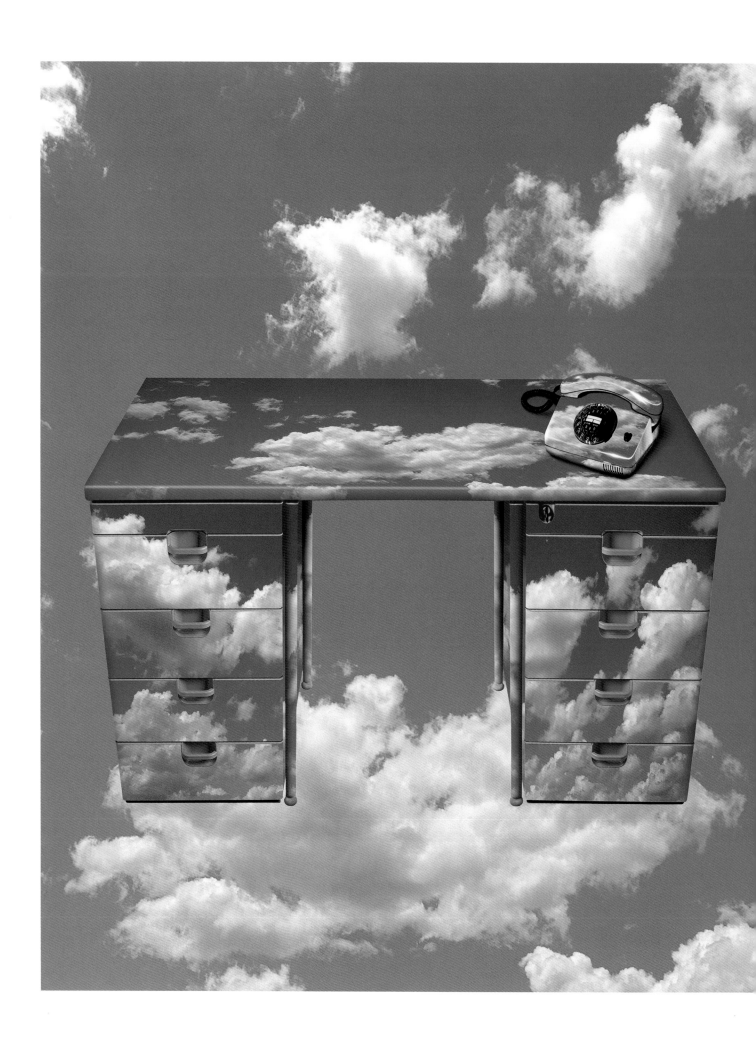

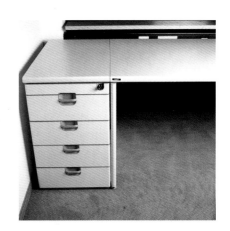

Clear Perspectives.

What one does not see clearly at first is the enormous amount of work that went into this picture. Each individual surface of the desk was overlaid with clouds and sky. Only then were the separate surfaces pieced together. Naturally the light, shadow, and surface of the desk and the telephone had to be retained during the overlay process.

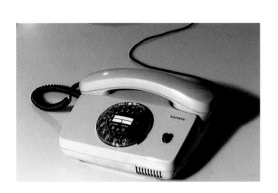

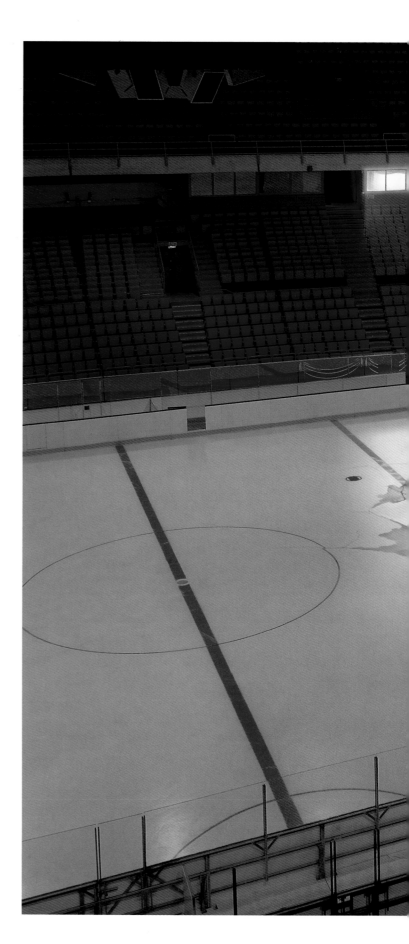

The Submarine that Came in from the Cold.

Perfect illustrations of crushed ice and ice floes. The lighting effects retouched into the stadium add a wonderfully dramatic touch.

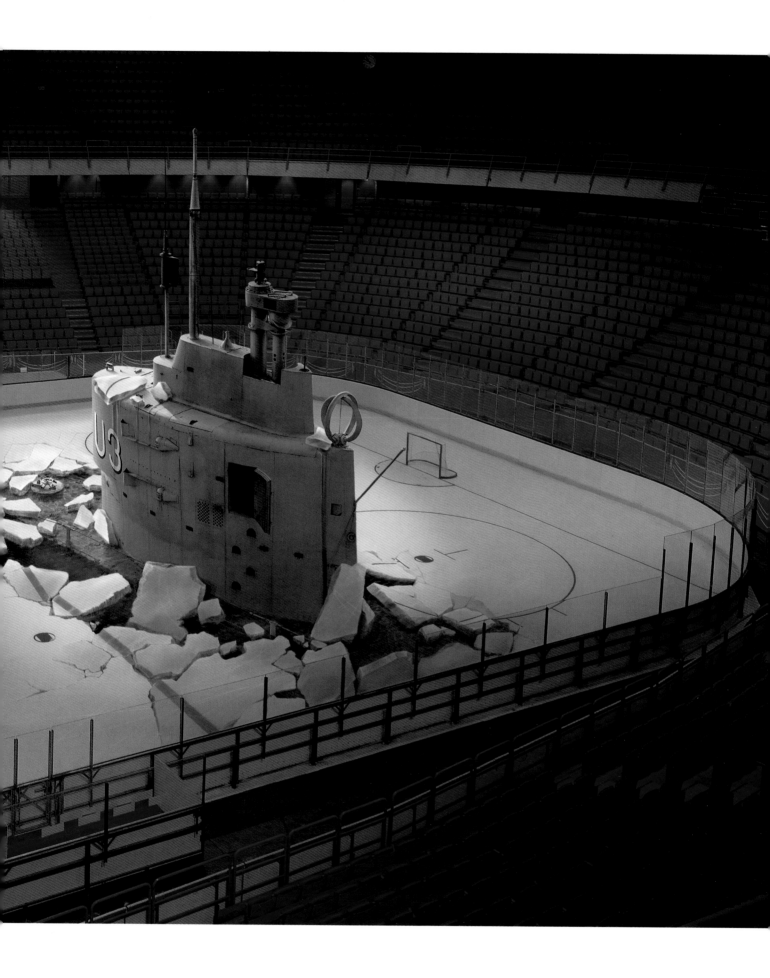

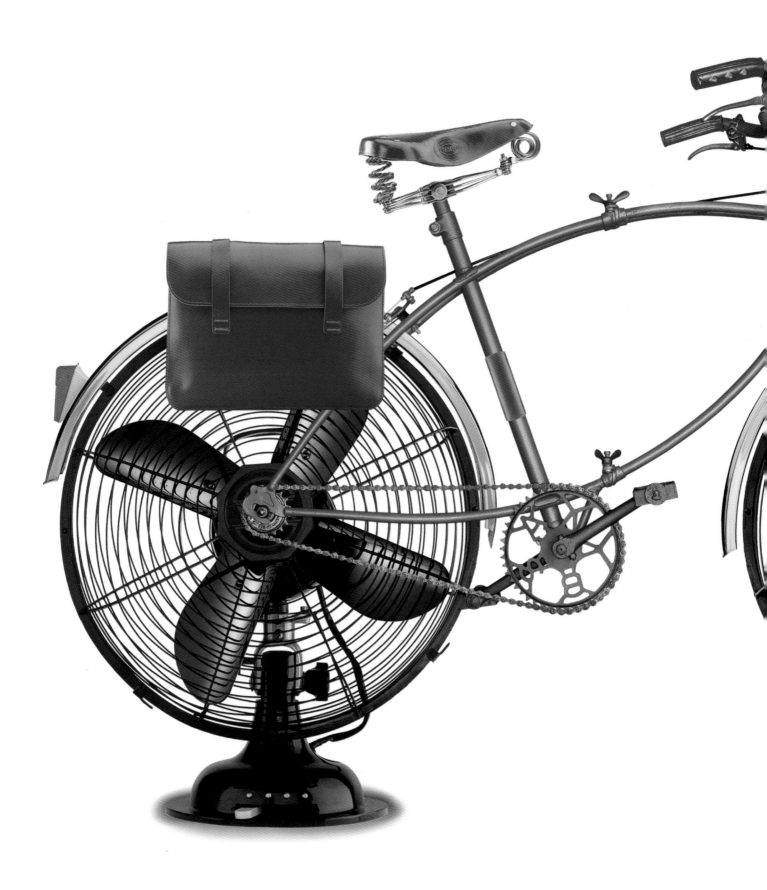

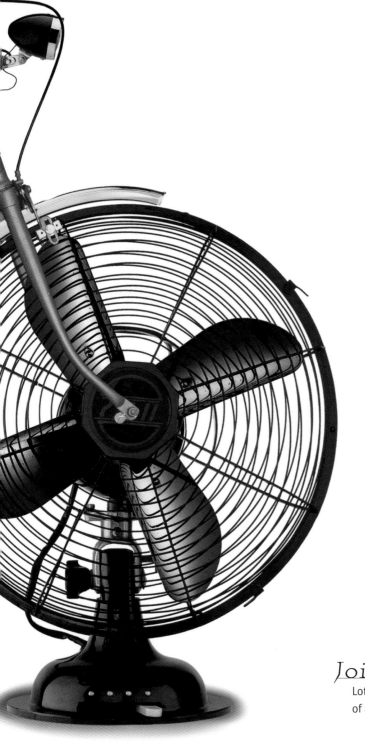

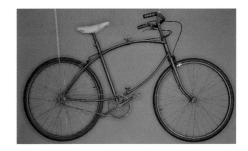

Join the Fan Club!

Lots and lots of details were mounted onto the bicycle here. A typical case of a digital DIY . . .

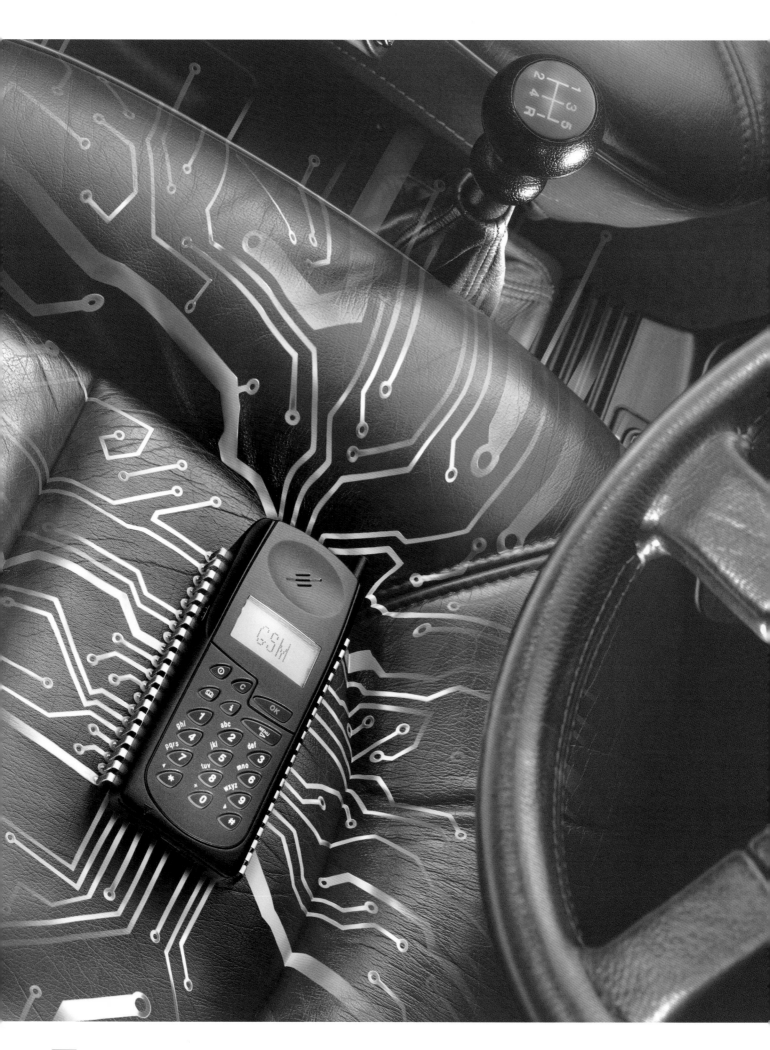

Technology

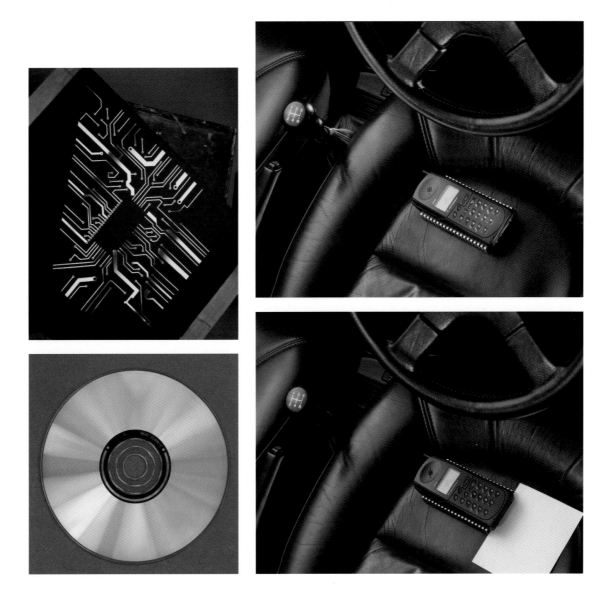

Move Over!

The straight circuits on the PCB had to be shifted, distorted, and fitted to the contours of the seat.
Then the shimmering reflections of a CD surface were laid over the entire picture.

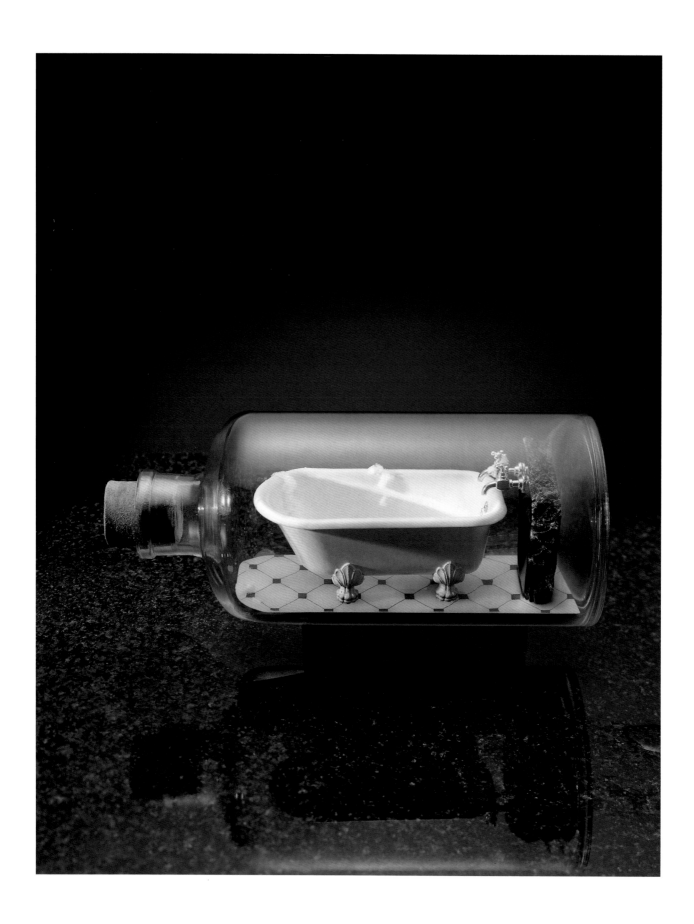

Small is Beautiful.

The latest invention for the business traveller:
a bathtub that fits into any briefcase.

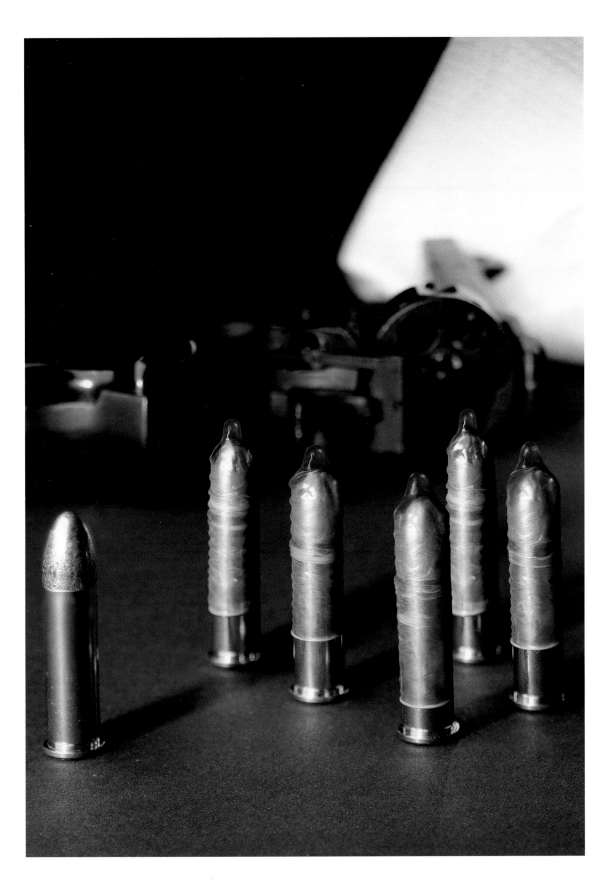

Contraceptive.

A visual experiment interpreting the motto "Make love, not war".

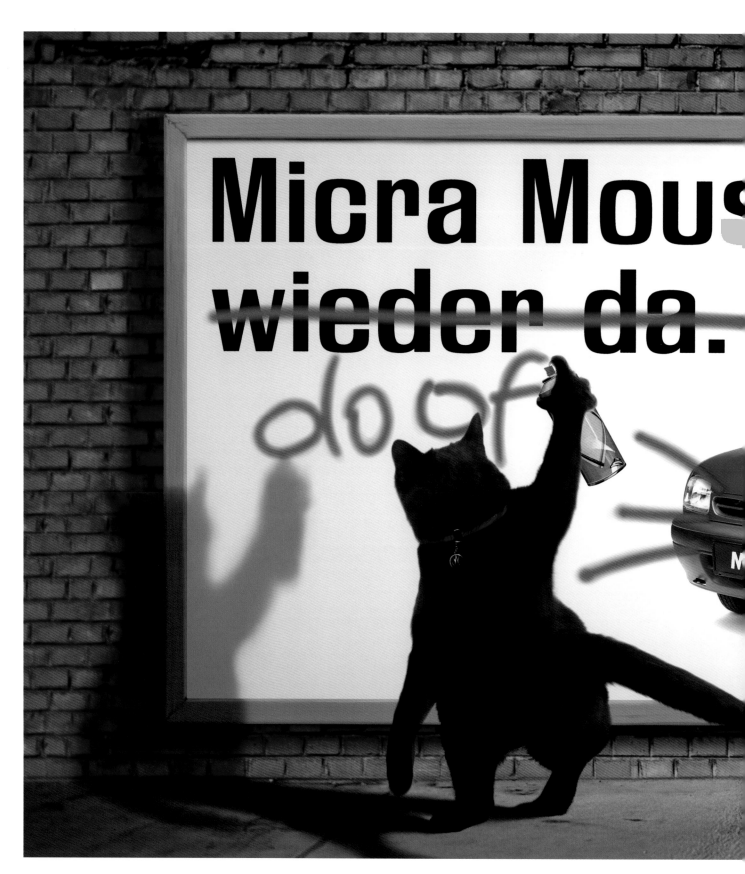

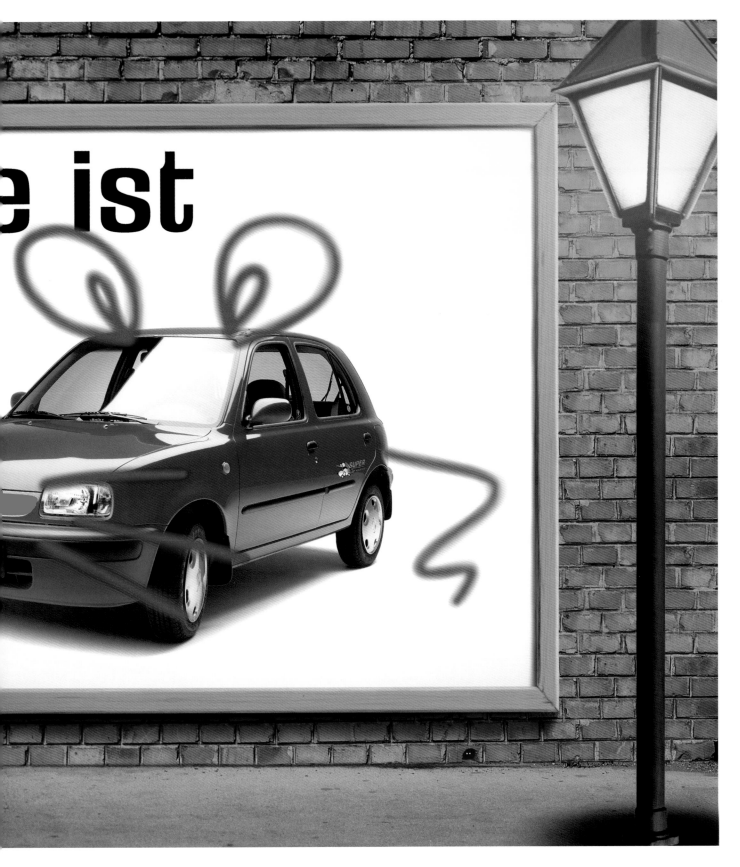

Cat As Cat Can.

This picture demonstrates what one can do with a cat in Paintbox: it was turned around, its head, tail, and legs were rotated and repositioned. A spray can was placed in its paw. Then it was given a dark shadow and placed in a completely illustrated setting. Last, but not least, the tiled background was painted red to contrast with the black cat.

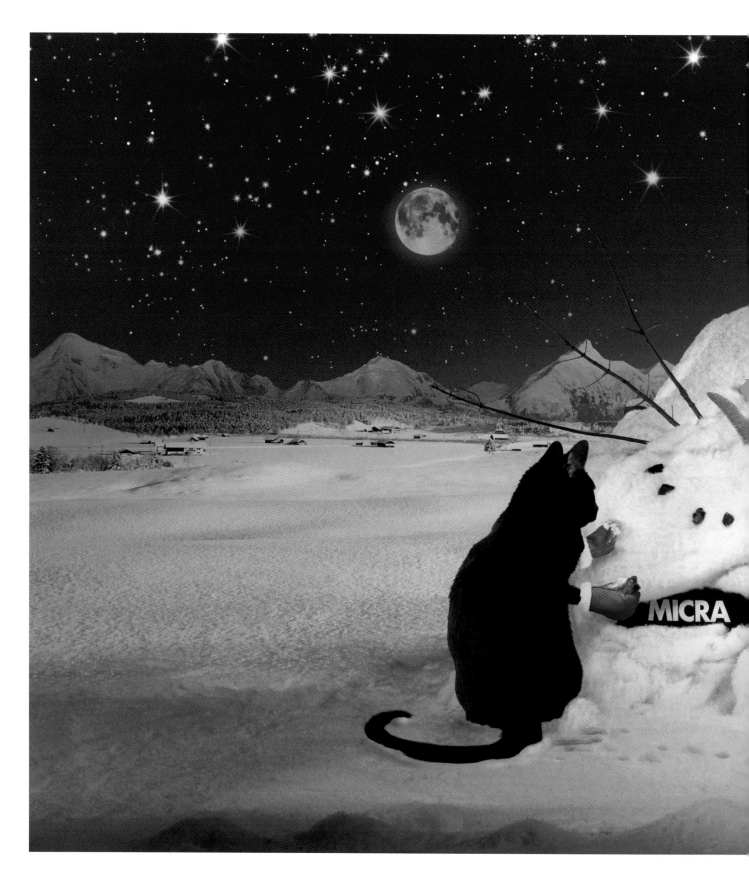

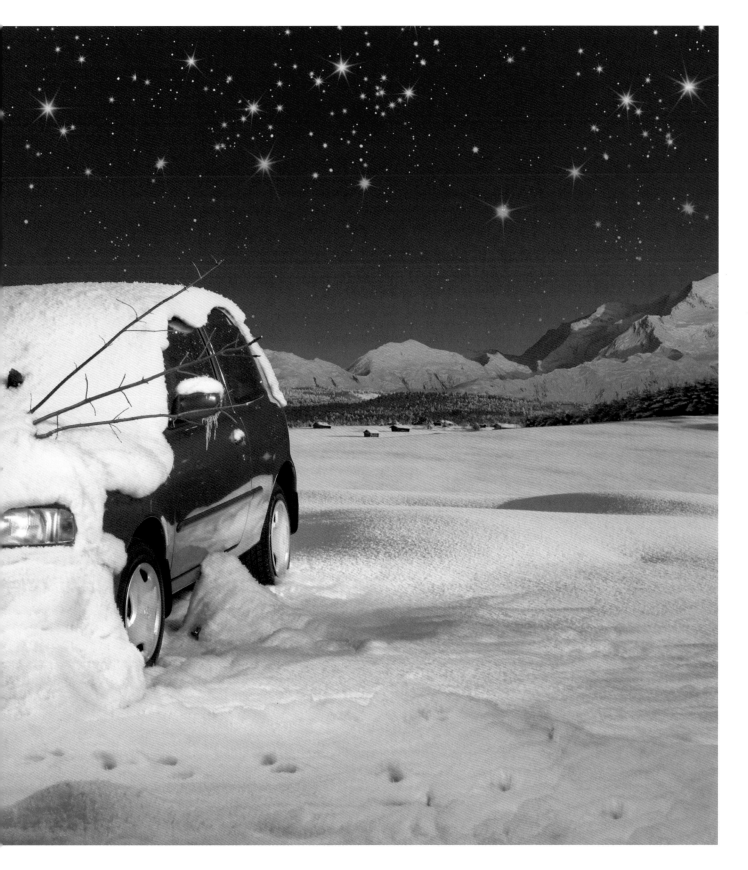

Artificial snow from Paintbox!

It started to snow digitally here, until the cat is seen in the depths of winter.

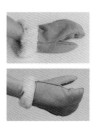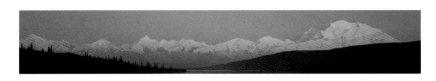

Brush Hour.

This advertisement demonstrates what the new airbrushes in Paintbox 2 can do.

No Sticky Fingers!

Paintbox 2 allows you to "cut & paste" lots of lively pictures next to and over each other, depending on your taste. All without getting sticky fingers . . .

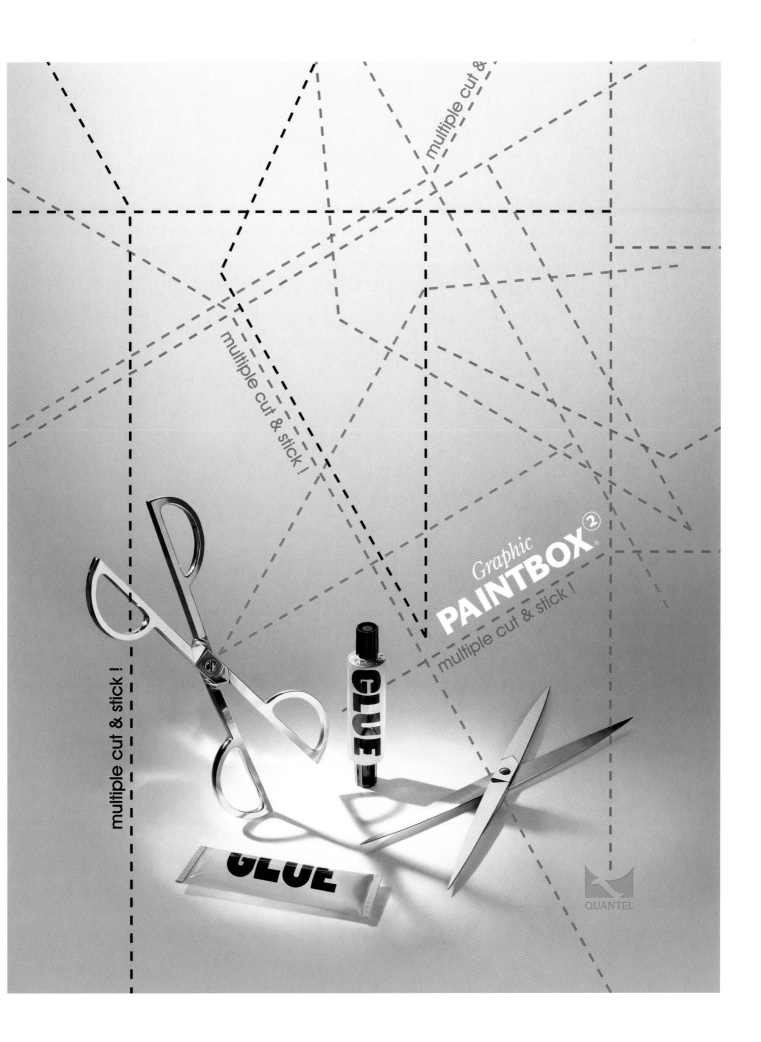

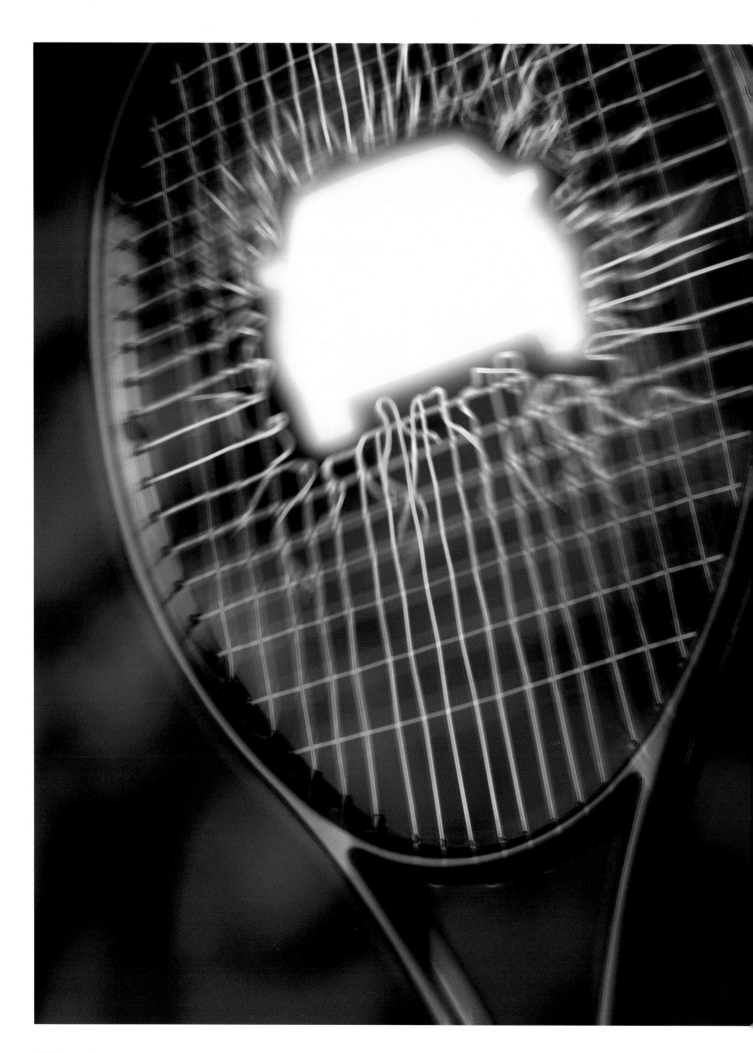

Car Crash Tennis.

After TV stations around the world stopped broadcasting normal tennis in the year 2769 (not spectacular enough!), the World Tennis Association founded the Car Crash Tennis League. This is where real cars are batted back and forth on gigantic playing fields with giant-sized tennis rackets.

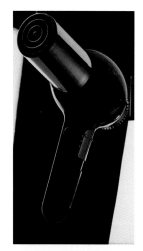

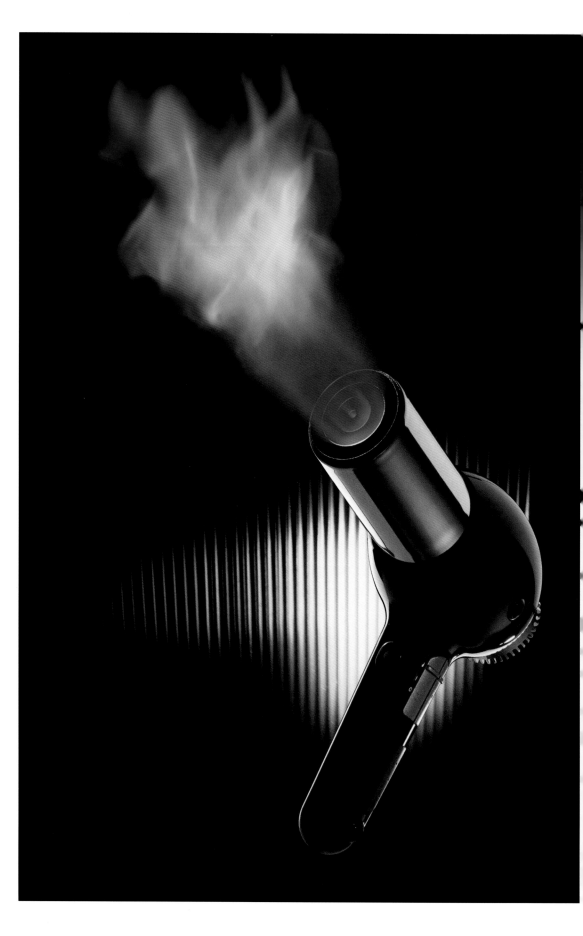

BBQ

The handy alternative for grill parties: the barbecue hair drier.

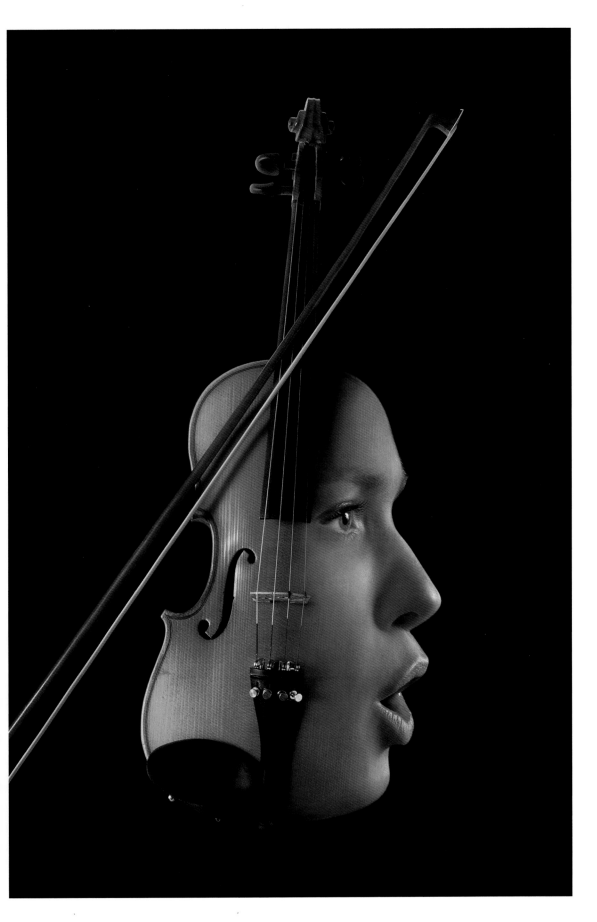

Violins Violated.

Anyone care to argue that famous violins have their own personalities?

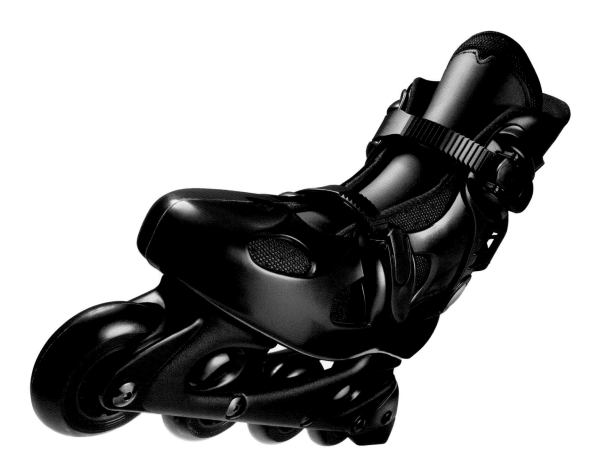

You Can Always Get What You Want . . .

Whatever you want, you can get it with your credit card - or with Paintbox. With the latter you can even transfer a flat pattern to a three-dimensional object, so that it covers that object like a skin. In order to maintain three dimensions during digital processing, the object's lighting effects must be transferred to its new "skin".

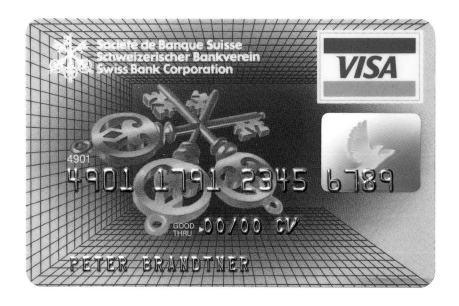

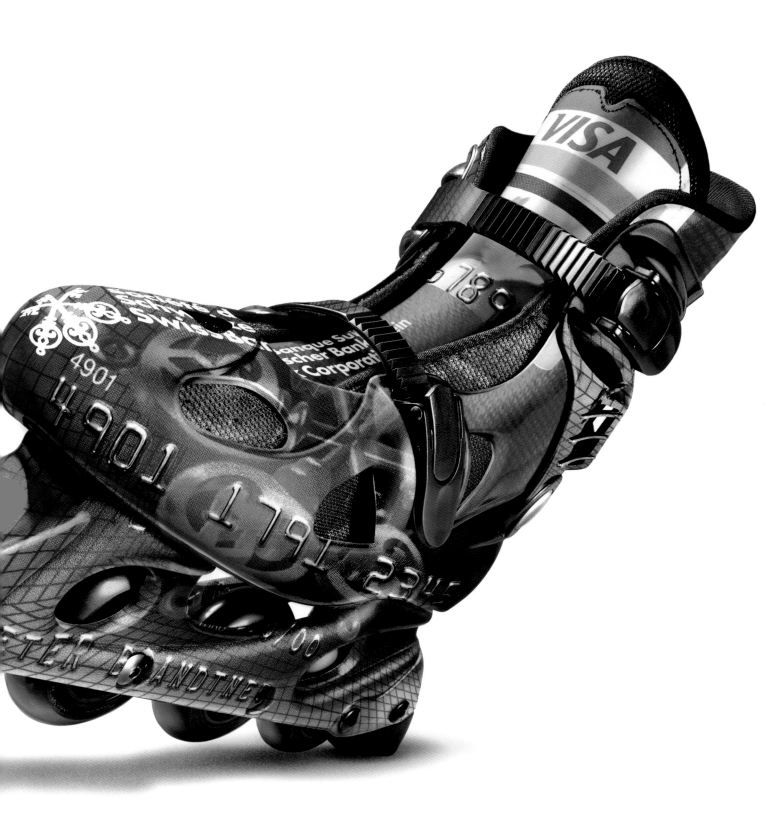

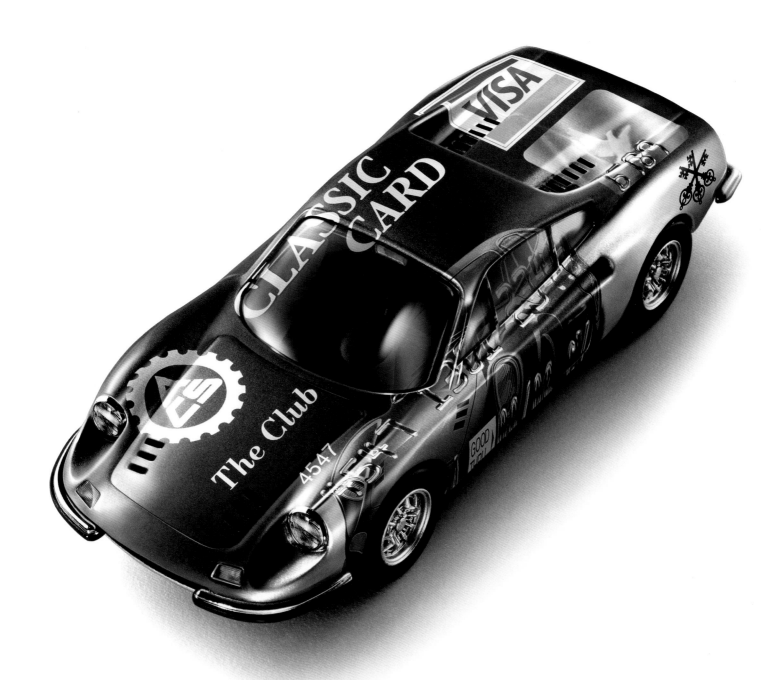

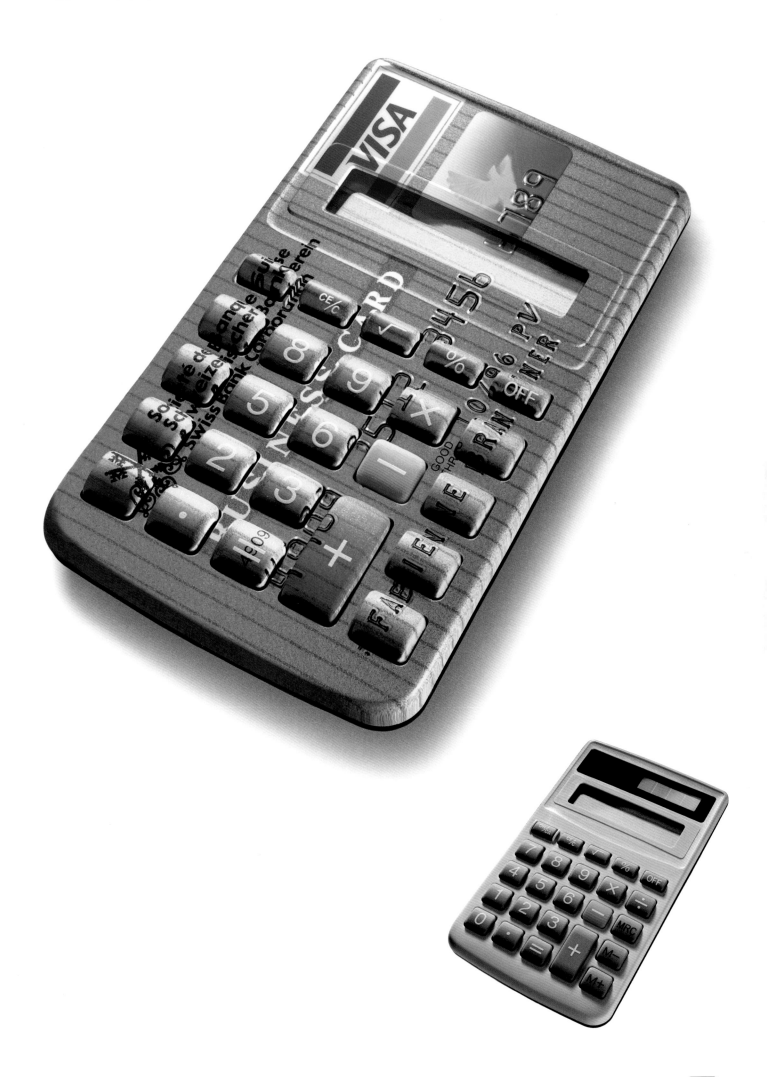

Landscape

Rôti

Year after year, hoards of people start moving, spurred on by a collective imperative let's get the hell out of here!

Hundreds of thousands obey these imaginary marching orders. Together they join forces in their motorised units, and endless columns invade defenceless neighbouring countries. Others flock to join countless airborne divisions, which are transported to distant lands by huge air fleets. There they destroy all the culture and tradition that has taken centuries to develop to maturity.

As soon as they arrive, like termites they fall upon literally everything they find in these foreign countries - cities, villages, beaches, mountains, food drink . . . They tear off (most) of their clothes and roast their unsightly bodies in the sun. Like pieces of meat on a grill, they cook their bodies on the beach. The skin reddens, becomes singed, and finally cracks. And whereas a roast develops a delicious layer of crispy crackling, the body of a tourist merely gets a terrible sunburn.

How sympathetic, on the other hand, we find those who simply stay home and content themselves with travelling by PC to virtual worlds and digital landscapes . . .

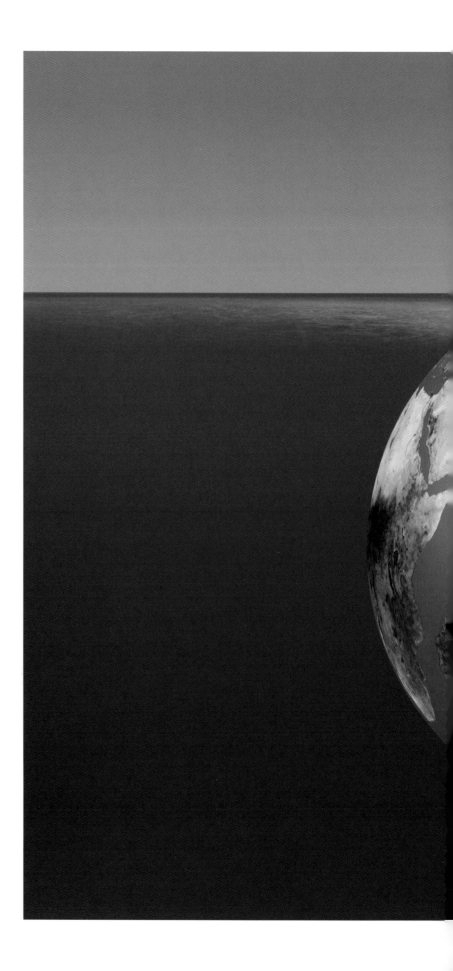

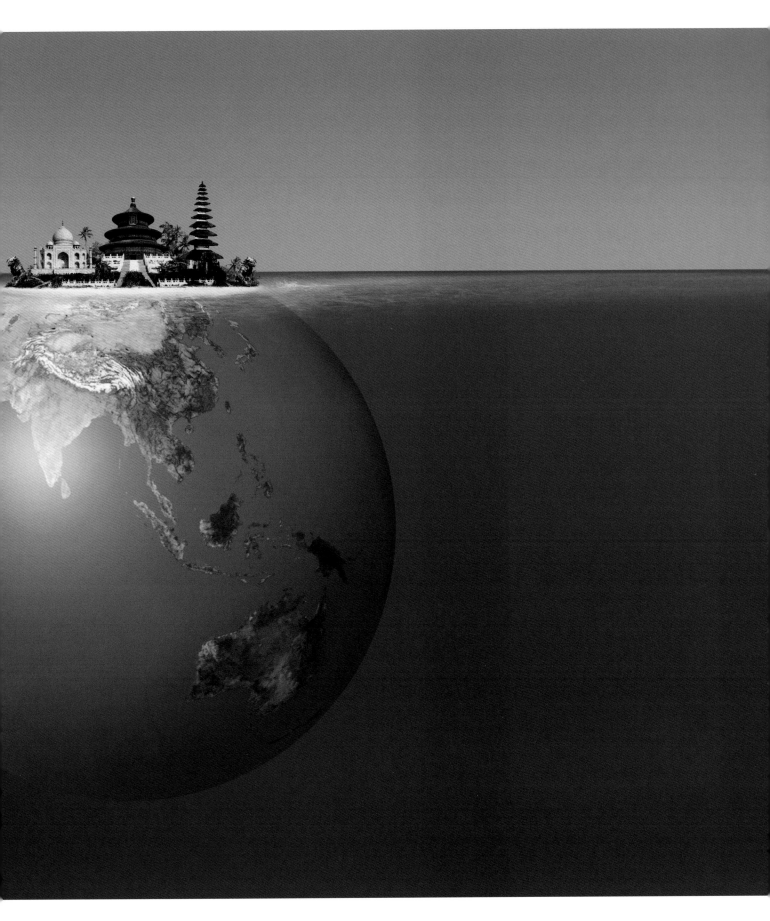

Culture Club.

We all dream about it: taking the fascinating pieces of the existing world, and refashioning them into a new, uniform whole . . .

This is exactly what was done here. A beautiful sea with a shimmering surface was then added. Finally clever lighting effects were created.

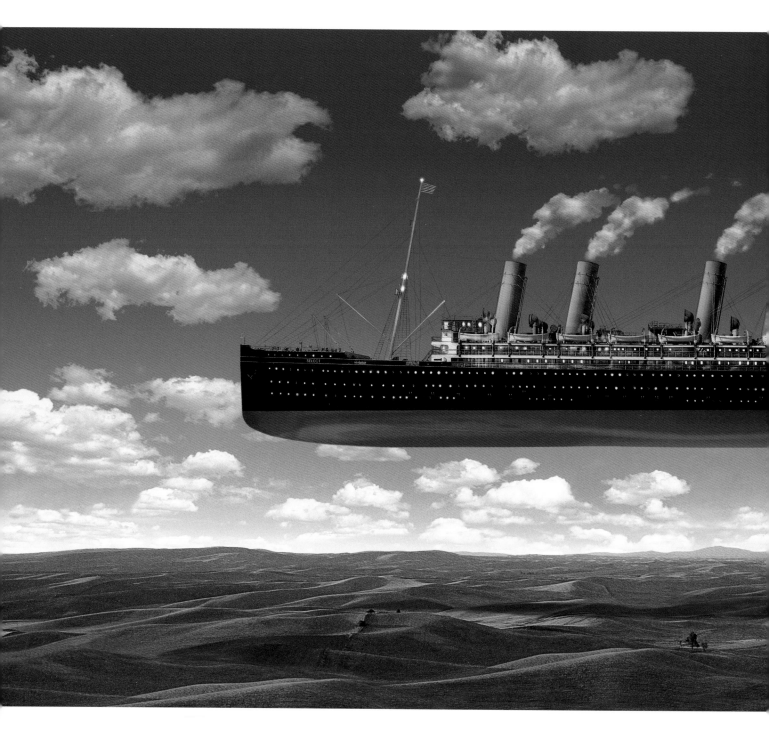

Landscape

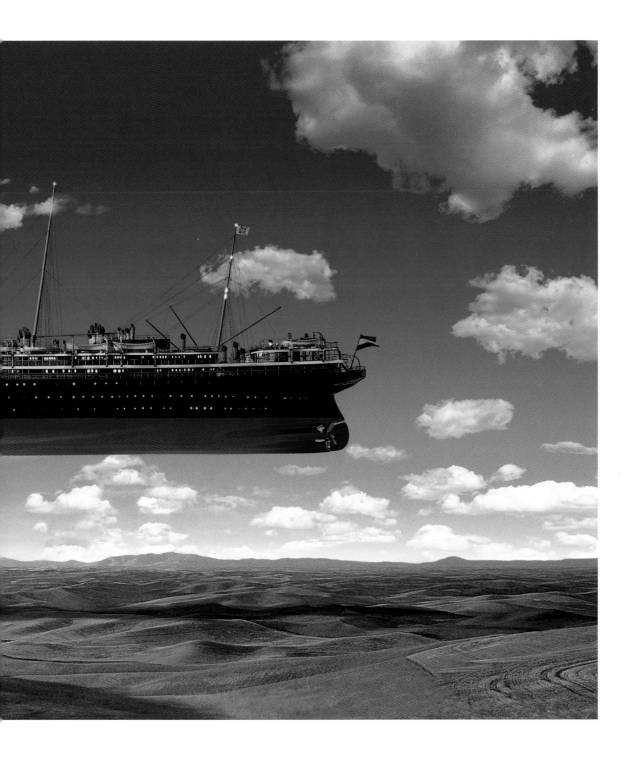

Riders in the Skies.

A series of striking images that took a great deal of time and effort to prepare. To begin with, the artist carefully researched which images went well together. It was important to use a variety of different landscapes and moods. The pictures were then made into a collage and digitally processed. In order to achieve an "open air feeling", all the objects were given a light blue shadow (such as one sees in all photos taken outdoors. . .).

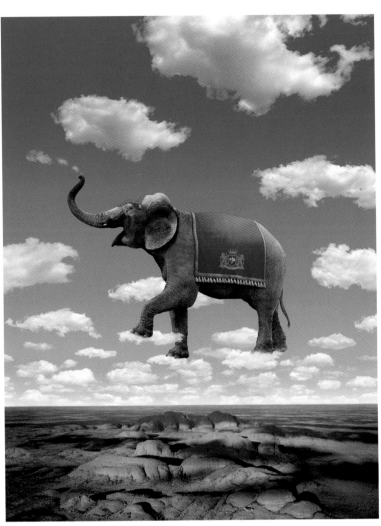

Landscape

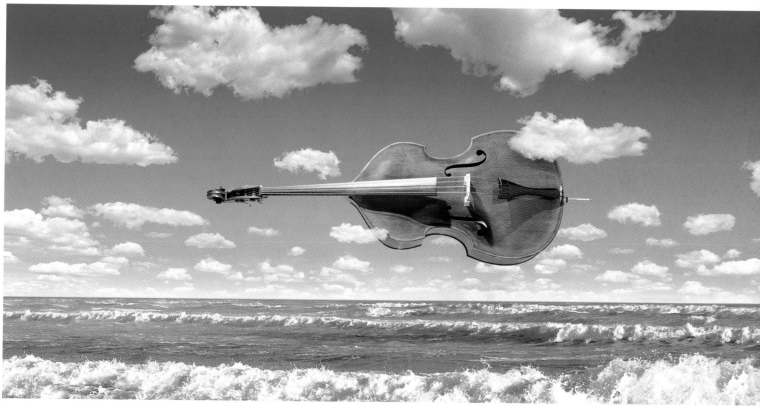

Corporate Identity.

This is a series of perfect examples showing how a visual trademark or logo can be digitally integrated into the most diverse of images. A host of elements were changed in the process, such as the perspective, lighting effects, depth of focus, and the image components themselves.

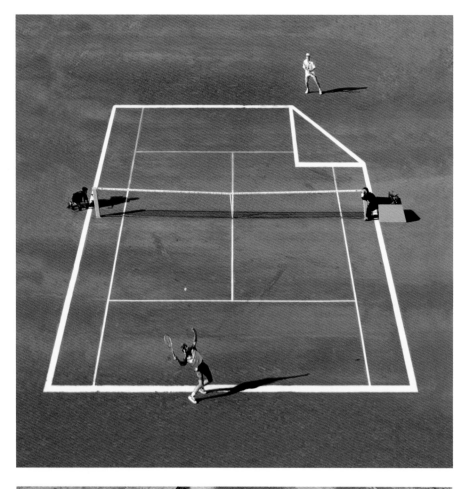

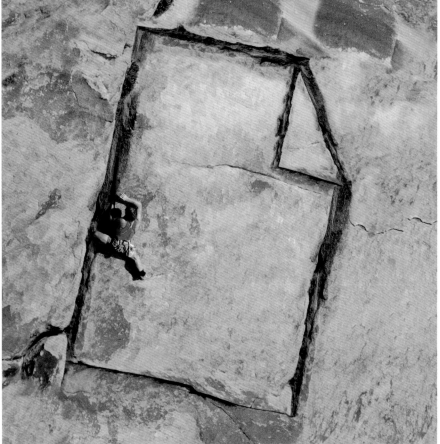

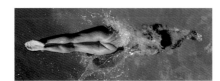

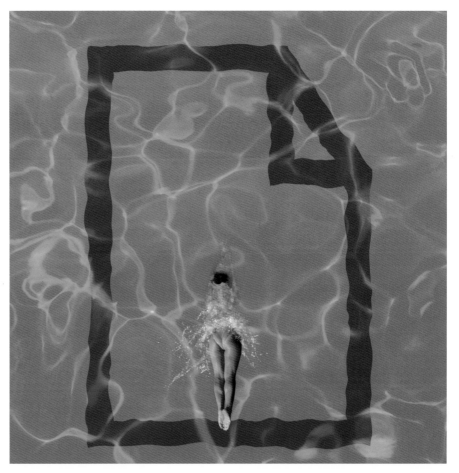

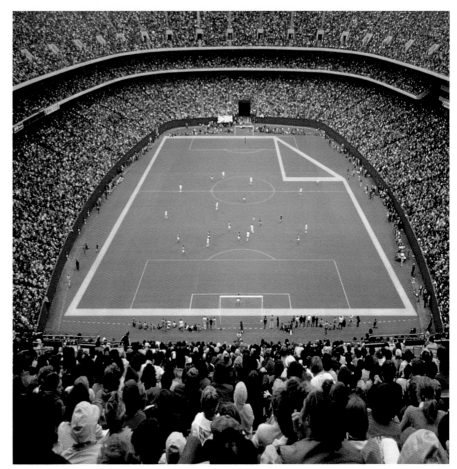

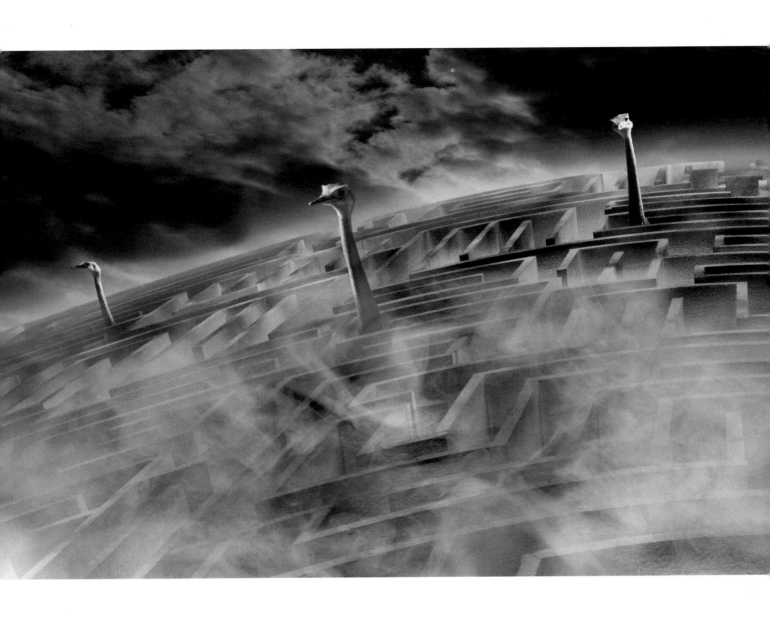

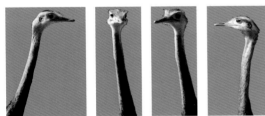

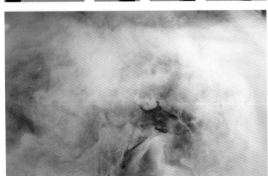

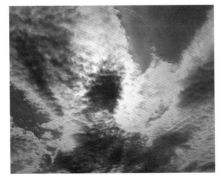

Enigmatic Park.

This mysterious world was created by an illustrator from simple individual photographs. A convincing example of the creative possibilities of digital image processing.

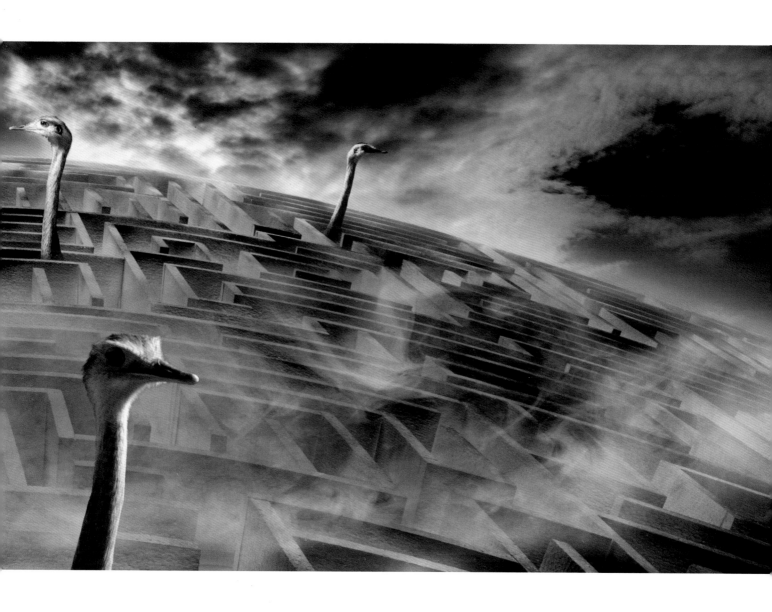

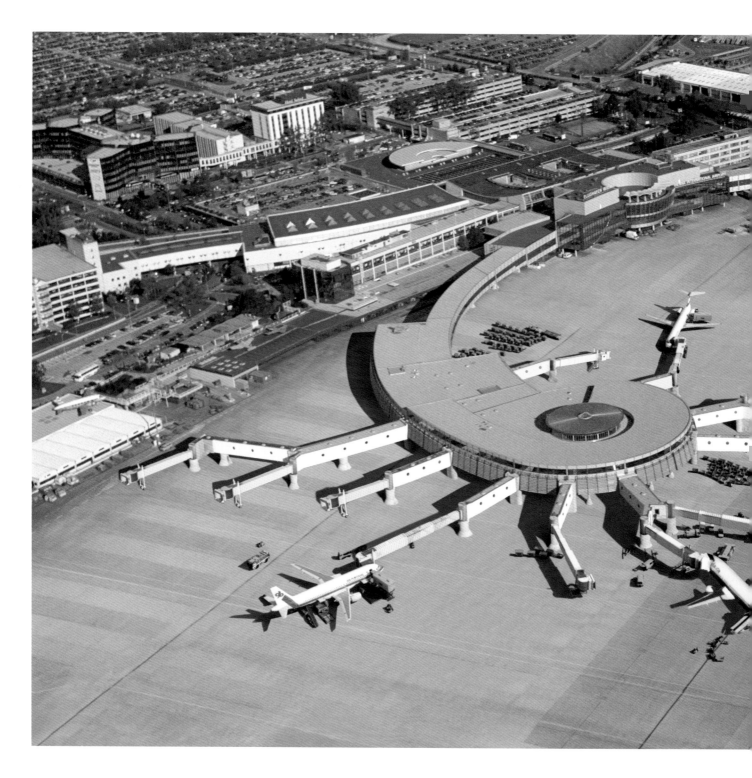

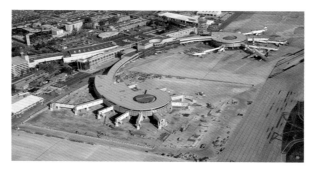

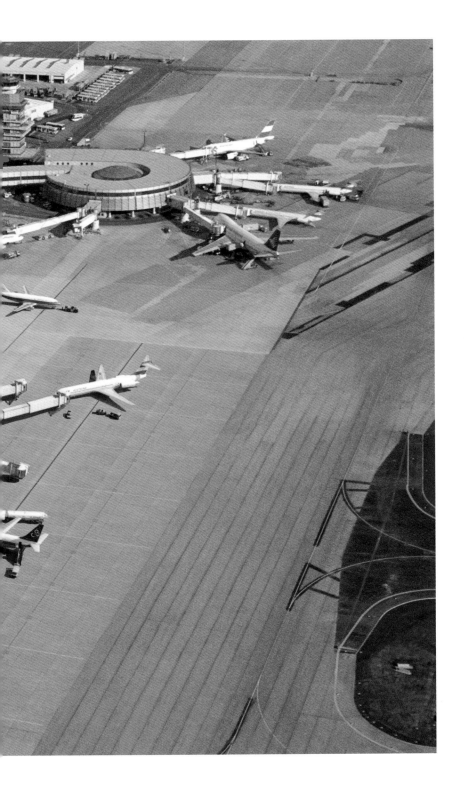

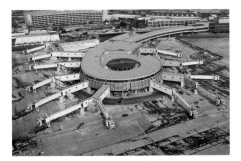

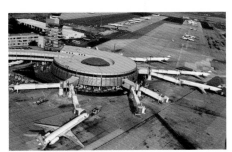

Returning to the Future.

You are about to take a virtual flight to the future. Here, the unfinished terminal at Vienna airport was digitally completed and imbued with "real" airport operations - aeroplanes, carts, service vehicles, luggage, passengers, etc. The three-dimensional effect was achieved by applying light and shade.

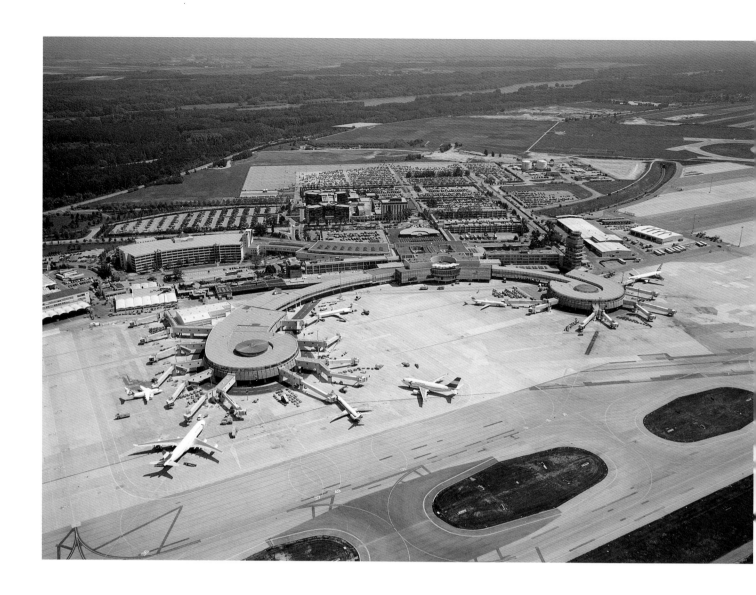

What a Night!

It takes more than an aerial photograph to portray the glittering world of an airport at night. One can see the missing contrast in the small night picture. In order to achieve a perfect nightscape, the daytime photos were darkened. Then the twinkling lights of the same airport at night were inserted.

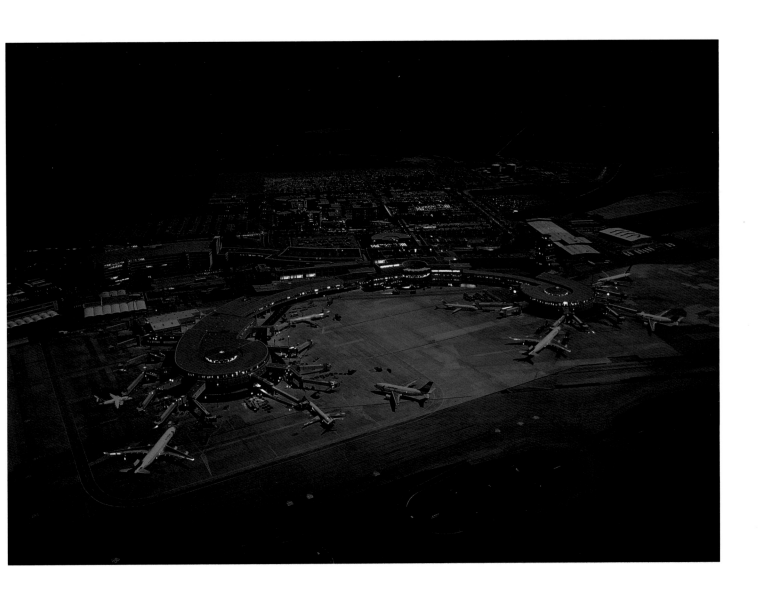

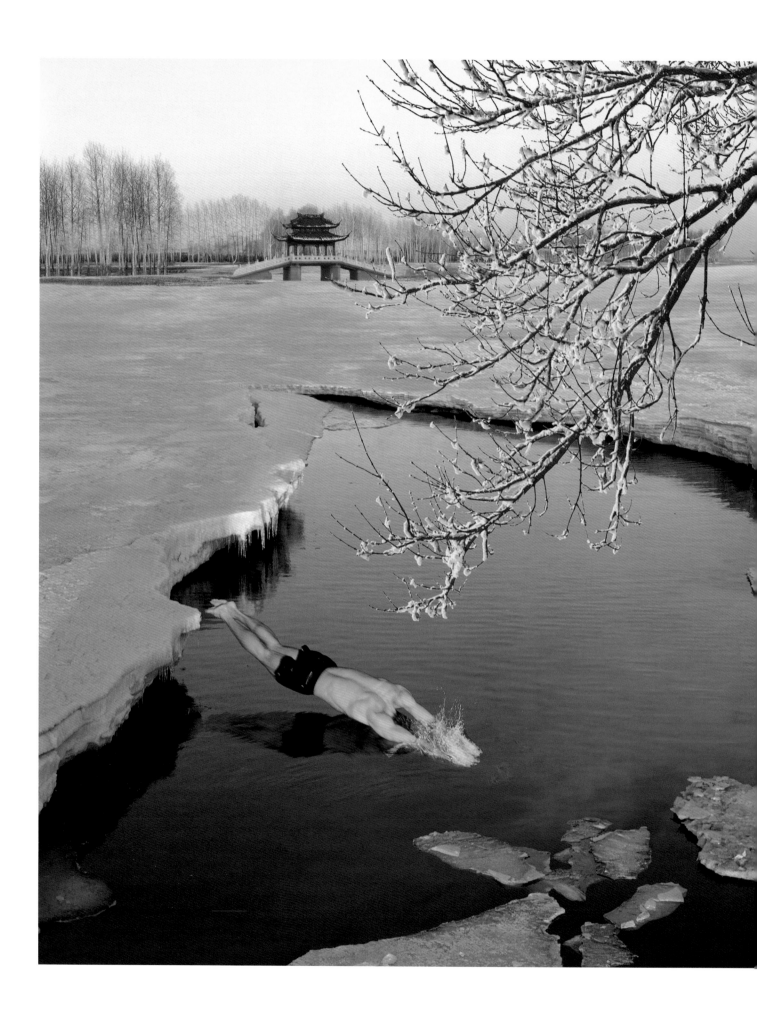

Catch a Cold!

The cool brilliance of this picture reminds one of the paintings of the old masters. This, too, required a huge amount of strokes, but with an electronic airbrush. The reflection in the water, as well as the big splash, are excellent illustrations.

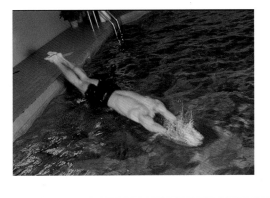

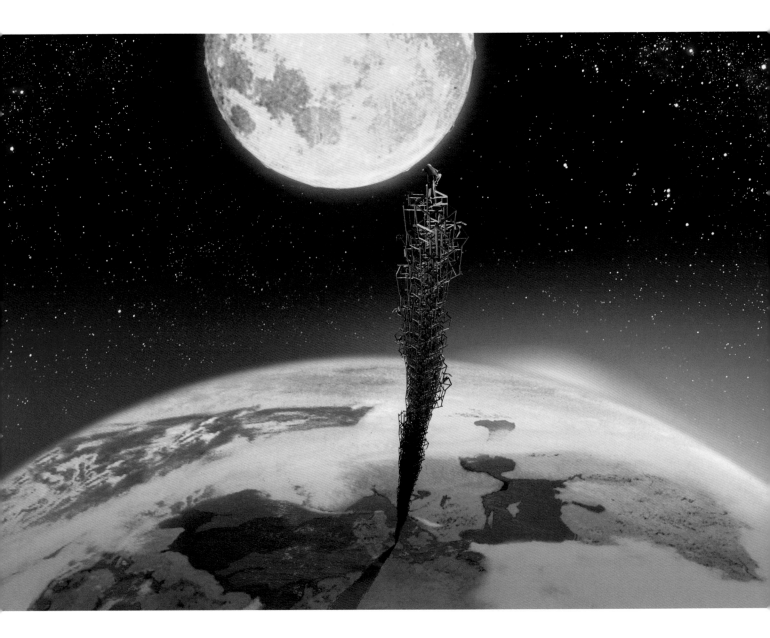

Charity!

The megaproject „Charity to the Moon" was called into being in the 22nd century when everybody had had enough of charity golf and tennis tournaments. Suddenly donations started flowing like water, for millions of people wanted to take part in the construction of a gigantic chairway to the moon by purchasing a chair. However, nobody had any idea which worthy cause the donations were to be used for . . .

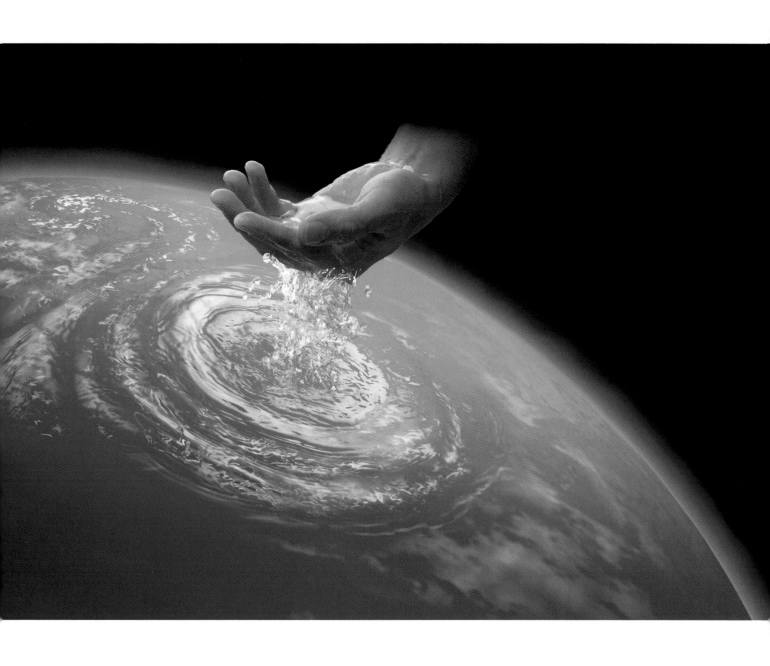

What Jonathan Swift never told us . . .

That the giant Gulliver became so thirsty on one of his journeys that he drank the entire world of Lilliput at a single gulp!

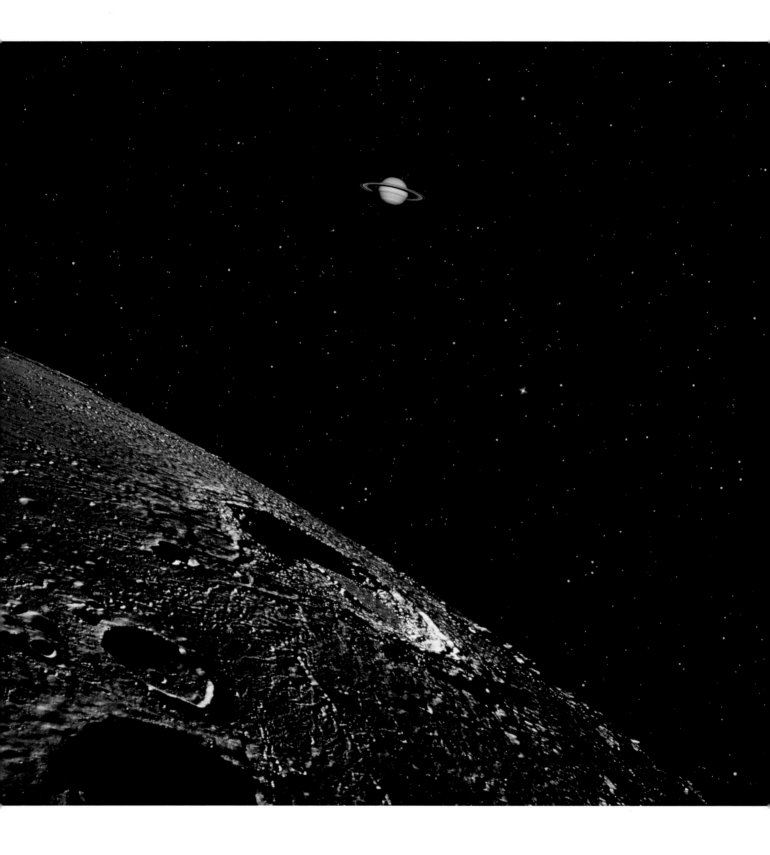

Galileo's Mistake.

Galileo was wrong and here you can see why: the earth is actually a disk!

Note to the reader:

Next time you go on a world cruise, be careful not to fall of the edge of the earth into the void!!!

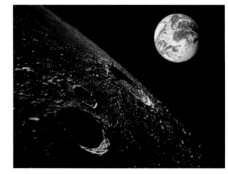

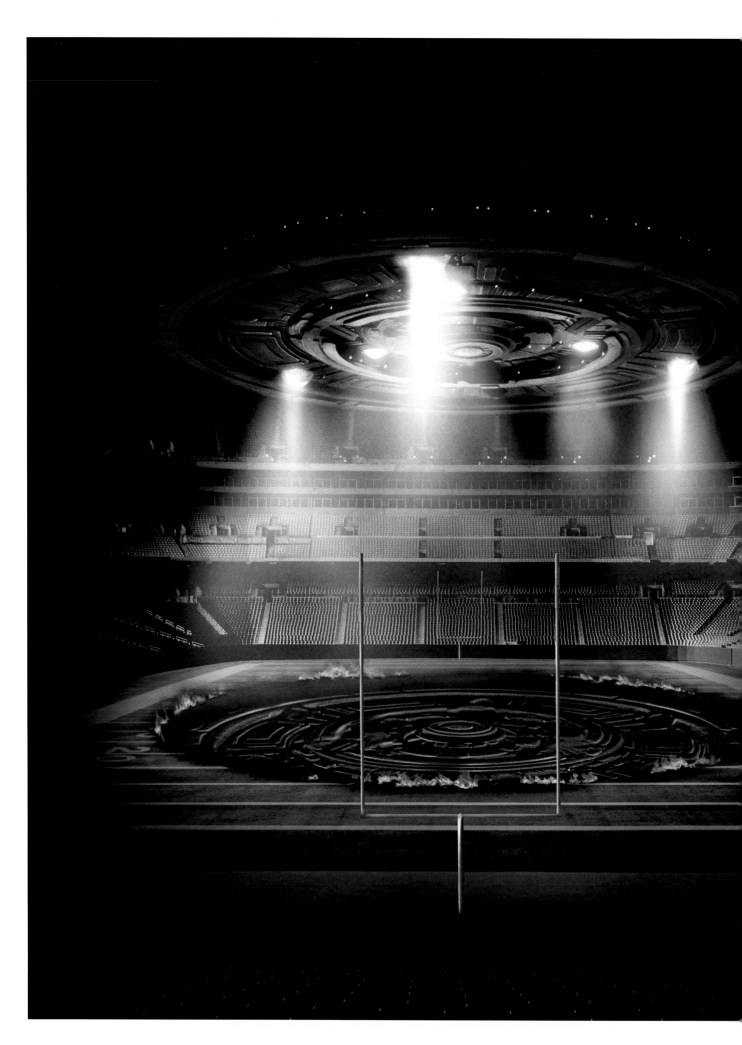

Independence Day.

Hollywood is not always to blame when aliens threaten the earth . . . Aliens also come out of Paintbox. This fact has yet to be dealt with in the X-Files! The contours and depth of focus of the UFO imprint in the playing field are impressive here, as are the frighteningly beautiful effects of light and shadow.

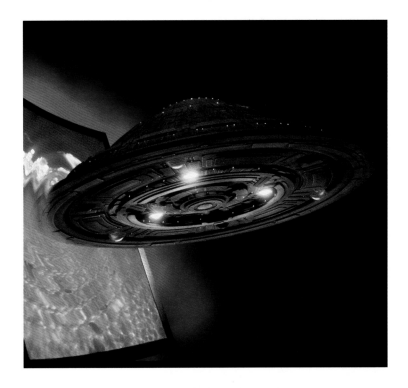

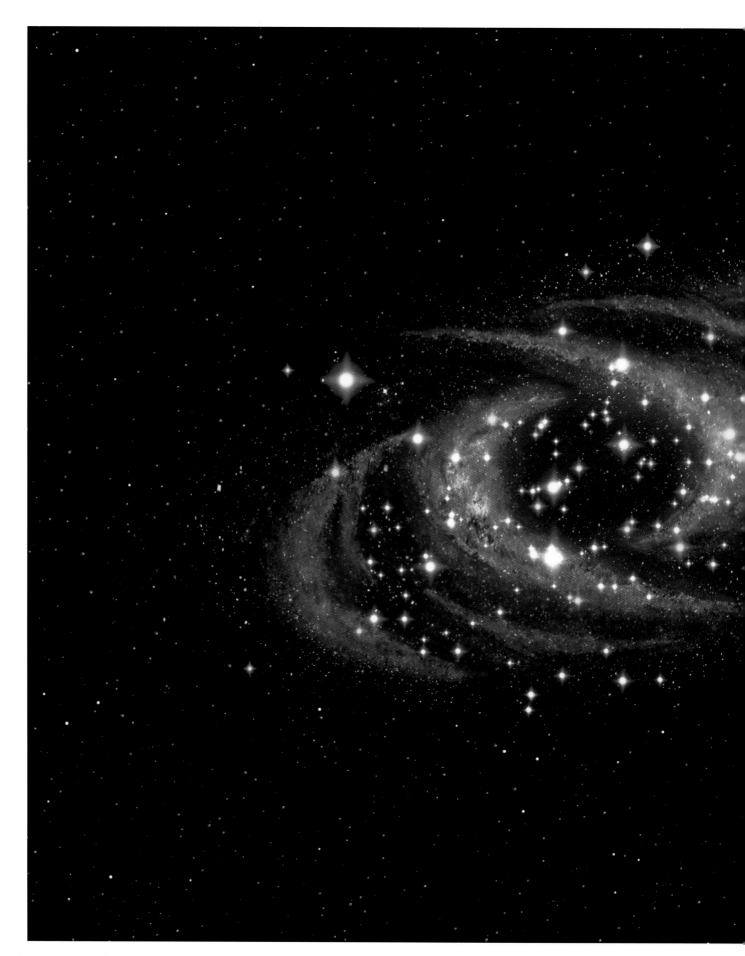

Lost in Space.

The artist almost lost himself in time and space with this work. It took a lot of work to make the logo look like a galaxy, and until it could be recognised as such. By the way, the logo belongs to an energy utility.

A Fairy Tale.

"All alone, Little Red Riding Hood ventured into the deep Forest of Cellular Phones..."

That's how the fairy tale could begin in the 23rd century. Whether you find this menacing or humorous is up to you. The fact is, not even the creator of this picture knows how many cell phones are depicted here!

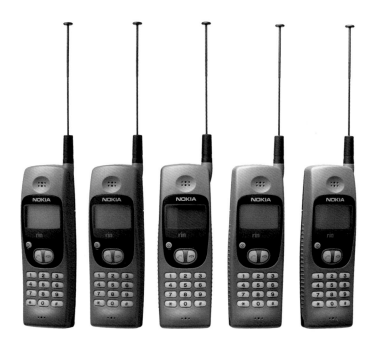

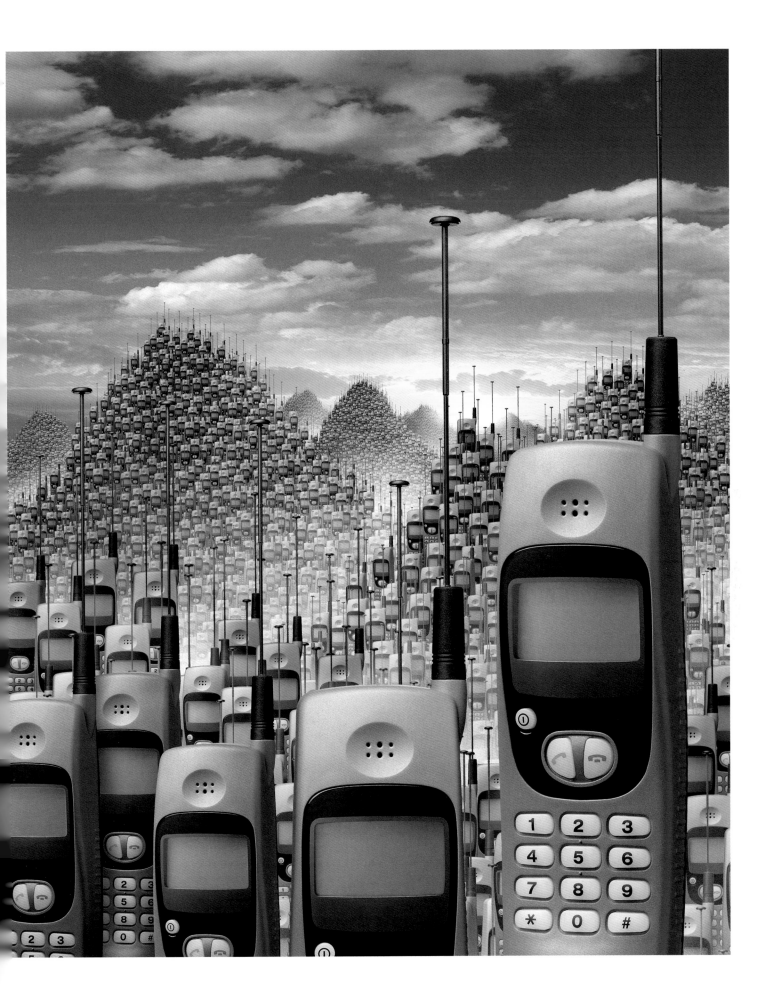

Imagine . . .

If an investor or contractor lacks imagination, some skilfull
electronic retouching can put things right.

Scottish Graffiti.

Here's how an old house can be made brand new again: by carefully painting over the facade. The only difficulty is that pattern has to be "bent" around each protrusion in the wall.

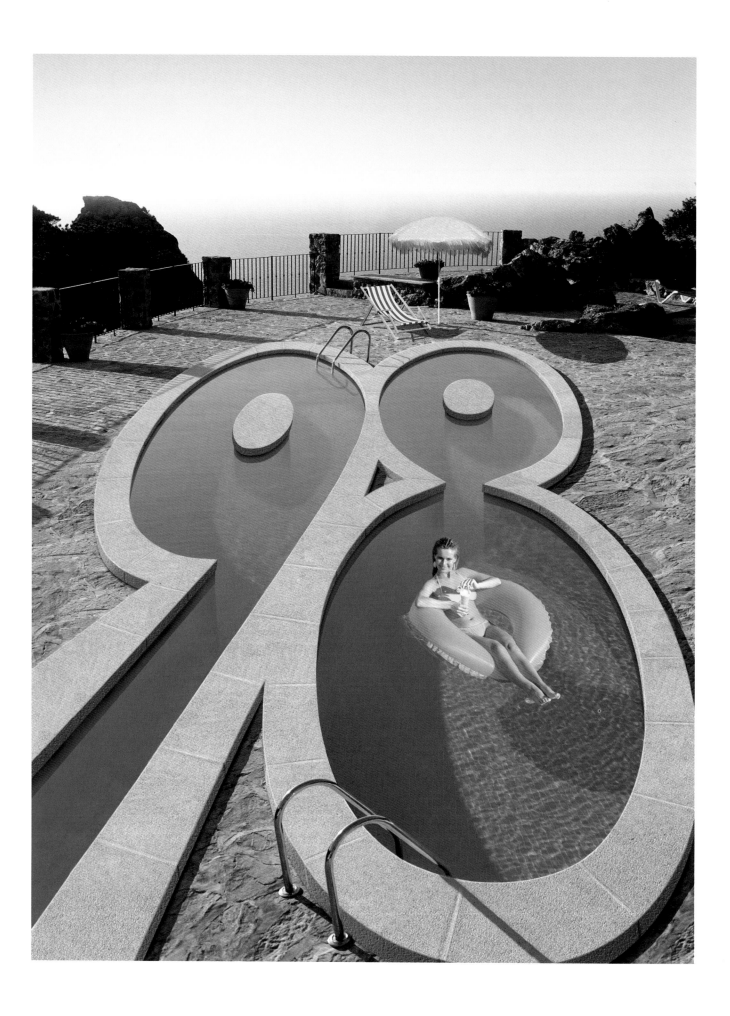

Swimming Pool of the Year.

After "Man of the Year", "Car of the Year", Centrefold of the Year", etc., here you can
see the "Swimming Pool of the Year".

Let's Get Stoned!

Everyone should have themselves immortalised in stone. You, me, my Tamagotchi, and of course, your favourite comic book hero . . .

The interesting thing about this work is that one needs a lot of material from the stone's structure to be able to create the digital facial features and shapes.

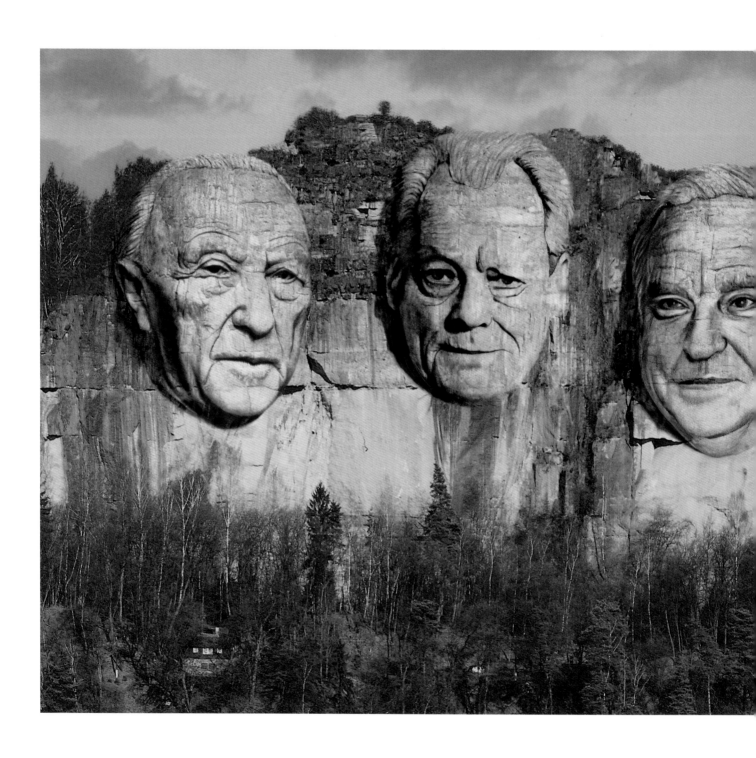

Where the Hell is Bismarck?

This German Mount Rushmore shows Chancellors Konrad Adenauer, Willy Brandt, and Helmut Kohl. But somehow the trio seems incomplete . . .

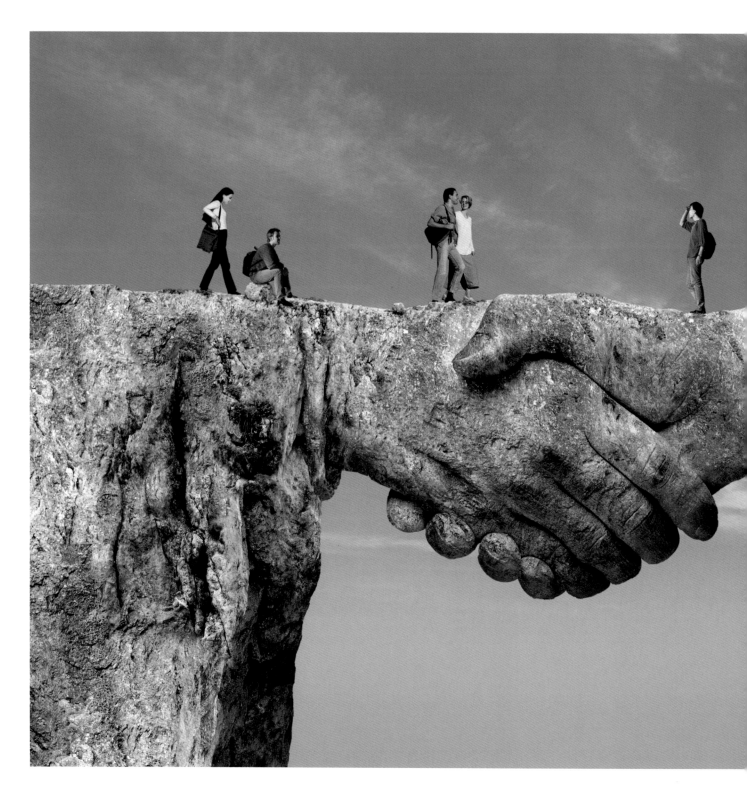

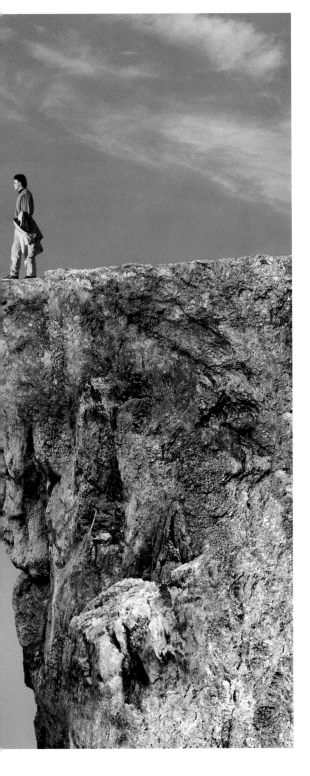

Rock Solid.

To complete such a realistic stone sculpture in Paintbox requires careful preparation. For example, the hands were coated with a clay paste before being photographed so that they would already have a rough, cracked surface in the photograph. Extensive material on stone and rock structures had also to be collected. The people were then photographed in the correct perspective (in side profile). Only then could the digital collage of all these elements be started.

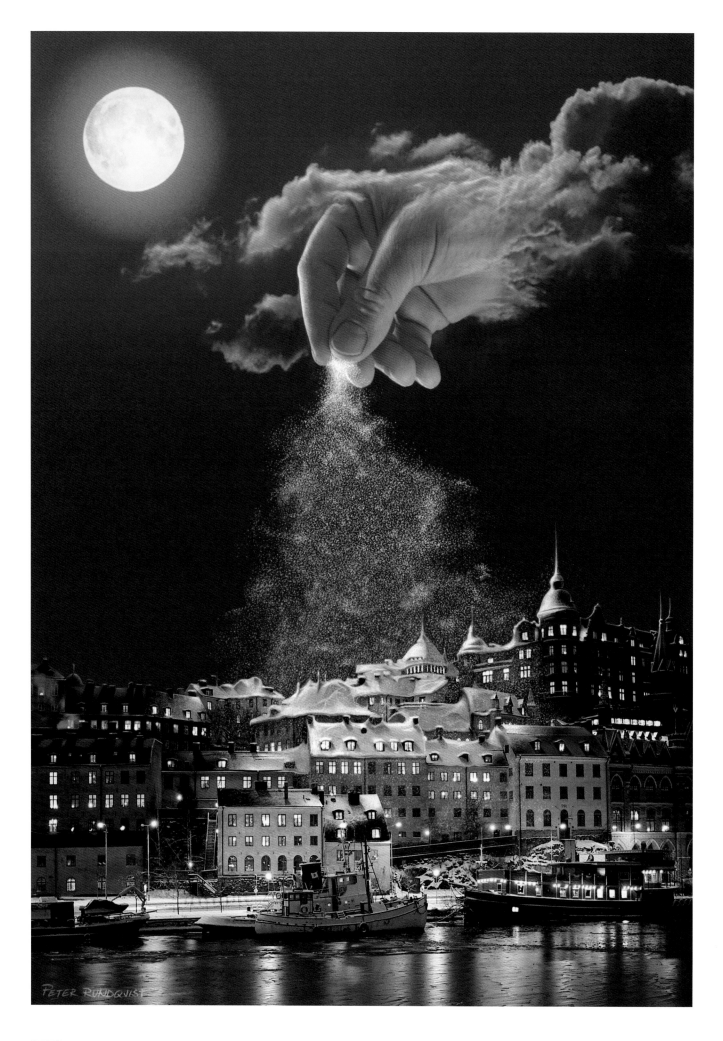

It's Cool Man!

Truly cool, the way the illustrator has made it snow here, and the way the snow realistically collects on the roofs. A true winter wonderland . . .

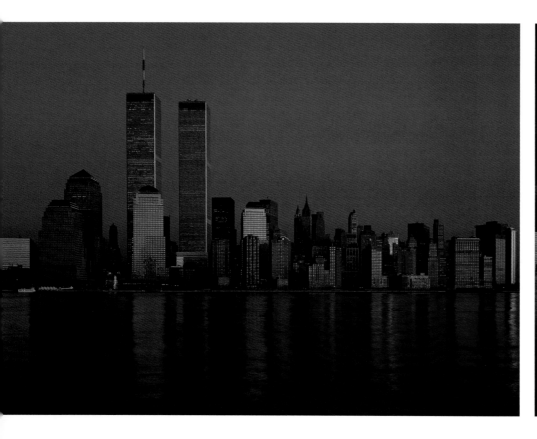
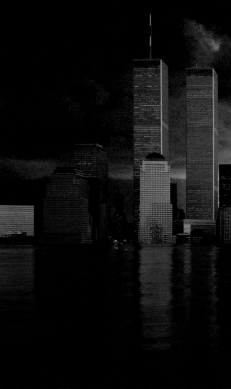

Very Flashy . . .

Here you see a digital storm breaking over New York City. On the next page you can see just how much it devastated the city.

Incidentally, the reflections in the water have to be considered at each individual stage of the destruction.

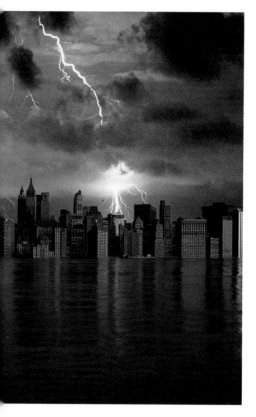
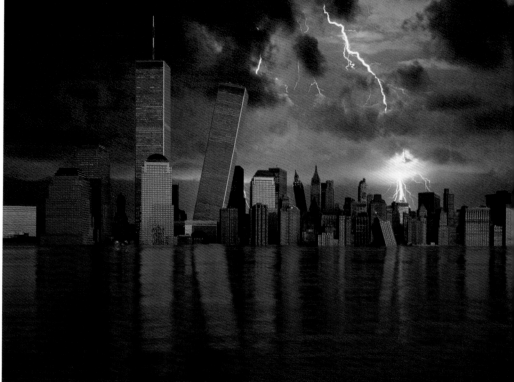

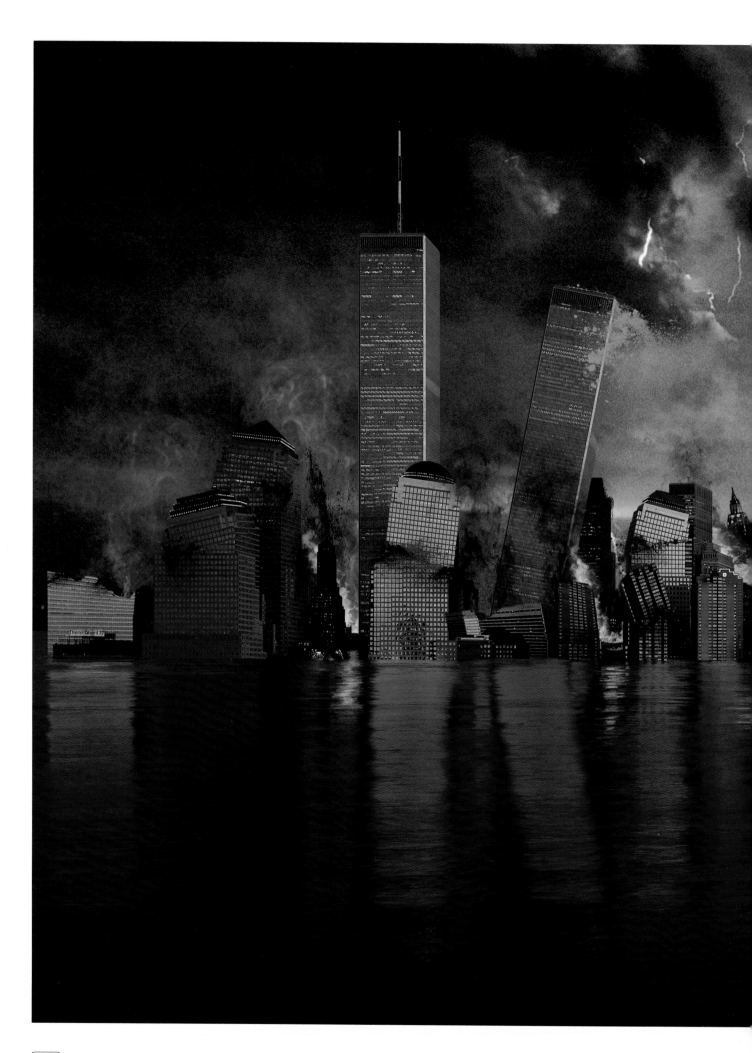

Landscape

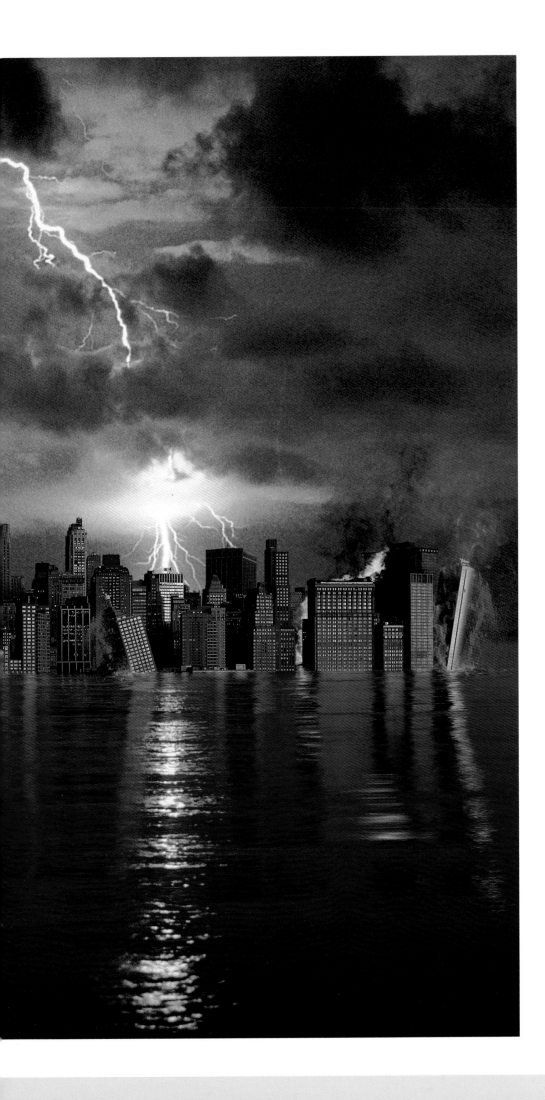

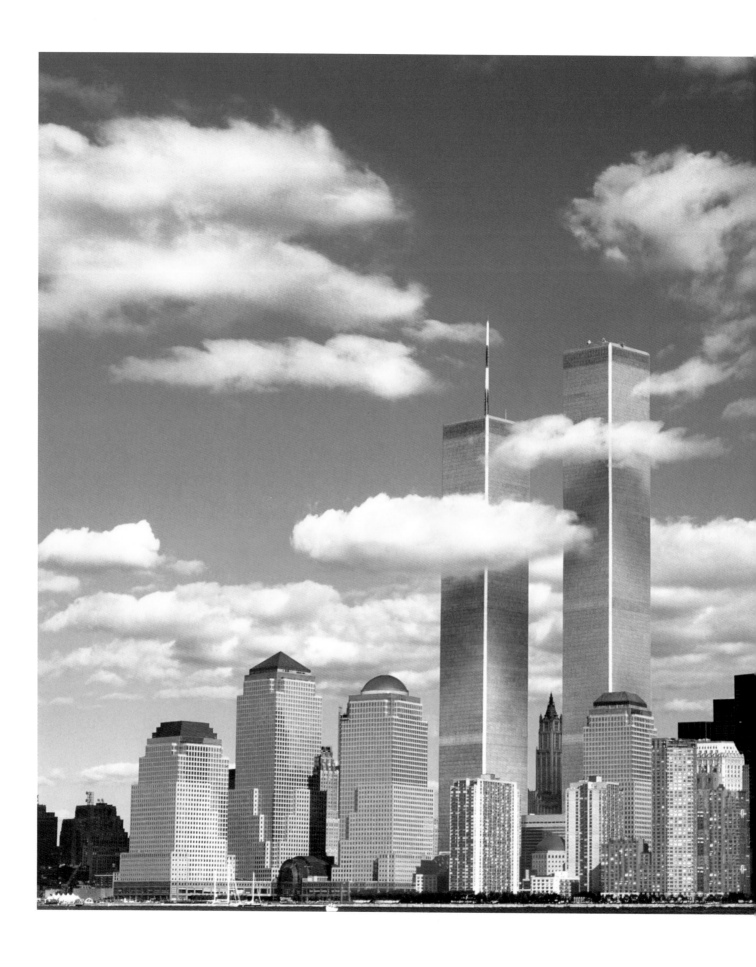

Landscape

Larger than Life.

Anyone suffering from delusions of grandeur should treat themselves to a Paintbox. With Paintbox you can have the skyscrapers grow to the sky, or transform your real-life portrait into your dream likeness (didn't you always want to be 2.20 metres tall with biceps like Conan the Barbarian?).

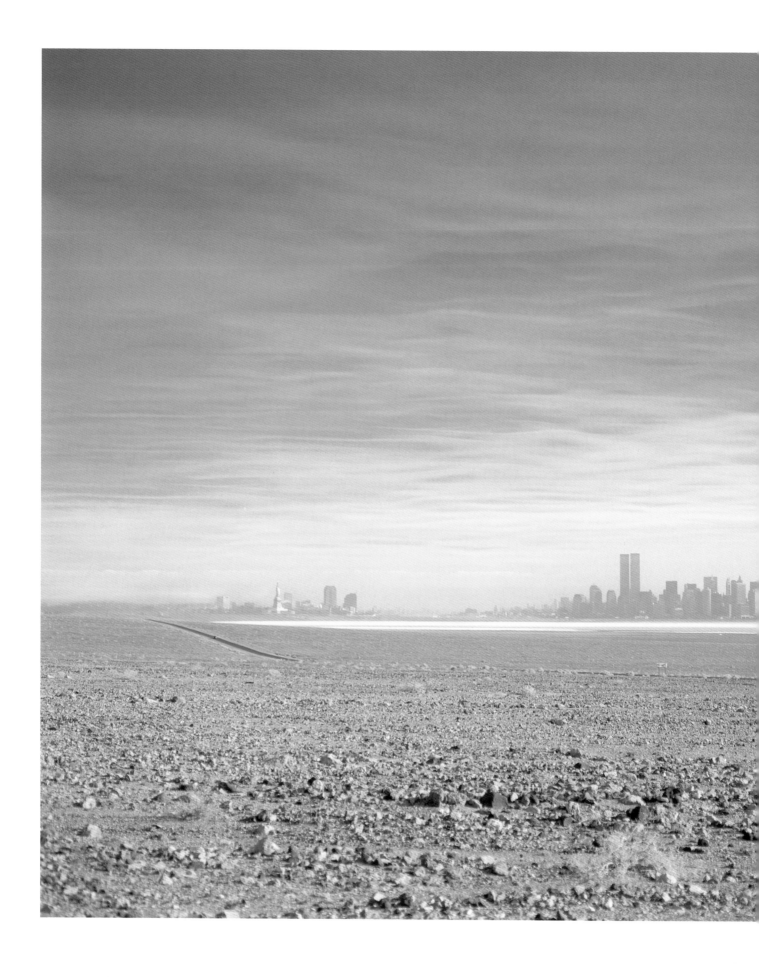

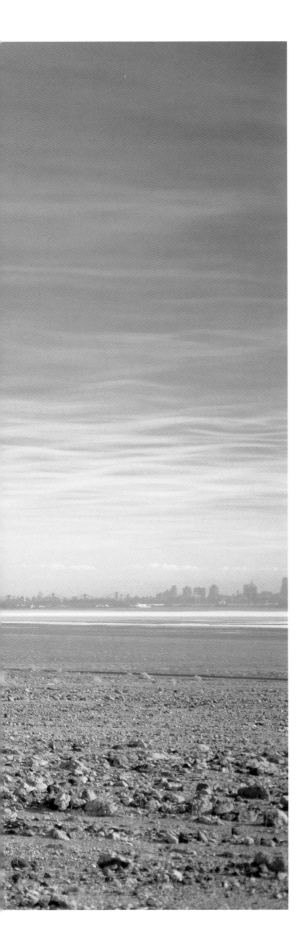

Summer in the City.

A picture for the cold season: imagine it becoming so hot that the Atlantic Ocean evaporates in front of New York City . . .

However, if it is already summer where you are, you should just turn the page post-haste . . .

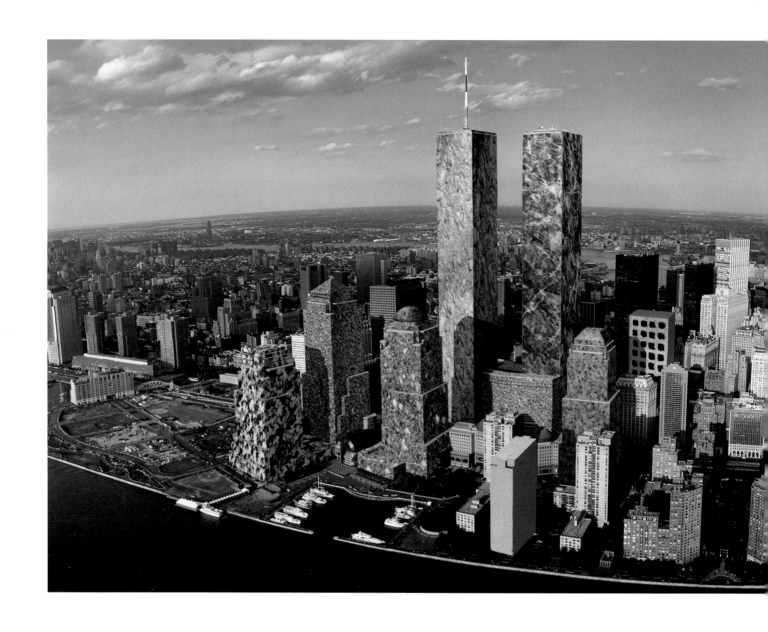

Stone Age.

What might New York have looked like in the Stone Age? Maybe this picture is the answer . . .

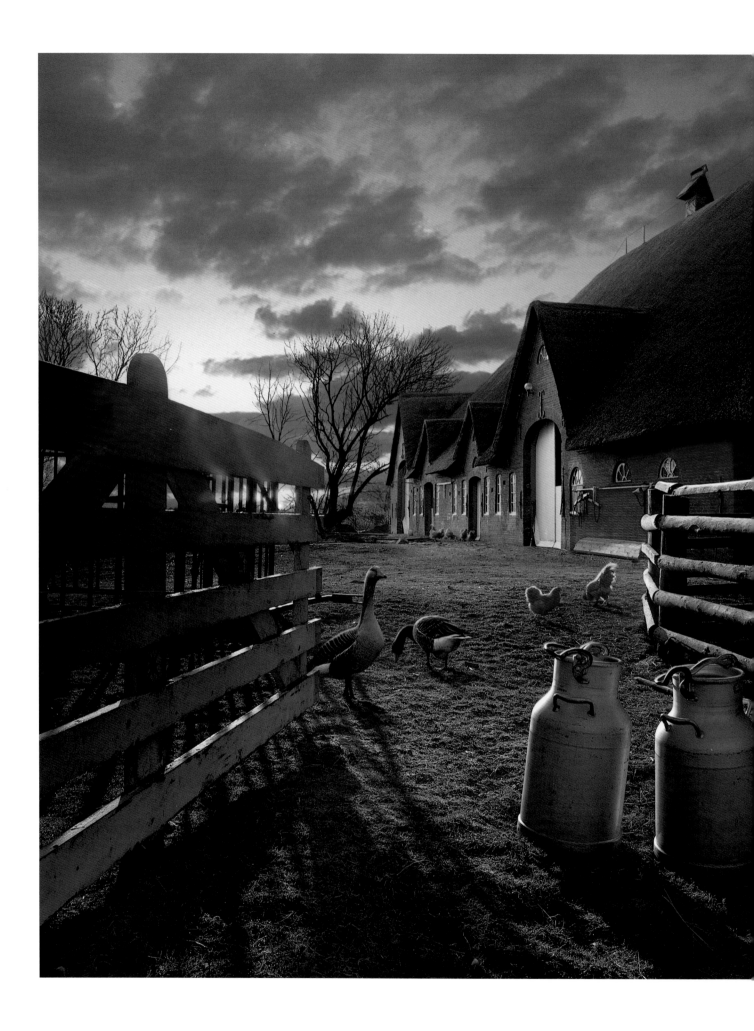

Landscape

Dream On!

Idylls such as those seen here cannot be photographed in real life. As if created by an old master, they contain skilful contrasts, lighting and colouring that you never find together in nature.

A Hard Workout.

Composing this picture required many, many hours of hard work. This picturesque landscape
was created by careful detailed work from a multitude of different elements.

In the Summertime.

Snow in summer? No problem. A good digital illustrator can make it snow all year round. A ticklish and demanding task, perfectly accomplished in this picture.

Sightseeing.

Sightseeing can be this simple: one takes the most important sights of a city (in this case Vienna), and retouches them together. That's how a sightseeing schedule such as "See Europe in 6 Days" can be made a comfortable and stress-free pleasure.

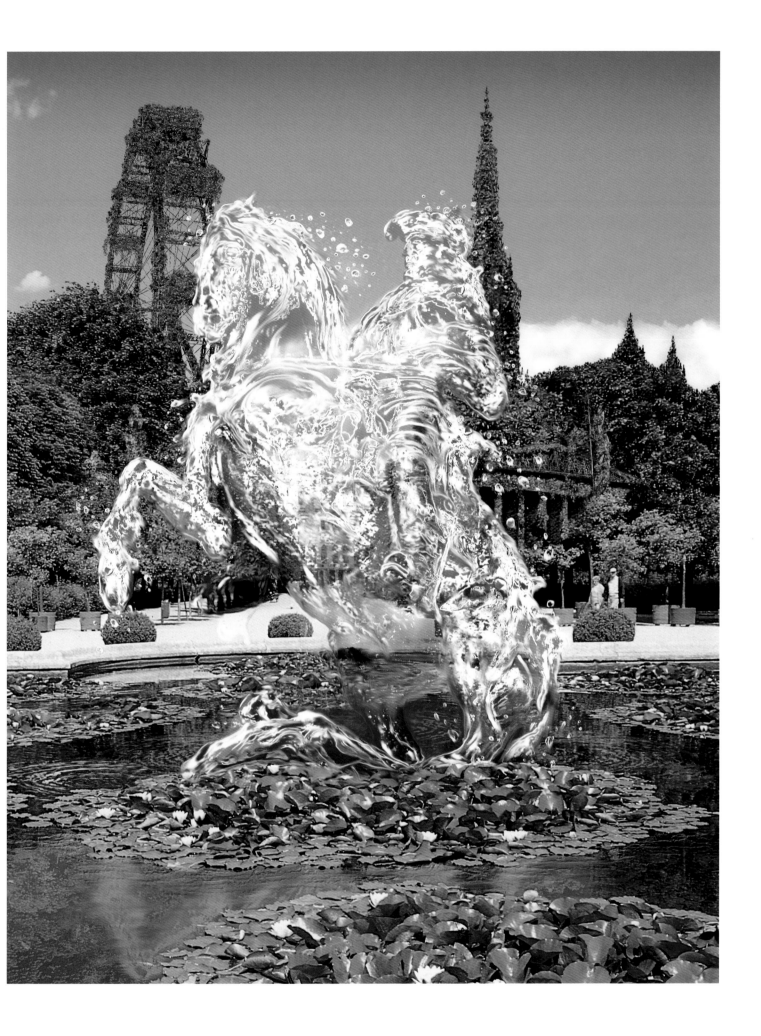

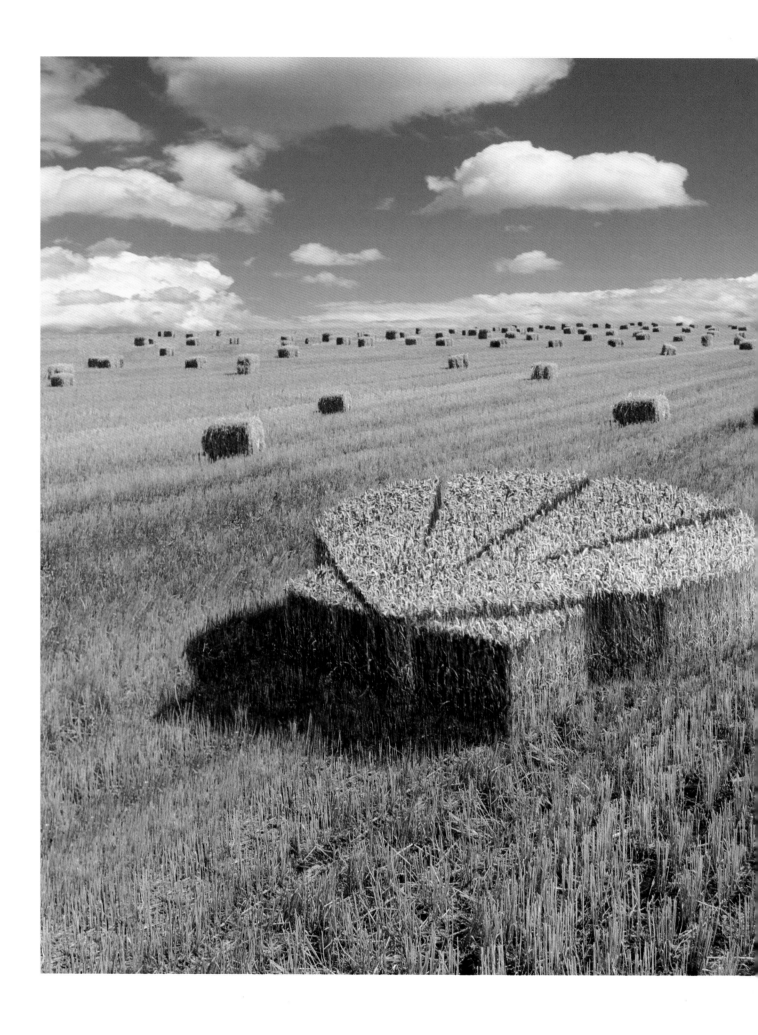

Corn Fakes.

Anything can be counterfeited in Paintbox. Even a golden harvest of grain. Here too, the placement of light and shade affects the realism of the overall impression.

Food

Fromage

An old friend of mine used to say, "Cheese is simply one of the most exquisite foods there is" - he was Swiss, of course. Now everyone knows that the Swiss have blessed the rest of us with Swiss cheese. This truly tremendous achievement is comparable to the hamburger's triumphant conquest of the entire world, or the not-so-global expansion of the Wiener Schnitzel. The latter originated - as did nearly all Austrian culinary specialities - not in Vienna, but rather in the former crown lands. In this case from Northern Italy, where breaded veal cutlets have been served as scaloppina milanese since time immemorial. From Northern Italy, it is only a short hop over the Alps back to Switzerland, which is where - apart from Emmental cheese - many other delicacies, such as Tête de Moine, Munster, or Appenzeller also originated.

But enough about particular specialities, and back to cheese in general. It should be mentioned here that cheeses are a lot like people. They come in the most distinct colours, nationalities, and, groups of them, defined by their common origin, simply just don't get on well with other groups. If cheeses were to make war, they would conduct the fiercest battles with one another, and also have very different allies. The White Dessert Wines would rush to the aid of the Blue Cheese nation during a conflict with the Red Wine Cheeses. That would then lead to a confrontation with the powerful Red Wines. In no time at all, we would have a very combustible crisis situation. But what do the true cheese experts, the French, say? "C'est la vie, c'est la guerre, c'est la food."

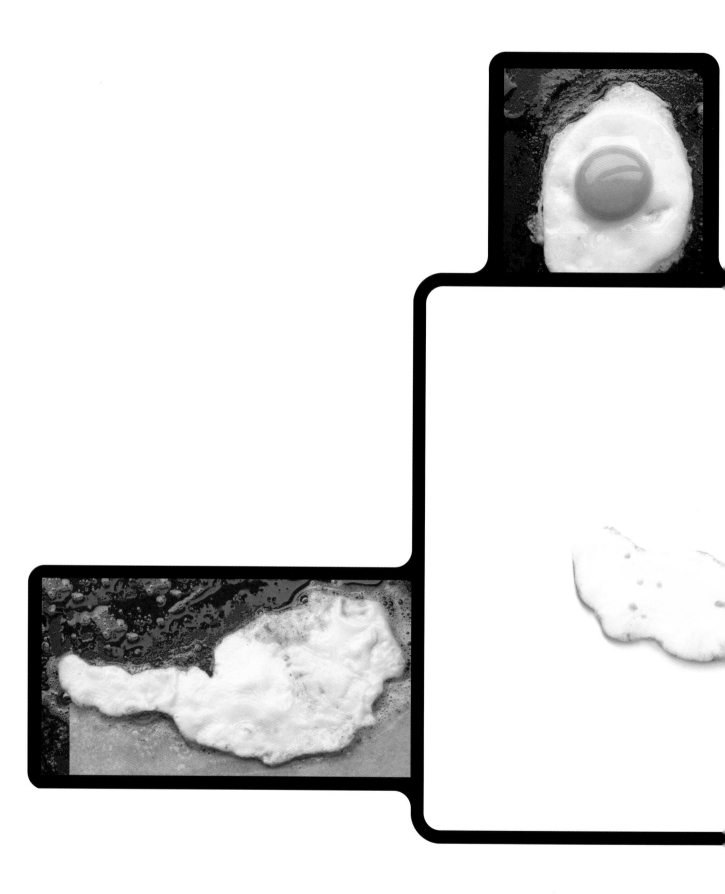

Don't be a chicken!

Don't worry, this fried egg is not the product of genetic engineering (lots of egg white and little yolk). On the contrary, it simply represents a map of Austria.

This collage was created for a new branch of an international advertising agency in Vienna. Two real fried-egg photos (with and without yolks) served as the original input material.

AUSTRIA

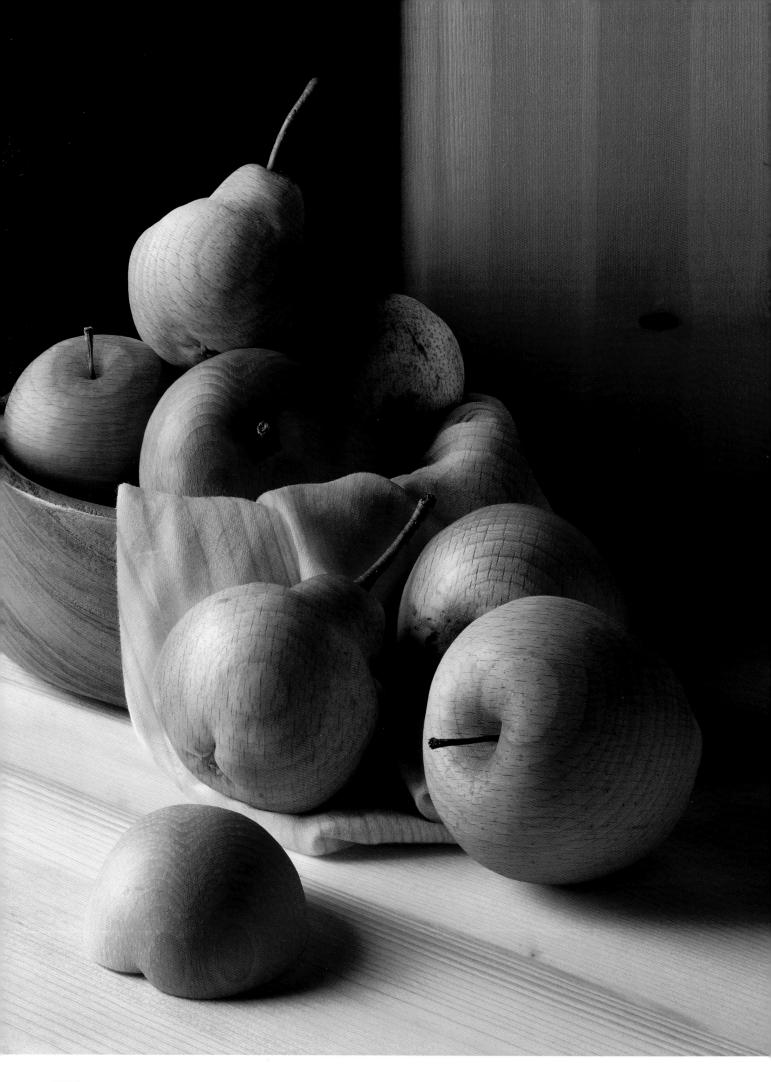

Fresh Frood.

Wooden balls and fruit were photographed in the same light for this appealing picture. The surfaces of the wood and fruit were then painstakingly blended together to create a new and fascinating peel.

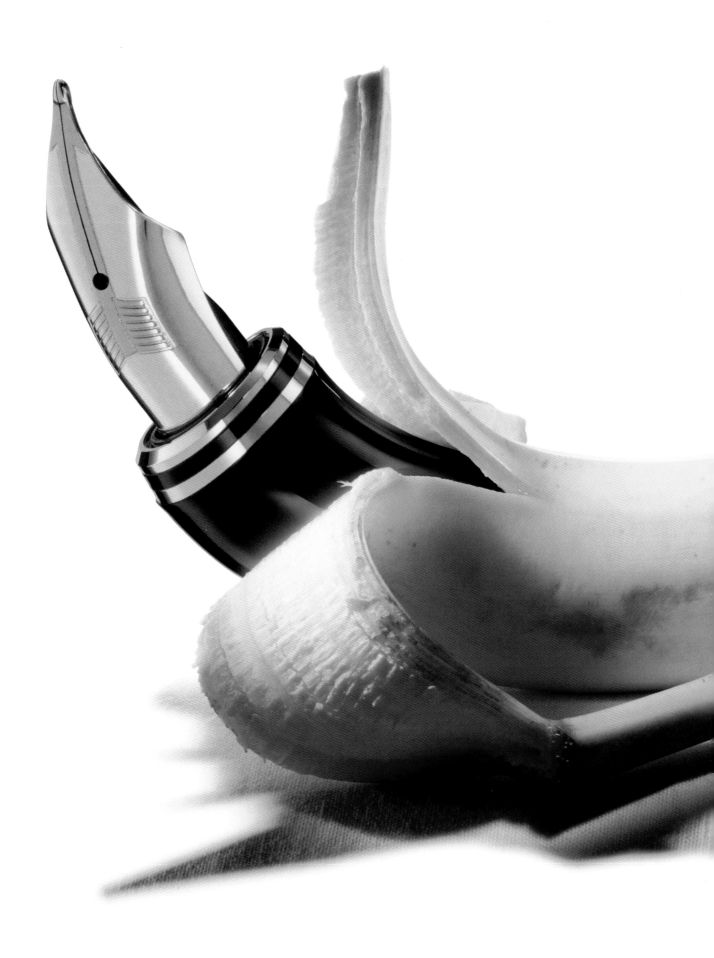

Forbidden Fruit.

Public Health Warning: biting this fruit may be hazardous to your health. A perfect, digital montage, with super-realistic curves, reflections, and lighting effects.

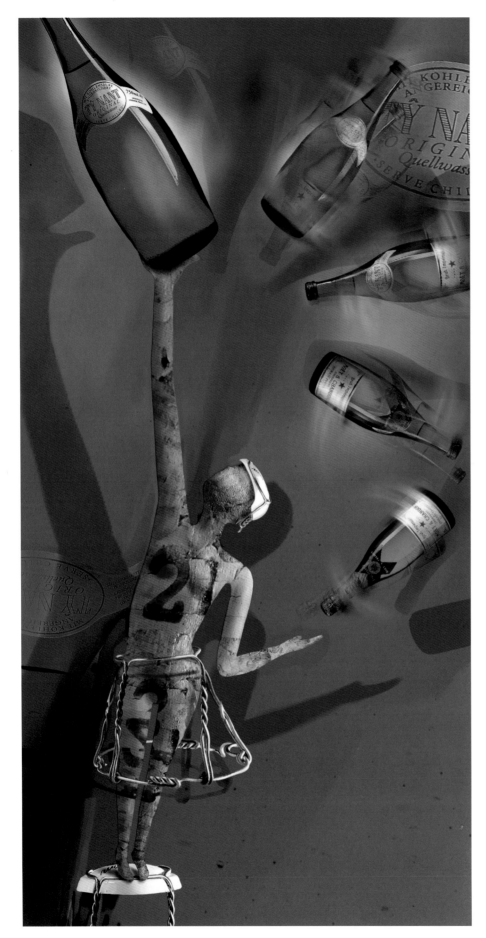

"Plop . . ."

Instead of popping corks and sparkling champagne, the Paintbox artist worked a lot of overtime here.
The entire picture is a purely digital composition: the figure, the movement, the light and shade.

Food

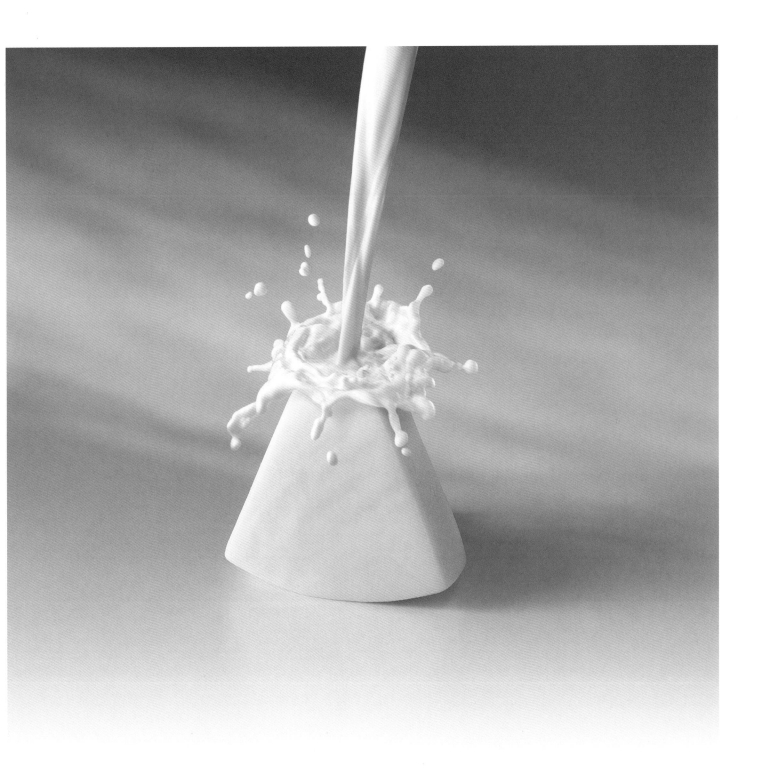

Eat Art.

The ultra-realistic, mouth-watering appeal of this picture can only be created digitally. The wonderful splash of milk, so creamy and consummately formed, can hardly be photographed in real life.

 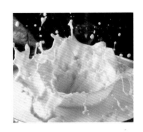

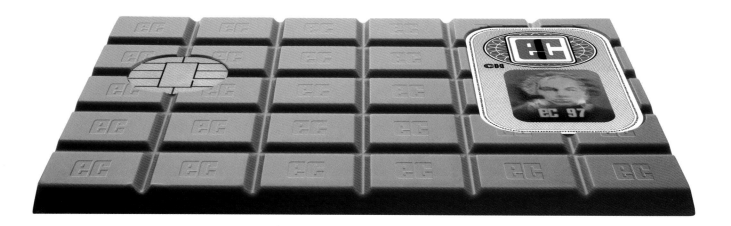

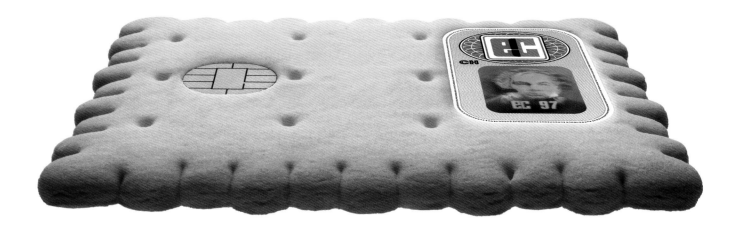

Food

Who says you can't eat money?

The Eurocheque cards shown here look extremely appetising.

Far tastier than a real cheque card ever looked . . .

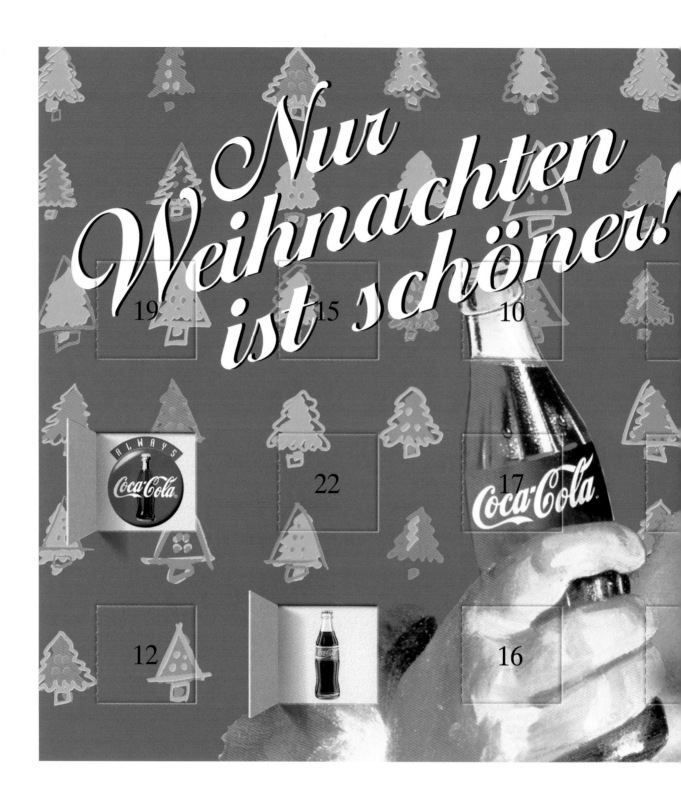

Where's Rudolf?

He, and most likely the reindeer sled too, is probably hiding behind
one of the closed doors of the Advent calendar. And talking of
doors, the basis for the picture was an extremely plastic Paintbox
illustration, which was then overlaid on the entire picture.

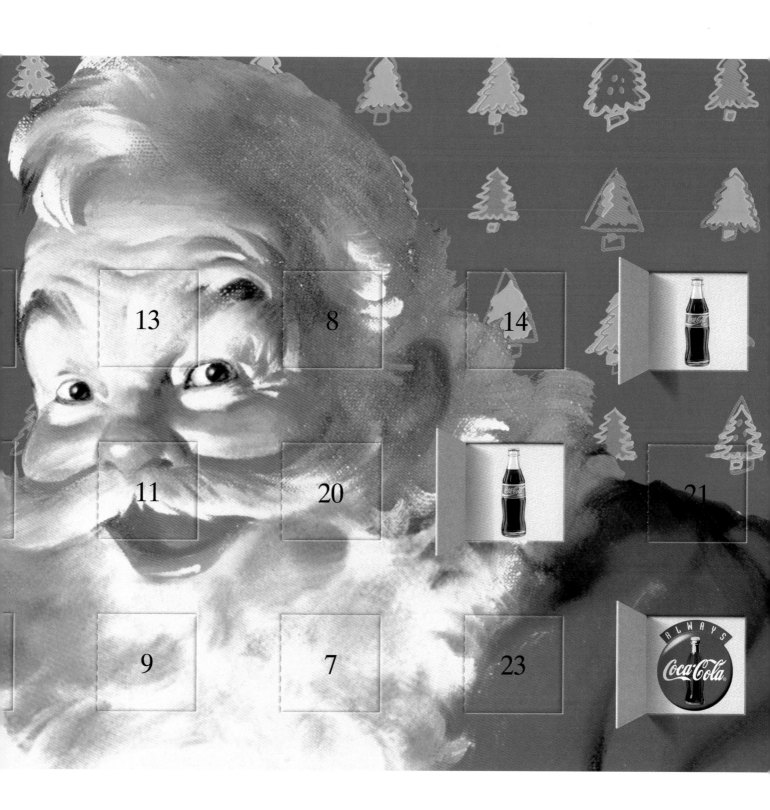

Sweat Shop.

A great deal of blood, sweat and tears went into this picture. First the lidless can was rotated and distorted using a 3-D animation program. Then the water droplets with the reflections of the distorted can were photographed and placed on the can. Then the can was given a lid, photographed separately. Last but not least, free-flying water drops were added to generate an impression of dynamism.

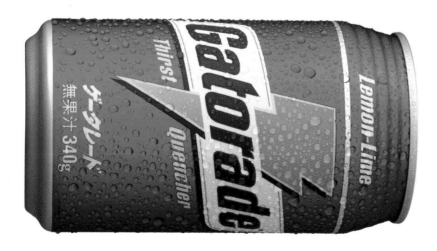

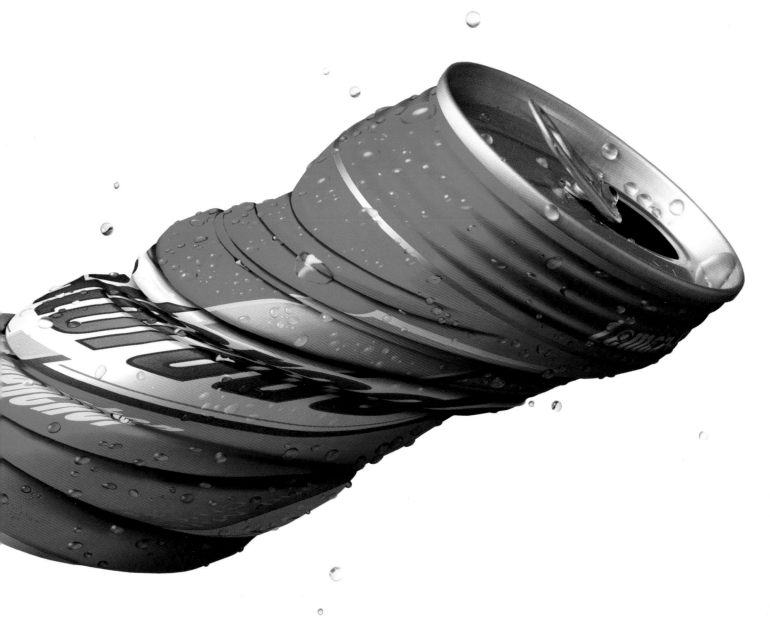

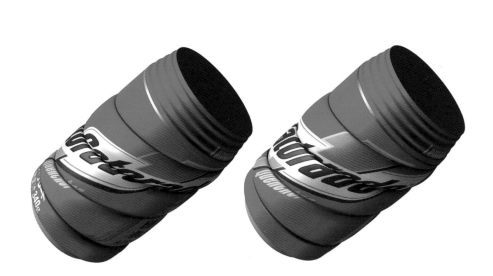

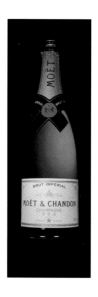

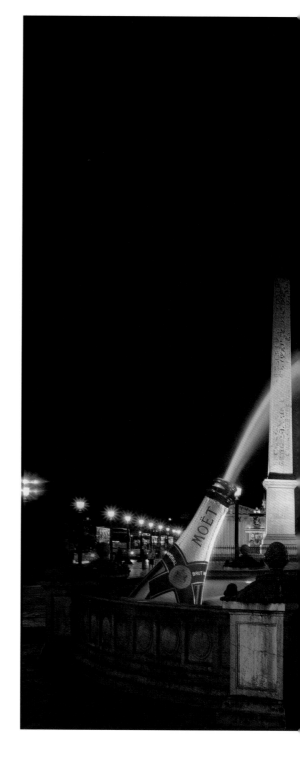

Darling, It's Bath Time!

Cleopatra is said to have bathed in mare's milk, an eccentric billionaire, descended from ducks, takes a daily money-bath, and we are travelling to Paris to immerse ourselves in champagne. À votre santé!

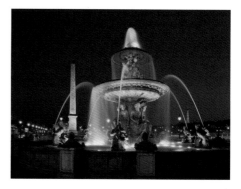

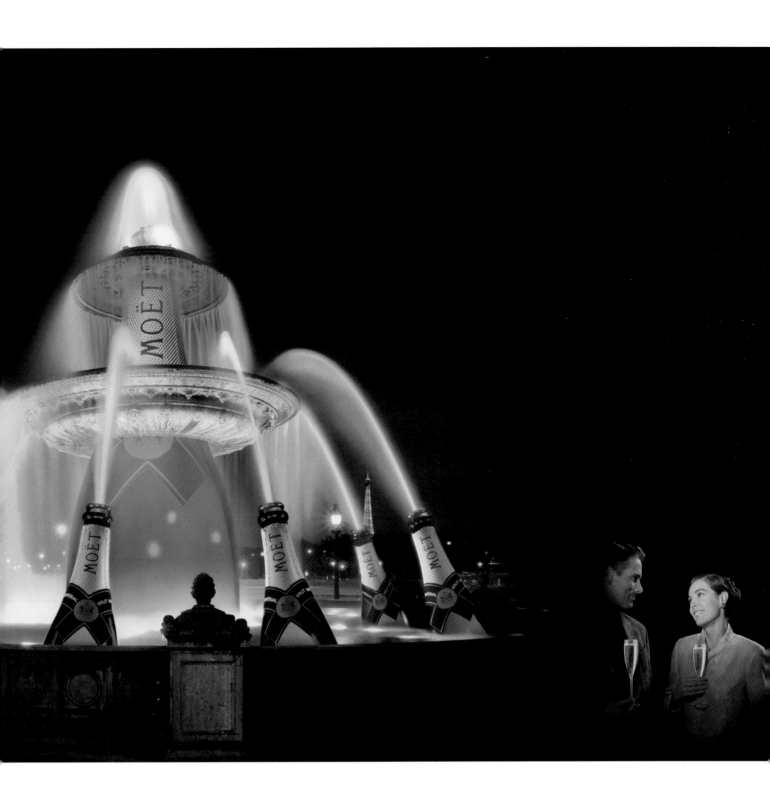

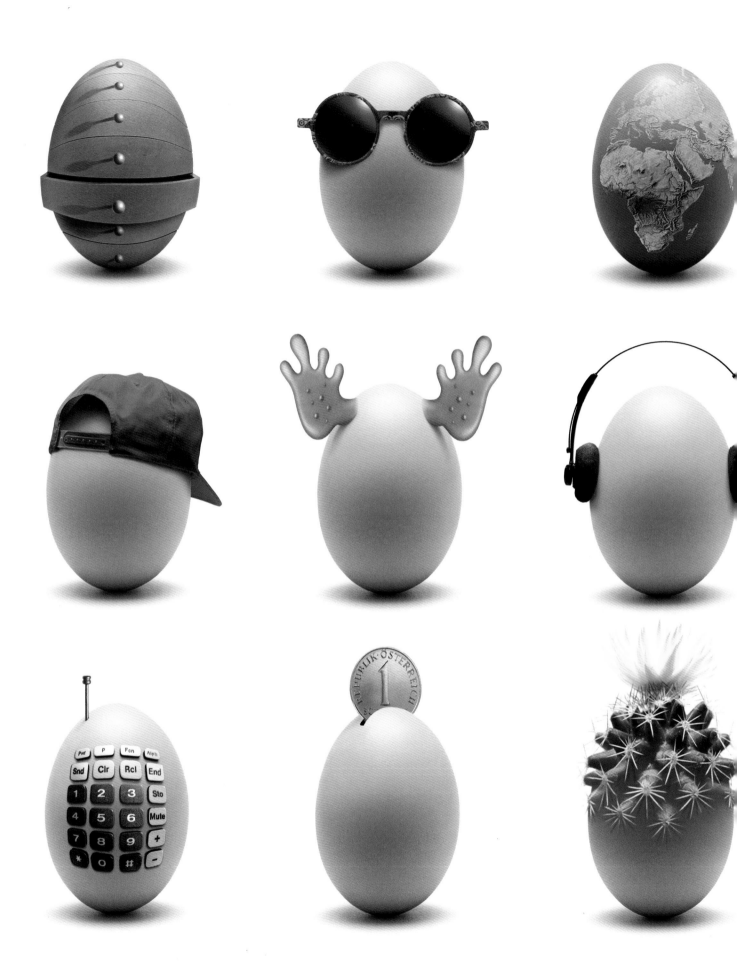

Food

Eggvertising.

This series of pictures of eggs shows what the eggheads in an advertising agency think about, and the products they advertise.

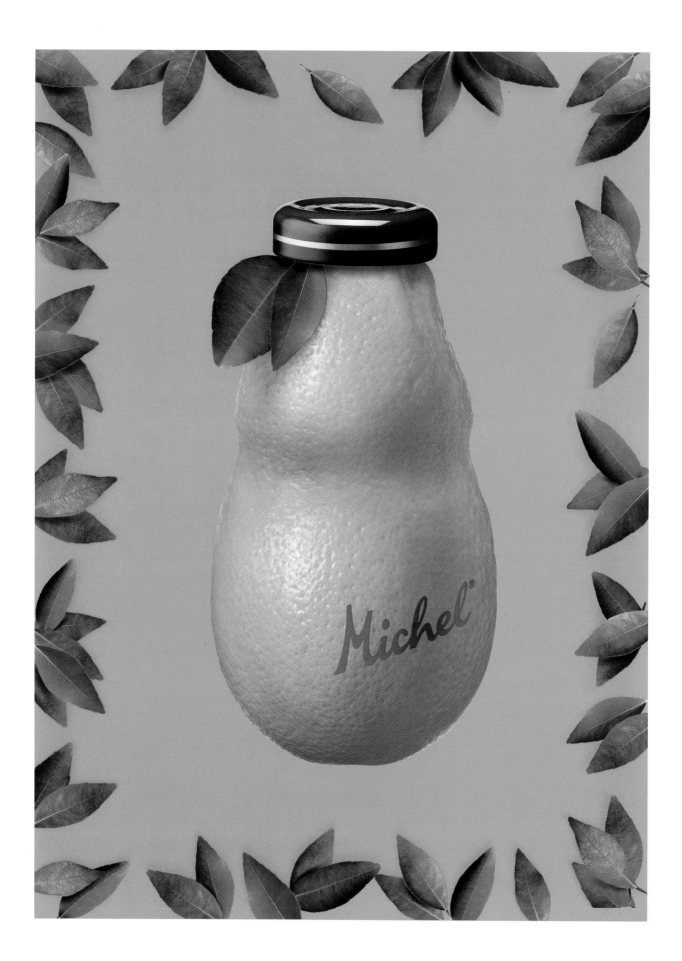

Orange in Wonderland.

The oddest fruits always bloom in the human imagination. Nowadays they can be digitally visua-
lised. The fusion of a bottle with an orange does not pose a problem at all. The next question is,
what do the trees look like that bear such rare fruit. . .

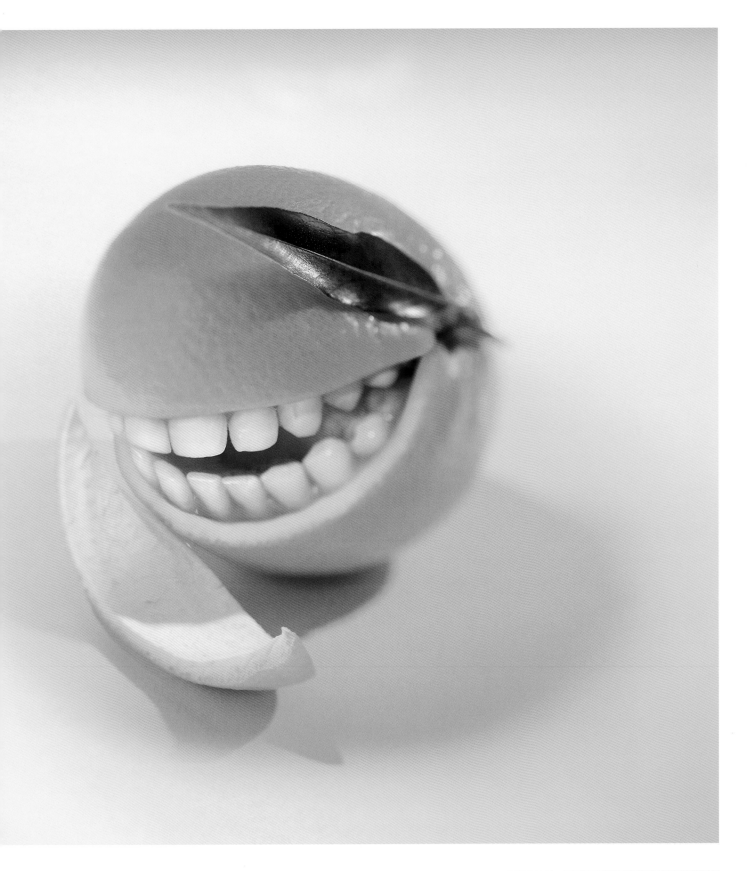

Stripteeth.

What do you do when you peel an orange and suddenly find a set of teeth smiling at you? Drop it or smile back?
The life-like effect of this collage is due to both photos being shot in the same light, the same perspective, and with the same depth of focus.

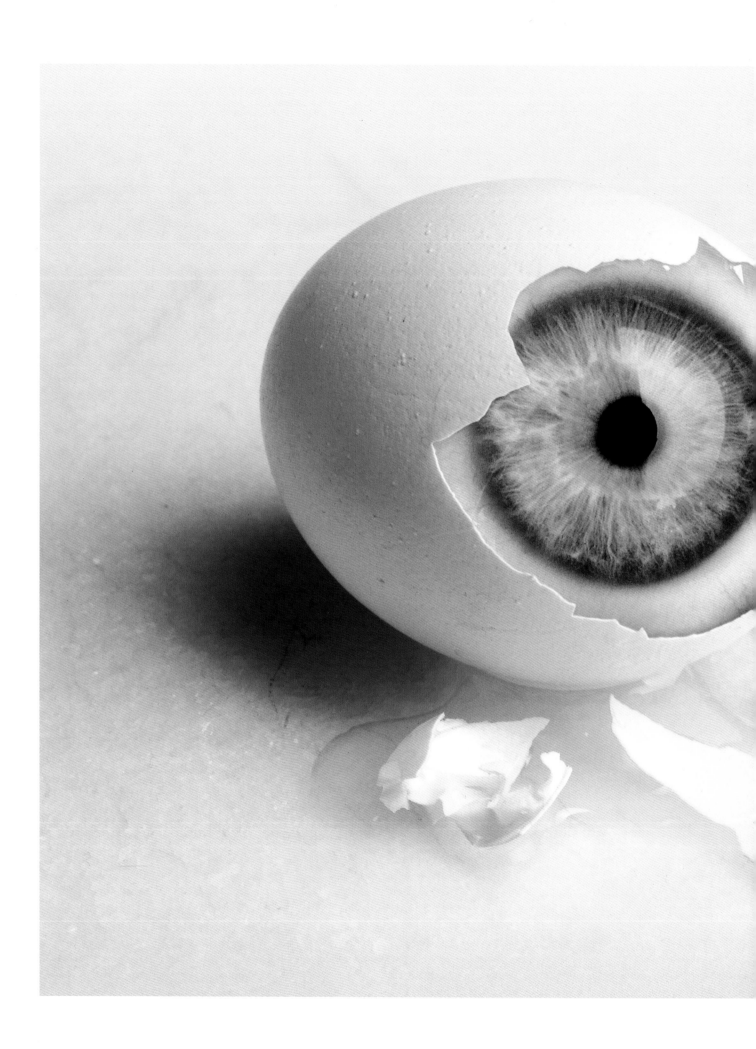

Handle With Care.

The original photos, shot in the exactly the same light and perspective, were digitally compiled with care and a fine touch. The result: a visually fascinating idea and a perfect implementation.

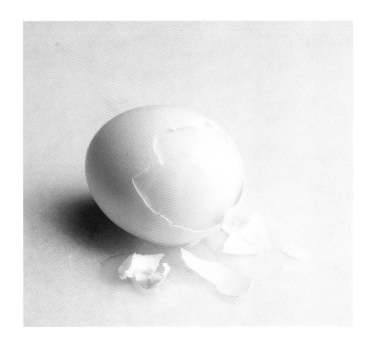

painting

274

Dessert

After a sumptuous dinner, it is the dessert that is the culmination for the palate. However, though sweets may delight the taste buds, they are not always welcomed by a stomach already amply filled. The stomach often has a cunning way of taking revenge for the renewed onslaught on its digestive capacities: with heartburn or an oppressive sensation of being sated.

Apropos revenge: frequently a successful act of revenge is also a sort of dessert. A final, triumphant delight that is particularly sweet when one has been extremely disappointed, humiliated, or injured by someone. A successful act of revenge generally gives rise to one of the strongest feelings of happiness of which a human being is capable. It is a rare blend of feelings of joy, justice, and satisfaction. Commensurate with supreme satisfaction one feels afterwards, the act of taking revenge is itself not such a simple matter. Your revenge must be fine-tuned to the psyche of your victim so as to inflict the greatest possible emotional injury. In a society whose rules of behaviour are characterised by "political correctness", and where the senses have increasingly become dulled by an incessant, multimedia flood of stimuli, a carefully conceived act of revenge, carried out with scheming genius, has become a rarity.

Actually, an imaginatively planned act of revenge is an art form, a satisfying, emotional dessert, served following a failure in interpersonal relations. An art form like music, poetry, architecture, theatre, or painting . . .

NUR HIER ERHÄLTLICH:

DIE 1. KOSTENLOSE FENSTER-LEBENS- VERSICHERUNG DER WELT.

Sheet Metal Cheat.

Perfect illusions and visual transformations can be created digitally. The metal signs shown here are an example. They were created from simple black and white originals. Colour, reflection, and shading were used to create the illusion of tin signs.

![HT HOLLER](enamel sign)

der
schmeckt!

aus echten Hollerblüten

The Good Old Times!

Various elements were added to a 50s-style illustration, which was then given depth and reflected light. This is how a classic enamel sign came into being. The addition of screws in deep recesses also helps create a realistic enamelled effect.

Under His Thumb.

The Paintbox artist has the electronic airbrush completely under his thumb, enabling him to create such fantastic illustrations. Structure and smoke were laid over the finished illustration.

Fetishism.

Some people like dirty underwear or worn-out shoes. Others have a preference for black leather or skin-tight rubber. And others again are crazy about cool chrome and shiny paintwork.

This digital airbrush painting was created for the latter: a 50's dream in paint and chrome.

Black & White.

The original was black & white and two-dimensional, the end product is metallic blue and three-dimensional. A good example of the possibilities of Paintbox.

IN TASTE

THE NEW LEADER IN TASTE

Body Talk.

Two-dimensional originals were given depth as a result of digital processing. The 3-D effect was achieved through the interplay of light, shade and depth of focus.

**Sparen Sie
nicht beim
Bauen.
Sparen Sie
beim Kredit.**

**Sparen Sie
nicht beim
Bauen.
Sparen Sie
beim Kredit.**

Bricks in a Wall.

A black & white original was transformed into a three-dimensional sign and then collaged with a photo.

Going, Going, Gun . . .

These guns may look dangerous, but they are actually harmless. They are nothing more than digital illustrations that can be destroyed at the touch of a button. It would be nice if life were as simple when it comes to real weapons . . .

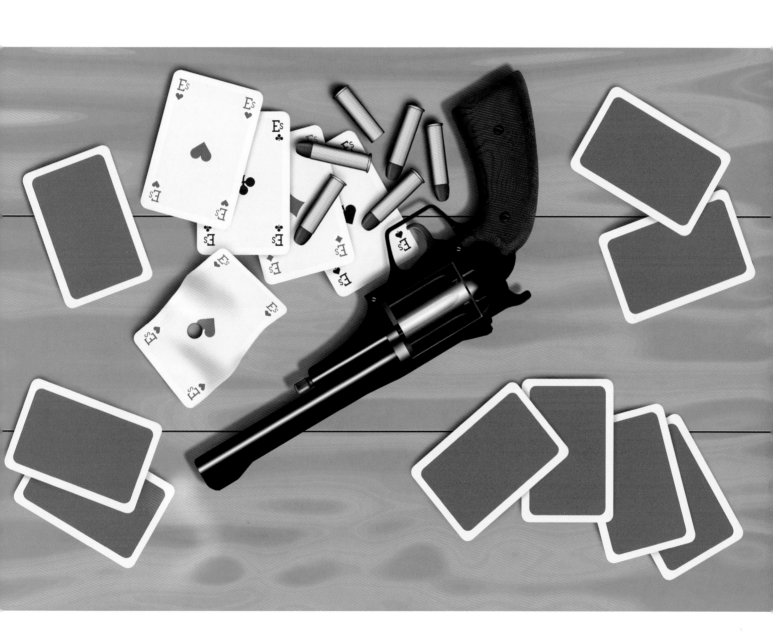

Gardens of Eden.

This lavish and detailed work is a mixture of collage and illustration.

No Milk Today.

Feeling blue? Take the day off! Actually, she's just taking it free and easy . . .

Bombastic.

A digital illustration which captures the attention with its glittering chrome effects.

The Killing Depths...

In the depths of the ocean lives a terrible monster. A sunken cargo of fish sticks is mutating into gigantic killer-fish sticks due to the radiation from nuclear waste dumped into the ocean.

Index

paintbox company
Vienna Paint / Austria

paintbox artist
Andreas Fitzner

agency
Demner, Merlicek & Bergmann

art director
Guillaume Borel

photographer
Gerhard Heller

client / product
Wiener Festwochen

paintbox company
Vienna Paint / Austria

paintbox artist
Albert Winkler

art director
Klemens Kubala

client / product
Meisterklasse Lürzer

paintbox company
Vienna Paint / Austria

paintbox artist
Albert Winkler

agency
CCP

art director
Daniel Gantner

photographer
Josef Fischnaller

client / product
Hyundai

paintbox company
Vienna Paint / Austria

paintbox artist
Albert Winkler

agency
CCP

art director
Werner Celand

photographer
Josef Fischnaller

client / product
Hyundai

paintbox company
Vienna Paint / Austria

paintbox artist
Albert Winkler

art director
Albert Winkler

photographer
Tobi Carrasco

client / product
QUO Magazine / Spain

paintbox company
Vienna Paint / Austria

paintbox artist
Albert Winkler

art director
Meisterklasse Lürzer
Janna Kozeschnik-Thür

photographer
Jorit Aust

client / product
Meisterklasse Lürzer

paintbox company
Vienna Paint / Austria

paintbox artist
Albert Winkler

art director
Meisterklasse Lürzer
Albert Winkler

photographer
Rainer Hosch

client / product
Meisterklasse Lürzer

paintbox company
Vienna Paint / Austria

paintbox artist
Andreas Fitzner

agency
Adel Saatchi & Saatchi

art director
Antonis Stavropoulos

photographer
Dieter Brasch

client / product
Silk Cut

paintbox company
Vienna Paint / Austria

paintbox artist
Andreas Fitzner

agency
Haslinger, Keck

art director
Marco de Felice

photographer
Günther Parth

client / product
Knilli

paintbox company
Vienna Paint / Austria

paintbox artist
Andreas Fitzner

agency
Palla, Koblinger & Partner

art director
Roman Sindelar

photographer
Archiv

client / product
Tlapa Fashion

paintbox company
Vienna Paint / Austria

paintbox artist
Andreas Fitzner

agency
Saatchi & Saatchi

art director
Falko Mätzler

photographer
Horst Stasny

client / product
Klassenlotterie

paintbox company
Vienna Paint / Austria

paintbox artist
Andreas Fitzner

agency
Ogilvy & Mather

art director
Michael Heine

photographer
Stock

client / product
Touropa

paintbox company
Vienna Paint / Austria

paintbox artist
Andreas Fitzner

agency
McCann-Erickson

art director
Sylvia Zauner

photographer
Sebastian Hänel

client / product
Pannon GSM

paintbox company
Gruppe S.F. & H. / Austria

paintbox artist
Edo Zierotin

photographer
Othmar Heidegger

client / product
self promotion

paintbox company
Grafi Image S.A. / Spain

paintbox artist
David Teixidor, Toni Garreta,
Joan Manuel Rodriguez

agency
Vinizius / Young & Rubicam

art director
Jordi Almuni

photographer
Ricardo Miras

client / product
Vodka Smirnoff

paintbox company
Vienna Paint / Austria

paintbox artist
Albert Winkler

agency
Young & Rubicam

art director
Gabi Wagner

photographer
Jorit Aust

client / product
Woolworth

52

54

58

60

paintbox company
Vienna Paint / Austria

paintbox artist
Andreas Fitzner

art director
Ralph Manfreda

photographer
Mark Glassner

client / product
Wiener Magazin

paintbox company
The Box / Denmark

paintbox artist
Jan Tuilling

agency
Bates Copenhagen

art director
Simon Woller

photographer
Christian Gravesen / Schiller

client / product
LM Ericsson

paintbox company
Vienna Paint / Austria

paintbox artist
Albert Winkler

agency
LOWE / GGK

art director
Regula Widmer

photographer
Günther Parth

client / product
Stiefelkönig

paintbox company
Vienna Paint / Austria

paintbox artist
Albert Winkler

agency
LOWE / GGK

art director
Regula Widmer

photographer
Günther Parth

client / product
Stiefelkönig

62

64

66

68

paintbox company
Repropaint / Austria

paintbox artist
Rainer Macku

agency
a.r.g.e. Kalender

art director
Robert Hollinger

photographer
Götz Schrage

client / product
self promotion

paintbox company
Vienna Paint / Austria

paintbox artist
Albert Winkler

agency
Museum in progress

art director
Hans Ulrich-Obrist

photographer
Rosemarie Trockel

client / product
Austrian Airlines

paintbox company
IQ Videographics Limited / UK

paintbox artist
Mark Bullen

agency
Dolphin

art director
Mark Farrow

photographer
Andy Earl

client / product
Lightning Seeds
Jollification / Epic Records

paintbox company
Tapestry / UK

paintbox artist
Mark Henry

agency
Simons Palmer Clemmow Johnson

art director
Graham Storey

photographer
Sheamus Ryan

client / product
Fuji

70

72

73

74

paintbox company
IQ Videographics Limited / UK

paintbox artist
Mark Bullen

agency
Abbot Mead Vickers

art director
Walter Campbell & Tom Carty

photographer
Mark Mattock

client / product
Mountain Dew / Pepsi

paintbox company
GMB Group p/c / UK

paintbox artist
Anne Mulqueeney, Andy Lambert

agency
IWP Limited

art director
Andrew Irving

photographer
Geoff Smith

client / product
GMB

paintbox company
Vienna Paint / Austria

paintbox artist
Andreas Fitzner

agency
Saatchi & Saatchi

art director
Markus Hartmann

photographer
Rainer Bald

client / product
Furore Fashion

paintbox company
Centro Digital Pictures ltd. / Hongkong

paintbox artist
Dale Codling

agency
Leo Burnett

art director
Andrew Bell

photographer
Kevin Orpin

client / product
Regent Hotel Mermaid

75

76

77

78

paintbox company
Grafi Image S.A. / Spain

paintbox artist
Grafi Image Team

art director
Grafi Image Team

photographer
Archive

client / product
self promotion

paintbox company
Tapestry / UK

paintbox artist
Mark Henry

agency
N/A

art director
Nick Simpson

photographer
Nick Simpson

client / product
N/A

paintbox company
Centro Digital Pictures ltd. / Hongkong

paintbox artist
Dale Codling

agency
Ogilvy & Mather

art director
Andrew Bell

photographer
Ringo Tang

client / product
Neil Pryde

paintbox company
Vienna Paint / Austria

paintbox artist
Albert Winkler

photographer
Studio Trizeps

client / product
Global 2000

paintbox company
Vienna Paint / Austria

paintbox artist
Albert Winkler

agency
Vienna Paint

art director
Albert Winkler

photographer
Jorit Aust

client / product
self promotion

paintbox company
Reproff A/S (Wiz-Art) / Denmark

paintbox artist
Leif Normark Sorensen

agency
Norgard Mikkelsen

art director
Viggo Thomsen

photographer
Ulrik Jensen

client / product
Albani Perrier

paintbox company
Vienna Paint / Austria

paintbox artist
Albert Winkler

art director
Fritz Ziehaus

photographer
Dieter Brasch

client / product
Blaumax Jeans

paintbox company
Vienna Paint / Austria

paintbox artist
Peter Baustädter

agency
Vienna Paint

art director
Peter Baustädter

photographer
Studio Trizeps

client / product
self promotion

paintbox company
Vienna Paint / Austria

paintbox artist
Albert Winkler

art director
Werner Schellenberg

photographer
Studio Trizeps

client / product
Butter

paintbox company
Vienna Paint / Austria

paintbox artist
Edo Zierotin

art director
Edo Zierotin

photographer
Dieter Brasch

client / product
self promotion

paintbox company
Vienna Paint / Austria

paintbox artist
Andreas Fitzner

agency
Image Werbung

art director
Daniela Vogel

photographer
Günter Menzl

client / product
Hypobank

paintbox company
Vienna Paint / Austria

paintbox artist
Albert Winkler, Edo Zierotin

agency
Barci & Partner

art director
Bertrand Kirschenhofer

photographer
Studio Trizeps

client / product
Die Erste Bank

100

102

104

106

paintbox company
Vienna Paint / Austria

paintbox artist
Albert Winkler

agency
Meisterklasse Lürzer

art director
Meisterklasse Lürzer

photographer
Wolfgang Werzowa

client / product
Meisterklasse Lürzer

paintbox company
Gruppe S.F. & H. / Austria

paintbox artist
Othmar Heidegger

art director
Othmar Heidegger

photographer
Othmar Heidegger

client / product
self promotion

paintbox company
Vienna Paint / Austria

paintbox artist
Albert Winkler

agency
Ogilvy & Mather

art director
Jost Strnat

photographer
Peter Strobl

client / product
Bundesländer Versicherung

paintbox company
Reproff A/S (Wiz-Art) / Denmark

paintbox artist
Leif Normark Sorensen

art director
Leif Normark Sorensen

client / product
self promotion

108

110

111

112

paintbox company
Quantel / UK

paintbox artist
Marta Blanford, Mike Clark

agency
Discovery Design Group

art director
Mike Clark, Janet Daniel, John Hite

photographer
Michael Pohuski,
stockagency Waterhouse

client / product
sharkweek, Discovery Channel,
Key Art

paintbox company
Vienna Paint / Austria

paintbox artist
Albert Winkler

agency
Trend Verlag

art director
Ernst Pavlovic

photographer
Studio Trizeps

client / product
Trend Verlag

paintbox company
Vienna Paint / Austria

paintbox artist
Albert Winkler

agency
Vienna Paint

art director
Albert Winkler

photographer
Studio Trizeps/ Langoth &
Fallnhauser

client / producto
self promotion

paintbox company
Light box ltd. / UK

paintbox artist
John Clarke

photographer
Jack Daniels

client / product
self promotion

113

114

116

118

paintbox company
MCG Keyframe AG / Switzerland

paintbox artist
Giorgio Bertoli, Robert Meyer

agency
Advico / Young & Rubicam

art director
Matthias Babst

photographer
Andy Rosasco

client / product
ZVSM (Zentralschweizerischer
Milchverband)

paintbox company
MCG Keyframe AG / Switzerland

paintbox artist
Giorgio Bertoli, Robert Meyer

agency
Advico / Young & Rubicam

art director
Matthias Babst

photographer
Andy Rosasco

client / product
ZVSM (Zentralschweizerischer
Milchverband)

paintbox company
Grafi Image S.A. / Spain

paintbox artist
Toni Garreta, David Teixidor,
Joan Manuel Rodriguez

agency
Tandem Campmany Guasch DDB

art director
Lluis Diez

photographer
Enric Climent / Archives

client / product
Volkswagen

paintbox company
Grafi Image S.A. / Spain

paintbox artist
David Teixidor

agency
Casadevall Pedreno P.R.G.

art director
Melchor Palacios

photographer
Jose Luis Mendez

client / product
Aris Restaurants

122

124

130

132

paintbox company
Vienna Paint / Austria

paintbox artist
Albert Winkler

agency
Euro RSCG

art director
Klemens Kubala

photographer
Mario Katzmayer

client / product
Diners Club

paintbox company
Vienna Paint / Austria

paintbox artist
Andreas Fitzner

agency
Young & Rubicam

art director
Alfred Pfeifer

photographer
BMW Archive / Thomas Popinger

client / product
BMW

paintbox company
Vienna Paint / Austria

paintbox artist
Andreas Fitzner

agency
Demner, Merlicek & Bergmann

art director
Daniel Meier

photographer
Studio Trizeps

client / product
Mazda

paintbox company
Centro Digital Pictures Ltd. /
Hongkong

paintbox artist
Dale Codling

agency
DDB Needham

art director
Richard Kramer

photographer
Kevin Ordin

client / product
Audi

134

136

138

142

paintbox company
Technical Art - Electronic Paint
GmbH / Germany

paintbox artist
Norbert Schäfer

art director
Norbert Schäfer

photographer
Norbert Schäfer

client / product
BMW

paintbox company
Technical Art - Electronic Paint
GmbH / Germany

paintbox artist
Norbert Schäfer

art director
Norbert Schäfer

photographer
Norbert Schäfer

client / product
Porsche

paintbox company
Vienna Paint / Austria

paintbox artist
Andreas Fitzner

agency
McCann-Erickson

art director
Jirí Smolik

photographer
Stock

client / product
Opel

paintbox company
MCG Keyframe AG / Switzerland

paintbox artist
Giorgio Bertoli

agency
Bosch & Butz

art director
Res Perrot

client / product
SBG (Swiss Bank Corporation)

143

144

146

147

paintbox company
The Box / Denmark

paintbox artist
Jan Tuilling

agency
Young & Rubicam Copenhagen

art director
Torsten Ensig

photographer
Christian Gravesen/Schiller

client / product
Ministry of the environment

paintbox company
Vienna Paint / Austria

paintbox artist
Andreas Fitzner

agency
Dr. Puttner Bates

art director
Ulli Engel

3d-illustrator
Thomas Mackinger

client / product
Casinos Austria

paintbox company
Nureg Paint / Germany

paintbox artist
Horst Auerochs

art director
Manfred Neussl

photographer
Atelier Schuldt

client / product
FOCUS Magazine

paintbox company
ASK for digital imaging /
Germany

paintbox artist
Lars Klawitter

agency
P.C.S

art director
Christian Rahofer

photographer
Peter Allert

client / product
SKWB Salzburg

paintbox company
Repropaint / Austria

paintbox artist
Rainer Macku

agency
McCann-Erickson

art director
Sylvia Zauner

photographer
Julian Grösel, Tamas Reichel

client / product
Pannon GSM

paintbox company
Repropaint / Austria

paintbox artist
Rainer Macku

agency
Trend Verlag

art director
Ilse Wandl

photographer
Julian Grösel

client / product
Trend Verlag

paintbox company
Vienna Paint / Austria

paintbox artist
Andreas Fitzner

agency
TBWA / Tell

art director
Paul Holcmann

client / product
Coca Cola

paintbox company
Graphamundi / Germany

paintbox artist
Andrea Kadrnka

art director
Andrea Kadrnka

client / product
GEFA-Flug GmbH

paintbox company
GRAFX Creative Imaging / USA

paintbox artist
Daniel Bennett, Jose Campos,
Scott Harding

agency
John Dearlove & Affiliates

art director
John Dearlove

photographer
Jeff Schewe

client / product
TUKAIZ Communications

paintbox company
Repropaint / Austria

paintbox artist
Rainer Macku

art director
Christian Guth

photographer
Julian Grösel

client / product
Forbes Magazin München

paintbox company
Studio Sannicolo / Sweden

paintbox artist
Giulioano Sannicolo

agency
Hall & Lederquist /
Young & Rubicam

art director
Lars Hansson

photographer
Thomas Ringquist

client / product
Kraftfoods AB Gevalia

paintbox company
Grafi Image S.A. / Spain

paintbox artist
Toni Garreta

agency
Vinizius
Young & Rubicam

art director
Jordi Almuni

photographer
Jordi Blancafort

client / product
General de Confiteria S.A. /
Chewing-Gum „TREX"

166

168

169

170

paintbox company
Centro Digital Pictures Ltd. /
Hongkong

paintbox artist
Dale Codling

agency
J. Walter Thompson

art director
Andrew Ho

photographer
Sandy Lee

client / product
Motorola

paintbox company
Reprozwölf / Austria

paintbox artist
Roman Keller

agency
Ogilvy & Mather

art director
Michael Heine

photographer
Hannes Kutzler

client / product
Oase Bad

paintbox company
Nureg Paint / Germany

paintbox artist
Horst Auerochs

art director
Siegfried Ottinger

photographer
Foto Borowitz

client / product
HIV Advice Center

paintbox company
Vienna Paint / Austria

paintbox artist
Andreas Fitzner

agency
Barci & Partner

art director
Marco de Felice

photographer
Der bunte Elefant

client / product
Nissan

172

174

178

180

paintbox company
Vienna Paint / Austria

paintbox artist
Andreas Fitzner

agency
TBWA / Tell

art director
Günther Hauser

photographer
Peter Kremsner

client / product
Nissan

paintbox company
Vienna Paint / Austria

paintbox artist
Albert Winkler

art director
Albert Winkler

photographer
Dieter Brasch

client / product
Quantel

paintbox company
Grafi Image S.A. / Spain

paintbox artist
Toni Garreta

agency
Casadevall pedreno p.r.g.

art director
Salvador Ardit

photographer
Jaime Malé

client / product
Seat

paintbox company
Vienna Paint / Austria

paintbox artist
Andreas Fitzner

art director
Dieter Brasch

photographer
Dieter Brasch

client / product
self promotion

181

182

188

190

paintbox company
Studio Sannicolo / Sweden

paintbox artist
Rolf Vikström Look

agency
Intellecta Stockholm

art director
Tommy Nyman

photographer
Steven Quigley

client / product
Vattenfall

paintbox company
MCG Keyframe AG/Switzerland

paintbox artist
Giorgio Bertoli

agency
FAVO

art director
Benny Wenger

photographer
Claudia Albisser/Ralph Lehner

client / product
Visa Swiss Bank Corporation

paintbox company
Vienna Paint / Austria

paintbox artist
Albert Winkler

agency
Publicis MCD München

art director
Birte Stahl

photographer
Stock

client / product
Siemens

paintbox company
Vienna Paint / Austria

paintbox artist
Albert Winkler

agency
Farner Publicis

art director
Norbert Brunner

photographer
Toni Putman (steamer),
Salamander (train), Hannes
Kutzler (elephant & cello),
Christian Kitzmüller (tower)

client / product
Select Cigarettes

196

200

202

204

paintbox company
Vienna Paint / Austria

paintbox artist
Albert Winkler

agency
Palla, Koblinger & Partner

art director
Bernd Fliesser

photographer
Stock

client / product
Xerox

paintbox company
Gruppe S.F. & H. / Austria

paintbox artist
Edo Zierotin

photographer
Othmar Heidegger

client / product
self promotion

paintbox company
Vienna Paint / Austria

paintbox artist
Andreas Fitzner

art director
Otto Wiederhold

photographer
Luftreportagen Hausmann

client / product
Vienna Airport

paintbox company
Vienna Paint / Austria

paintbox artist
Albert Winkler

art director
Otto Wiederhold

photographer
Luftreportagen Hausmann

client / product
Vienna Airport

206

208

209

210

paintbox company
Centro Digital Pictures ltd. /
Hongkong

paintbox artist
Kris Tsang

agency
J. Walter Thompson

art director
Stephen Mui, Ricky Cheung

photographer
Oswald Cheung

client / product
Citibank

paintbox company
Reproff A/S (Wiz-Art) / Denmark

paintbox artist
Leif Normark Sorensen

art director
Leif Normark Sorensen

photographer
Leif Normark Sorensen

client / product
childrens book

paintbox company
Tapestry / UK

paintbox artist
Paul (Badger) Wright

art director
Brian Bridges

photographer
Mick Dean

client / product
Grohe

paintbox company
Vienna Paint / Austria

paintbox artist
Albert Winkler

agency
CCP

art director
Daniel Gantner

photographer
Stock

client / product
Bene

212

214

216

218

paintbox company
Quantel / UK

paintbox artist
Marta Blanford, Mike Clark

agency
Discovery Design Group

art director
Mike Clark, Janet Daniel,
John Hite

photographer
Kevin Gilbert (stadium),
stockmarket (spaceship)

client / product
The Learning Channel

paintbox company
Vienna Paint / Austria

paintbox artist
Andreas Fitzner

agency
Mark & Nevosad

art director
John Mark

photographer
stock archive

client / product
Verbund Elektrizitätsversorgung

paintbox company
Vienna Paint / Austria

paintbox artist
Andreas Fitzner

agency
Saatchi & Saatchi

art director
Falko Mätzler

photographer
Staudinger Franke, Vienna Paint

client / product
Mobilkom Austria

paintbox company
4 Art digital scenics / Germany

paintbox artist
Reinhard Ottenlinger

photographer
Uwe Niehuus

client / product
self promotion

paintbox company
Tapestry / UK

paintbox artist
Raj Taylor

agency
Mustoe Merriman Herring Levy

art director
Kevin Little

photographer
Bob Elsdale

client / product
Gieves & Hawes

paintbox company
Vienna Paint / Austria

paintbox artist
Andreas Fitzner

agency
BZW

art director
Günther Roth

photographer
Stock

client / product
IMO Baumarkt

paintbox company
Studio Sannicolo / Sweden

paintbox artist
Rolf Vikström Look

agency
Nord & Co

art director
Jesper Holst

photographer
Alan Samagalski

client / product
Semic

paintbox company
Digital Works / Germany

paintbox artist
Hans Jürgen Gaetzner,
Karl Hoffman

client / product
Bild am Sonntag

paintbox company
Vienna Paint / Austria

paintbox artist
Albert Winkler

agency
Publicis MCD München

art director
Birte Stahl

photographer
Dieter Brasch

client / product
Siemens

paintbox company
Studio Sannicolo / Sweden

paintbox artist
Peter Rundquist

agency
Studio Sannicolo

art director
Peter Rundquist

photographer
Torleif Svensson Tiofoto

paintbox company
Vienna Paint / Austria

paintbox artist
Andreas Fitzner

art director
Peter Pfeil

photographer
Stock

client / product
Meisterklasse Lürzer

paintbox company
Vienna Paint / Austria

paintbox artist
Andreas Fitzner

art director
Mag. Irmgard Rauch

photographer
Stock archive

client / product
Bank Austria

236

238

240

242

paintbox company
4 ART digital scenics / Germany

paintbox company
Vienna Paint / Austria

paintbox artist
Reinhard Ottenlinger

paintbox artist
Andreas Fitzner

agency
Neno

paintbox company
Digital works / Germany

art director
Andreas Fitzner

art director
Tom Hölzlein

paintbox company
Digital works / Germany

paintbox artist
Karl Hoffmann

photographer
Andreas Fitzner

photographer
Rolf Schwermer

paintbox artist
Karl Hoffmann

photographer
Jürgen Müller

client / product
self promotion

client / product
berner

client / product
self promotion

client / product
Alfa Laval

244

246

248

252

paintbox company
Vienna Paint / Austria

paintbox company
Vienna Paint / Austria

paintbox company
Grafi Image S.A. / Spain

paintbox company
Repropaint / Austria

paintbox artist
Andreas Fitzner

paintbox artist
Andreas Fitzner

paintbox artist
David Teixidor, Toni Garreta

paintbox artist
Rainer Macku

agency
Ogilvy & Mather

agency
Scholz & Friends

agency
Tandem Campmany / Guasch DDB

art director
Rainer Macku

art director
Michael Heine

art director
Thomas Maresch

art director
Albert Giralt

photographer
Julian Grösel

photographer
Stock

photographer
Studio Trizeps

client / product
Volkswagen

client / product
Repropaint

client / product
Shell

client / product
Scholz & Friends

254

256

258

259

paintbox company
Vienna Paint / Austria

paintbox artist
Albert Winkler

art director
Wolfgang Fasching

photographer
Studio Trizeps

client / product
Team 7

paintbox company
Vienna Paint / Austria

paintbox artist
Andreas Fitzner

agency
Demner, Merlicek & Bergmann

art director
Guillaume Borel

photographer
Bernhard Angerer

client / product
Kurier newspaper

paintbox company
Nureg Paint / Germany

paintbox artist
Horst Auerochs

art director
Horst Auerochs

photographer
Studio Ro

client / product
self promotion

paintbox company
Grafi Image S.A. / Spain

paintbox artist
Toni Garreta

agency
J. Walter Thompson

art director
Xavier Orquín

photographer
Tony Putman

client / product
Kraft Jacobs Suchard
„El Caserío" Magazines

260

262

264

266

paintbox company
Vienna Paint / Austria

paintbox artist
Andreas Fitzner

agency
Dubach AG

art director
Heinz Schwegler

photographer
Felix Streuli

client / product
Eurocheque Swiss

paintbox company
Vienna Paint / Austria

paintbox artist
Andreas Fitzner

agency
TBWA / Tell

art director
Paul Holcmann

illustrator
Andreas Fitzner
Coca Cola archive

client / product
Coca Cola

paintbox company
Sohbi corporation / Japan

paintbox artist
Masaya Ouchi

agency
Hakuhodo Incorporated

art director
Akiteru Hayashi

photographer
Ikuo Sugihara

client / product
Snow Brand Milk Products

paintbox company
Centro Digital Pictures ltd. /
Hongkong

paintbox artist
Kris Tsang

agency
McCann Erickson Inc.

art director
Masaki Shibuya, Mr. Kataoka

photographer
Mr. Takakobayashi

client / product
Moet & Chandon

268

270

271

272

paintbox company
Vienna Paint / Austria

paintbox artist
Andreas Fitzner

agency
Reischer & Partner

art director
Walter Pani

photographer
Heinz Schmölzer, Claude Buri

client / product
Reischer & Partner

paintbox company
MCG Keyframe AG / Switzerland

paintbox artist
Giorgio Bertoli

agency
Wirz Werbeagentur

art director
Laila Hat

photographer
Wirz Werbeagentur

client / product
Michel Fruchtsäfte

paintbox company
Vienna Paint / Austria

paintbox artist
Andreas Fitzner

art director
Andreas Fitzner

photographer
Dieter Brasch

client / product
self promotion

paintbox company
Vienna Paint / Austria

paintbox artist
Albert Winkler

art director
Albert Winkler,
Michael Langoth

photographer
Studio Trizeps

client / product
Meisterklasse Lürzer

276

277

278

280

paintbox company
Vienna Paint / Austria

paintbox artist
Andreas Fitzner

agency
LOWE / GGK Salzburg

art director
Dieter Pirrnel

illustrator
Andreas Fitzner

client / product
Internorm

paintbox company
Vienna Paint / Austria

paintbox artist
Andreas Fitzner

agency
P.C.S.

art director
Christian Rahofer

illustrator
Andreas Fitzner

client / product
COBRA Jeanswear

paintbox company
Vienna Paint / Austria

paintbox artist
Andreas Fitzner

agency
Rath & Tat

art director
Robert Gabler

illustrator
Robert Kratschke,
Andreas Fitzner

client / product
Radlberger

paintbox company
Trannys / Australia

paintbox artist
Ted Blore

art director
Ted Blore

photographer
Ted Blore

284

286

288

289

paintbox company
Gruppe S.F. & H. / Austria

paintbox artist
Edo Zierotin

art director
Edo Zierotin

client / product
self promotion

paintbox company
Vienna Paint / Austria

paintbox artist
Andreas Fitzner

agency
Saatchi & Saatchi

art director
Falko Mätzler, Peter Pfeil

illustrator
Andreas Fitzner

client / product
Austria Tabak

paintbox company
Vienna Paint / Austria

paintbox artist
Andreas Fitzner

agency
Wachtel & Partner

art director
René Wachtel

illustrator
Andreas Fitzner

client / product
Post & Telekom Austria

paintbox company
Vienna Paint / Austria

paintbox artist
Andreas Fitzner

agency
Demner, Merlicek & Bergmann

art director
Bernhard Grafl

illustrator
Andreas Fitzner

client / product
Creditanstalt

290

292

293

294

paintbox company
Reproff A/S (Wiz-Art) / Denmark

paintbox artist
Leif Normark Sorensen

art director
Leif Normark Sorensen

client / product
self promotion

paintbox company
Gruppe S.F. & H. / Austria

paintbox artist
Edo Zierotin

art director
Edo Zierotin

photographer
Othmar Heidegger

client / product
Design Austria

paintbox company
MCG Keyframe AG / Switzerland

paintbox artist
Giorgio Bertoli

art director
Giorgio Bertoli

client / product
self promotion

paintbox company
Vienna Paint / Austria

paintbox artist
Albert Winkler

art director
Ernst Pavlovic

illustrator
Albert Winkler

client / product
Trend Verlag

paintbox company
4 Art digital scenics / Germany

paintbox artist
Reinhard Ottenlinger

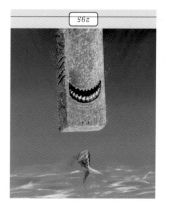

295